DE STIJL

Hans L. C. Jaffé

Thames and Hudson · London

*Translated from Dutch and French by R. R. Symonds
and from German by Mary Whitall*

*The Editor and Publishers regret that it was
necessary to omit from this edition some of the
material which appeared in the original
German edition.*

This edition © 1970 Thames and Hudson

©1967 DuMont Schauberg, Cologne

Printed in Great Britain by Camelot Press Ltd. Southampton
500 18096 2 Clothbound
500 20088 2 Paperbound

Contents

ABONNEMENT BIJ VOORUITBETALINGBINNENLAND 4.50 BUITENLAND 5.50 PER JAARGANG. VOOR ANNONCES WENDE MEN ZICH TOT DEN UITGEVER.

DE STIJL

MAANDBLAD VOOR DE BEELDENDE VAKKEN. REDACTIE THEO VAN DOESBURG. UITGAVE X. HARMS TIEPEN.

ADRES VAN REDACTIE: KORT GALGEWATER 3 LEIDEN. ADMINISTRATIE: X. HARMS TIEPEN. HYPOLITUSBUURT 37 DELFT, INTERC. TEL. 729 EN 690.

1e JAARGANG. OCTOBER NEGENTIENHONDERDZEVENTIEN. NUMMER 1.

TER INLEIDING.

Dit tijdschriftje wil zijn eene bijdrage tot de ontwikkeling van het nieuwe schoonheidsbewustzijn. Het wil den modernen mensch ontvankelijk maken voor het nieuwe in de Beeldende Kunst. Het wil tegenover de archaïstische verwarring — het „moderne barók" — de logische beginselen stellen van een rijpenden stijl, gebaseerd op zuivere verhouding van tijdgeest en uitdrukkingsmiddelen. Het wil de huidige denkrichtingen betreffende de nieuwe beelding. die. hoewel in wezen gelijk. zich onafhankelijk van elkaár ontwikkeld hebben, in zich vereenigen.

De Stijl magazine, Vol. 1, No. 1, 1917

Introduction

The De Stijl movement is characterized from its very beginnings, in the summer of 1917, by a close relationship between its members' artistic works and their writings; practical creative work and theoretical examination of the results go hand in hand. It is thus also typical of the foundation and development of De Stijl that the artists — painters, sculptors, architects and writers — made their collective bow in 1917 with the first issue of a new journal, *De Stijl*, edited by Theo van Doesburg.

Van Doesburg, founder and guiding spirit of the De Stijl group, continued to edit the journal until his early death in 1931. With this modest publication, financed for the most part from his own pocket, he created a platform for the voices of boldness and progress, for the *avant-garde* in the fullest and best sense of the phrase. He had realized early on that in the cultural situation of the early twentieth century works of pure art needed to be accompanied by a theoretical exposition, even, often, by an *apologia* — that the artist had to explain and defend his revolutionary innovations. His own alert, lively mind always responded to this need with great enthusiasm, but Van Doesburg went beyond this in that he persuaded the friends whom he had gathered during 1917 to collaborate

9

in the artistic programme of De Stijl, to express their theories in words and to publish their views on the implications of their work in De Stijl. In the first number of the journal the contributions are preceded by an introduction in which Theo van Doesburg formulates very clearly the editorial line on the relationship between artistic work and theory.

> This periodical hopes to make a contribution to the development of a new awareness of beauty. It wishes to make modern man receptive to what is new in the visual arts.

The journal was thus to provide the theoretical accompaniment to the practical artistic achievements of the members of the group — a contribution which Van Doesburg held to be of the greatest importance and influence. He considered exposition of this kind to be the duty of the truly modern artist, who was not just an 'artisan', a craftsman, but resembled the research scientist in his intellectual activities. Once again the introduction to the first number of the journal expressed his views clearly:

> The Editors will try to achieve the aim described above by providing a mouthpiece for the truly modern artist, who has a contribution to make to the reshaping of the aesthetic concept and the awareness of the visual arts. Since the public is not yet able to appreciate the beauty in the new plasticism, it is the task of the professional to awaken the layman's sense of beauty. The truly modern — i.e., conscious — artist has a double vocation; in the first place, to produce the purely plastic work of art, in the second place to prepare the public's mind for this purely plastic art. To serve this end, a periodical of an intimate character has become necessary. The more so, since public criticism has been unable to make good the lack of appreciation for abstract works of art. The Editors will make it possible for professionals to fulfil this latter task themselves.
> In so doing, this periodical will create a more intimate contact between artists and the public, between the practitioners of the different visual arts. By the mere fact that the modern artist is enabled to write about his own work, the prejudice that the modern artist works according to preconceived theories will disappear. On the contrary, it will appear that the new work of art does not derive from theories accepted a priori, but rather the reverse, that the principles arise out of creative activity.

With these clear, concise sentences Van Doesburg expounded the relationship of theory to practice in the De Stijl movement, and defined the

journal's position in the group's work. The reader had to be alive to the duty imposed on him by the journal: to be fully conscious of the feelings, impressions and sensations he experienced while looking at works of art. In spite of that, the articles in the journal are of secondary importance, the harmonic accompaniment to the creative thematic material of De Stijl.

With the artistic work of the De Stijl group, as with their writings, it is possible to speak of a collective *œuvre*. As in the early Cubist works, there is hardly any perceptible difference, in the early stages of De Stijl, between the works of the principal artists: pictures by Mondrian, Van Doesburg and Van der Leck painted in 1917 resemble each other almost as much as works by Picasso and Braque in 1909 or 1912. In both cases a common attitude of mind exists both to the world in general and to art, and this attitude finds its visual expression in the work of the De Stijl artists and then, almost immediately, its definition in the pages of *De Stijl*.

What was this common ground from which sprang both the artistic works and the writings of the De Stijl group? What was the common factor which united such different personalities as the painters Mondrian, Van der Leck, Huszár, the sculptor Vantongerloo, the architects Oud, Van 't Hoff and Wils, under the leadership of Theo van Doesburg, in a group which was joined over the years by such artists as Domela, Vordemberge and Lissitzky, the architects Rietveld, Van Eesteren and Kiesler, poets like Hans Arp and Hugo Ball, as well as such disparate figures as Gino Severini, Constantin Brancusi, Georges Antheil, Antony Kok and Werner Graeff? De Stijl's creed, with regard to practical creativity, can be summarized in a few words: first and foremost, total abstraction, *i.e.*, the complete rejection of literal reality as it appears to the five senses; following from this principle, a severe restriction of creative terms to the basic minimum: the straight line, the right angle — in other words, the horizontal and the vertical — and to the three primary colours, red, yellow and blue, and the three equally primary non-colours, black, grey and white.

This is the arsenal of means of expression with which the De Stijl group created a new kind of visual art: *de nieuwe beelding, die neue Gestaltung*, Neoplasticism, one of the decisive, revolutionary movements in the visual arts, a movement, moreover, which soon spread beyond the borders of Holland throughout the whole of Europe, and has exerted an influence upon the creative art of the world today which can hardly be over-estimated. This influence cannot be explained only by the discipline, the rigorous

restraint and the technical mastery of the group; the secret of De Stijl's influence lies in the fundamental principle of its philosophy, in the concept of harmony and the suppression of individualism.

But before we discuss the intellectual background and philosophical roots of De Stijl, a few short notes on the formation of this revolutionary movement are called for. There can be no doubt of the time and place of its formation: the group and the journal were founded in the late summer of 1917 in Leiden, where Theo van Doesburg was living at the time. Van Doesburg, who had long nursed plans for an association of progressive artists in Holland, was the real founder, and in 1917 had already won over three other painters to his ideas: Piet Mondrian, Bart van der Leck and Vilmos Huszár. Each of the four had his own contribution to make to a new revolution in style, but only when the four joined forces did a chemical reaction, as it were, produce a new movement in painting, the art of De Stijl.

Piet Mondrian was the oldest and most mature of the four. Born in Amersfoort in 1872, he was already forty-five in 1917; he had made something of a name for himself by the end of the nineteenth century as a landscape painter in the style of the Hague school, a rather provincial style derived from the school of Barbizon. His early works are typical of a young artist in the process of developing his talents, but give no indication of the revolutionary genius that was to evolve later. Mondrian himself, however, saw his development as an artist laid out in front of him like a long, straight path, which was to lead him, in his own words, 'ever forward' to a progressively clearer and more definite artistic expression of reality. His early subjects, mostly trees and windmills, show an increasingly strict tautness and simplification in their treatment, the shapes are arranged on one plane in great complexes, emphasized by the way the colour is used. Around 1907 came a phase when Mondrian fell under the influence of the Fauvists and the Dutch Luminists: his colouring at this period, partly due also to the use of an almost *pointilliste* technique, became purer and simpler. By 1910 Mondrian's interests were veering once more towards form: in his desire to ally himself with the Cubists he took in 1911 the important step of moving from Holland to Paris. The strong urge towards simplification and intensification at this period is plain in the various series of pictures on the same subjects: the series of trees, the two versions of *Still-life with Ginger Jar*, the series of sand dunes, the church façades and the lighthouses, in which Mondrian's path moves in an

Piet Mondrian. *Sketch for adjacent drawing* Piet Mondrian. *Drawing.* 1917

obvious progression from the reproduction of literal reality to the discovery
of compositional values. In the course of this process of artistic transition
the objects gradually lose their identity and their plastic independence,
and become parts of the compositional unity of the picture.

During his stay in Paris, from 1911 to 1914, Mondrian's path continued
steadily in this direction; his Cubist pictures became even more taut and
severe, since as far as possible he straightened out curves, eliminated
diagonal lines and, above all, composed the rhythm of his pictures from
a structure of straight lines and right angles. In the works of these years
he took Cubism further than the original Cubists: he went beyond the
bounds of Cubism and came very near to abstraction.

This style, still essentially Cubist, reached its climax in the following
period. In 1914 Mondrian had to leave Paris to go to his father's sick-bed
in Holland, where he was forced to remain for the next four years by the
outbreak of the First World War and the German invasion of Belgium.
During these four years he took up once more the theme of the sea, and
the pier at Scheveningen became the subject of a series of pictures: that

13

is, the rhythm of the waves breaking on the perpendicular structure thrusting out into the sea was the point of departure for his studies and paintings. The pictures in this cycle date mostly from between 1915 and 1917; as time passes they move further away from the starting point, and, finally, in the great picture of 1917, the subject of the pier and the sea is only a faint memory in the compositional rhythm.

This shows plainly enough the stage Mondrian had reached in 1917, and the contribution he had to make to a new style. His works from the beginning of 1917 are characterized by two typically Cubist traits: the subordinate role of colour — the pictures in the pier and ocean series are all almost monochrome, the subject not being one that inspires a lavish use of colour — and the centripetal scheme of composition, drawing the compositional forces towards the two centres of an oval. Mondrian's contribution to the new collective *œuvre* of De Stijl thus consisted of a well-advanced, if not quite completed, movement towards abstraction, and in a logical development of Cubist compositional principles which went further than anything to be found in the work of any of the Cubists themselves at that time.

Very soon after, in the second half of 1917, Mondrian's pictures in the new style began to appear, the first of a long series of pictures with variously shaped rectangles on a white background. This is the first stage of the new development; in the second stage Mondrian turned again to the short fragmentary lines which composed his Cubist pictures and combined them with the coloured rectangles. Finally the very short, independent, fragmentary lines became continuous lines, on the one hand enclosing the coloured shapes, on the other linking the coloured shapes and the white background, weaving them into a solid, expanding plane. These purely two-dimensional compositions form the starting point for Mondrian's Neoplasticism, which he developed logically and patiently after his return to Paris; over the years he painted a fascinating series of masterpieces, each one evolving as a direct consequence of the one before it. These works of Mondrian's painted after the decisive event of the founding of De Stijl, are characterized by colour and centrifugal composition — two attributes in direct opposition to his earlier works. The picture no longer contracts towards its focal points to make an oval, but spreads outwards, the rhythm spills over the edges of the painting, and while the interplay of the coloured shapes is cut by the frame it is by no means brought to a halt. Thus what happened in the middle of 1917 — the formation of a

14

freely associated group dedicated to a new style — is reflected in Mondrian's work; although his development can be seen as one inevitable process, the foundation of De Stijl forms the watershed in his work.

Besides Mondrian, Bart van der Leck, born in 1876 and so four years his junior, made an essential contribution to the foundation of the new art. His early work belongs to the same category as Mondrian's first pictures — landscapes in the style of the Hague school — but later Van der Leck went his own way. Instead of experimenting with Fauvism and Cubism he joined the group of Dutch Monumentalists, whose aim was to achieve in the mural the superpersonal style of the past. In the pictures Van der Leck painted between 1908 and 1912 he developed a characteristic style of simplification and stylization; illustrating books helped him to limit his expressive terms more strictly. He brought this style to perfection around 1912; the background of his pictures assumes the flat severity of a wall; every suggestion of three-dimensional perspective has disappeared; figures appear in profile or full-face as sharply delineated silhouettes. The Tempest of 1916 represents the climax of this style: against a wall-like, white background, large firmly-outlined plane shapes in primary colours confront each other in vivid opposition. Van der Leck's contribution to the new art lies in this method of composition with large, geometrically defined planes in primary colours, still representational, but already completely two-dimensional.

Then in 1917 Van der Leck began to produce pictures which are remarkably similar to those that Mondrian was painting at the same time; coloured rectangles and fragmentary lines are distributed on a white background and the compositional principle is similar to the rhythm of Mondrian's works, the picture being dominated by a sense of outward movement. These works appear to be fully abstract, and only a careful comparison shows how they have developed from earlier compositions with figures. Van der Leck and Mondrian created a new compositional principle simultaneously and the 'family likeness' of their works is often reminiscent of the similarity between pictures by Braque and Picasso in the early years of Cubism. Mondrian himself declared in an autobiographical essay in later years that he first saw this new principle of abstract composition in the work of Van der Leck. Mondrian remained true to this principle and to abstraction throughout the rest of his life, while Van der Leck went back to using the same expressive terms in the rendering of figurative subjects. By doing so, beginning with his Rider of

Theo van Doesburg. *Drawing.* 1916 Vilmos Huzár. *Linocut.* 1917

1918, he opened a rift between his views and the collective ideas of De Stijl. Nevertheless, in his general attitude he was faithful to the spirit of De Stijl: he raised the expressive medium of painting to a level above the merely personal, thus accomplishing the most fundamental aim of De Stijl. Moreover, his attempts in later years to create space by the strength of colour added a new dimension to De Stijl's plasticism.

Theo van Doesburg, born in 1883, was much younger than his friends the two painters, but he began to paint not long after they did. He too went through a phase of Fauvism and early Expressionism, and consequently the painting of Kandinsky and his book *On the spiritual in art* had a formative influence on his artistic personality. At the outbreak of war his career was interrupted by military service; only in 1916 was he able to resume his place in the world of art, to which he brought, besides a thorough grounding in theory, a strongly developed feeling for composition which he had learned from the work of Cézanne. For Van Doesburg, too, 1917 was a year of decisive changes, in which he painted pictures parti-cularly close in their compositional principles — both in colour and in rhythm — to the works of Mondrian and Van der Leck; Van Doesburg, too, contributed to the almost anonymous, collective *œuvre* of De Stijl at that time, an identity which was mainly possible because the dynamism, which eight years later was to cause his break with Mondrian, did not yet

16

dominate his painting. Van Doesburg, the guiding spirit of De Stijl, did not, as a painter, claim a place of distinction among his comrades; it was in working with them and beside them that he made his contribution to the foundation of the new style.

The fourth and youngest of the painters who together evolved the new painting of De Stijl was Vilmos Huszár, born in 1884. His contribution is equally worthy of attention, for he had been looking since 1914, in paintings on glass and in graphic work, for a form whose chief characteristics would be simplicity and severity of composition. The Dutch Monumentalists were not without influence on the contribution he had to make to the new painting.

And so, in 1917, four artists merged in a new unity, four elements underwent a kind of chemical reaction to form a new substance. But, as often happens in chemical processes, the affinity of the elements is not enough in itself to bring the new compound into being. A catalyst is also necessary, a factor which is not included in the resulting compound but which releases the reaction. The role of catalyst in 1917 was played by the philosopher Schoenmaekers, a neighbour of Mondrian and Van der Leck in Laren. Schoenmaekers, a remarkable, fascinating personality, both mystic and mathematician, had expounded his Hegelian theories on the nature of the world and reality in two books: *Het nieuwe Wereldbeeld* ('The new image of the world') and *Beginselen der beeldende wiskunde* ('Principles of plastic mathematics'). He believed that on the basis of his method and with the aid of mystic concentration he would be able to plot the path to knowledge and understanding of the structure and meaning of the universe, but above all it was by the emphasis he laid on the mathematical structure of the universe that Schoenmaekers showed the four painters the plane on which they could find each other. His philosophy was the catalyst in the foundation of De Stijl: after experiencing it there were no longer four adjacent, related but separate *œuvres*, but one unified, collective *œuvre*, greater than the sum of its parts.

Of course Schoenmaekers' theories were not the only cause of this conjunction of genius. Another important one was the awareness of that intellectual and spiritual atmosphere which is nowadays called *Zeitgeist* and in the vocabulary of De Stijl was 'the general consciousness of the age'. The De Stijl artists always attached great value to this atmosphere, and in their very first manifesto 'the general consciousness of the age' is the starting point of their considerations:

17

is actually seen. These are the laws which obtain everywhere in daily life; they take shape in the scientific formula and in mechanized production alike, as well as in the pulsating rhythms of life in a large city. The De Stijl group observed all these symptoms of a 'new life' with warm sympathy, and regarded them as the source of their inspiration.

This clear emphasis on the longing for 'new life' is itself a phenomenon of the age. It was at this time, in the middle of the First World War, that artists and philosophers, scientists and poets were realizing that the old norms had lost their validity and that it was necessary to find a new scale of values for the future. The search, which took the form of a Utopian idealism, won particular support in the Netherlands, an island of neutrality during the war; the forces of innovation were concentrated in this domain of spiritual and intellectual combat.

De Stijl was founded in neutral Holland during the First World War, and it is not going too far to assert that this art could not have originated in any other country. The argument is often advanced that one proof of the Dutch nature of De Stijl lies in the resemblance of the pictures to the Dutch landscape as seen from an aeroplane or a church tower. This explanation seems superficial to me, particularly in view of the fact that all the De Stijl artists had been through a naturalistic phase in their early work, which was well behind them. It is true that Holland is the only country in the world where the horizon is an optical fact and not an imaginary line, and the eye of the artist cannot be closed to such a fact. Yet, one should, perhaps, take the explanation further: the Dutch landscape is not De Stijl's source of inspiration, but rather both have a common origin. The Dutch landscape is an artefact: its appearance has been imposed on it by principles of economical expediency and practical sense, following the fundamentals of Euclidean geometry. The straight lines and the right angles are the testimony to centuries of human labour. The precision and clarity of geometrical shapes play a vital part in the work of reclamation; the new land must be protected against the sea, against nature. The straight line and the right angle are the signs of man's struggle against nature and of the eventual triumph of man's labour over its capricious power. The straight line and the right angle are the sign of man's assertion of his will against the curves and bends, the acute and obtuse angles which belong to natural, organic creation. It is for the very same reasons that the straight line and the right angle dominate in the work of De Stijl: the triumph of the human mind over arbitrary and capricious nature finds

There is an old and new consciousness of the age. The old is connected with the individual. The new is connected with the universal. The struggle of the individual against the universal is revealing itself in the World War as well as in the art of the present day.

The war is destroying the old world with its contents: the dominance of the individual in every field.

The new art has brought forward what the new consciousness of the time contains: balance between the universal and the individual.

The artists of De Stijl saw in the events of their age a trend towards collectivization, to depersonalization as well as to mathematical exactitude, to the precision of the formula. They read the symptoms of this revolution in values in many different facts of everyday life, which they regarded with enthusiasm and sympathy: technology appeared to them to be the clearest sign of the new age, a herald of the future; in the work of machines they recognized a perfection, a regularity of which the human hand is incapable. But they also believed they could observe the same trend in other manifestations of modern life: in the organization of political parties, of the masses, of the trade unions. In every problem the element of chance, which was an inherent factor of every individualist kind of solution, was being forced to give way to the generalization of the formula, of the abstract solution. The modern work process seemed to them to be a prototype of this new form of life, and the blueprint its visible symbol. They compare the blueprint to a musical score where the composer's work already exists, complete and entire, on the page of manuscript; performance is a technical matter and can be left to craftsmen. They extended this conception of creation to painting: the value of a work of art no longer lay in its execution but in the creative idea from which it grew. Painting was thus no longer restricted to the surface of the canvas — it had moved into new realms, and it was this advance that the journal De Stijl supported: in its pages all the implications, ethical and political, of the new painting were to find a chance of expression and a fair evaluation.

This new attitude to reality and the extension of painting's horizons was also justified for the De Stijl artists by yet another fact: the invention and perfection of photography. After this development, it seemed to them that it could no longer be the task of the artist to capture for eternity the outward appearance of things; instead his aim should be to reveal the laws which govern all visible reality but which are veiled and distorted by what

here its visible expression, its plastic form. The urge towards perfection, the determination to build in spite of the forces of nature, have been Holland's inheritance for centuries, a national trait which manifests itself once more in the painting of De Stijl.

It is not hard to find other sources of the new art in Holland; every aspect of De Stijl and its works can be related to its Dutch origins. Perhaps the most obvious tap-root of De Stijl is Dutch puritanism, which is not confined to one religious sect: every Dutchman is a Puritan to a greater or lesser degree. Certainly in the sixteenth century Calvinism played a decisive role in forming Dutch spiritual and intellectual attitudes, and in the twentieth century it is certainly no empty coincidence that almost all the members of the De Stijl group came from strict Calvinist families, so that a connection is established between their rectilinear and rectangular principles and the rigidity of religious orthodoxy. The history of Calvinism furnishes apt parallels: the first act of Calvinism in the Netherlands was the destruction of religious images and we could certainly call the De Stijl group true successors of the iconoclasts. There are obvious similarities in the motives of both groups; for the iconoclasts every image of a saint was a diminution, an infringement of the absolute divinity of the Creator; every image of a part of creation seemed to the De Stijl artists an infraction, a mutilation of the divine purity of the laws of creation. The fundamentals of their thought ran along parallel tracks, for this absolutist, puritanical way of viewing the world is an inherent part of the Dutch character. Perhaps the most revealing indication of parallels between Dutch and Puritan thought is the double meaning of the word *schoon* which means both 'pure' and 'beautiful'. The parallel is expressed with equal clarity in the works of De Stijl, the beauty of which arises from their immaculate purity.

It is not hard to find examples of a similar conception in the art of the past: the serene purity of Vermeer's interiors, the bright clarity of Saenredam's churches, the simple orderliness of Pieter de Hooch's rooms are all visual expressions of the purifying spirit of puritanism. But the supreme example of this way of thought and feeling is surely Spinoza, whose principal work bears the title *Ethica more geometrico demonstrata* ('Ethics revealed by the geometrical method'). In view of the ethical content of their words one could also use this title for the collective *œuvre* of De Stijl. Spinoza chose the geometrical method of presentation in order to be able to prove the principle of his ethics in a way that

20

transcended personal arbitrariness and was thus irreproachable. The artists of De Stijl had a similar purpose when they chose to restrict their means of expression to elements of unalterable validity in order to be able to give creative form to the essential content of their philosophy: harmony. This compulsive search for the absolute, this desire to transcend nature must be included among the Dutch origins of De Stijl.

The restriction of expressive terms to the elemental served the most important aim of the De Stijl movement: the purification of the arts. Purification, cleansing in this case meant, above all, autonomy. De Stijl wanted to release the arts from their dependence on extraneous systems of values and give each art the freedom to obey only its own laws. This independence of the arts had a two-fold significance for the group. They wanted to free the plastic arts on the one hand from the necessity of representing any random object belonging to the natural world and, on the other hand, from another kind of random chance, from the subjective, temperamental whims of the individual. That art should be obliged to be dependent on either of these kinds of chance seemed to the De Stijl group a threat to its existence; for this reason they placed a total ban on representation — i.e., of the shapes of recognizable objects — in their art, and also limited the stock of their expressive means so severely that any subjective whim seemed to be ruled out.

In their efforts to purify art, the De Stijl artists felt that they were completing a historical process. Step by step, the visual arts had moved along the road from the reproduction of reality to the presentation of essential, abstract truth; in the art of De Stijl the point had at last been reached when art had won full autonomy. Now art was free from alien influences, now it was no longer the handmaid of any other human activity, now it was free to become a way to the knowledge of absolute truth. For this art, strictly non-figurative though it might be, was to present a subject in figures in the geometrical sense. These pictures, which carefully excluded all objects, were to portray, as objectively as possible, the subject which for the De Stijl artists was the essence of the art of all time: universal, absolute harmony. It would be quite mistaken to regard this art without any subject-matter as an art without content; its content is its very centre of gravity, the nucleus of its collective search and effort.

Universal harmony, the harmony which rules every part of the universe, was both the goal and the subject of the art of De Stijl. This harmony was to be revealed in all its pictures, sculptures and buildings. It is a concept

21

of the role of art which opens up limitless ethical and philosophical horizons for it. The fundamental creative theory, the conceptual form of this art, is closely related to Platonic philosophy, and its derivation from the Neoplatonist tradition and its theological variations is plain. The fact that this ambitious system of thought did not find its expression in words so much as in plastic images is, again, typically Dutch. Holland has no great philosophical tradition, but it has a great pictorial tradition. Truths and discoveries which other people would have expressed in the written word are transmitted here in pictures and images. De Stijl takes its most important steps in its pictures; the writings are *post factum* explanations.

The artists of De Stijl wanted to use their visual language to express their concept of reality and the laws governing reality. Their aim was to achieve a comprehensive view of this reality, one not restricted to a random fragment either by the choice of a single, random object as the subject of the picture, or by the arbitrary limitation of a random, individual point of view. For the artists of De Stijl it was of the utmost importance to keep the whole in view; in this way every property, every value was valid only in its relationship to other values and properties, giving rise to an art of pure relationships, or, in Mondrian's words, 'a true vision of reality'. Above all, the De Stijl artists wanted to depict the way reality conformed to laws and to express this idea, this formula of universal harmony, in visual terms. It is in accordance with this plastic conception of nature — which can be related to Spinoza's *natura naturans* — that natural phenomena have the same relationship to the law as variations to a theme, and it is the theme that De Stijl tries to reveal.

It was in order to represent essential truth and to escape the chance nature of variations that the De Stijl artists rid their pictures of every kind of portrayal of things and restricted themselves to an expressive language so limited that their representation really was as objective as possible. This is yet another manifestation of Dutch absolutism and does much to explain the compelling, almost religious, power of these pictures: a work of De Stijl presents the viewer with an exemplary purity which has the effect of another Categorical Imperative; by its very purity and perfection it makes a demand on the beholder. The spiritual principles and ethical perspectives of De Stijl are contained in this demand for purity; anyone looking at the picture should purify his vision of reality in the same way as the picture does: it is intentionally a paradigm. The artists of De Stijl

DE STIJL

DE STIJL

MAANDBLAD VOOR NIEUWE KUNST, WETENSCHAP
EN KULTUUR. REDACTIE: THEO VAN DOESBURG.
ABONNEMENT BINNENLAND F 6.-, BUITENLAND F 7.50
PER JAARGANG. ADRES VAN REDACTIE EN ADMINISTR.
HAARLEMMERSTRAAT 73ᴬ LEIDEN (HOLLAND).

4e JAARGANG No. 1. JANUARI 1921.

INLEIDING TOT DE NIEUWE VERSKUNST

DOOR I. K. BONSET

De logica, als uitgroeisel van een kunstmatig gefokt denk-
systeem waarbij elke hypothese de matrijs was waarmede
men bepaalde denkpatronen kon afdrukken, heeft onzen
zin voor zuivere woordplastiek ten eenen male bedorven.
De hexameter van Homeros was in de atmosfeer van den
tijd voorhanden en niemand zou er aan gedacht hebben
z'n levensbesef volgens een ander tempo in te leiden en,
nu in onzen tijd het e i g e n w e z e n, het subject.
identiek is met het oneigen wezen, het object, geeft de
dichter de contrastgevoelens van het (zijn) v e r d u b b e l d
subject: wereld · verschijnselen als éénheid. Wat hij van
den lezer eischt is niet: begrijpen volgens eenig logisch
patroon, maar: beleven. Daarvoor moet de moderne dichter
de verharding der kunstmatige logica, waardoor onze
zuivere intuïtie als een schors omgeven is, stuk slaan. Zoo
wil ik dat mijn vers, waarin ik mijn intuïtie geordend
heb, dezelfde uitwerking op den lezer heeft als het lemmet
van een ijsbreker op bevroren water.
Tegenover het sentimenteele methethoofdindehandengedweep: een heroïsche activiteit. Joséphin Péladan wilde
den geestelijken héros uit een symbolisch levensbesef

De Stijl magazine, Vol. 4, No. 1, January 1921

INTERNATIONAAL MAANDBLAD
VOOR NIEUWE KUNST WETEN-
SCHAP EN KULTUUR REDACTIE
THEO VAN DOESBURG

De Stijl magazine, Vol. 6, No. 1, January 1923

are on no account to be written off as agreeable manipulators of colour
and line, producing work of purely visual and decorative significance.
Such a judgment would be a grave injustice, for it would be to apply
to them norms which are valid for the decorative arts, and to such norms
they were always violently opposed. Every De Stijl picture proceeds from
the principle of harmony and thus expresses an ideal subject in visual terms.
An art, ignorant of this subject, which used De Stijl's formal language,
could be assessed according to the norms of the decorative arts, but not
the work of the De Stijl artists themselves, whose concern was always the
plastic expression of this subject, and who therefore reached out beyond the
realm of mere aesthetics.

It was Mondrian, above all, who defined the ethical implications of De
Stijl, in his articles in the early volumes of *De Stijl* and later in his pamphlet
Art and life. His recurring theme is this: the life of modern man has not
yet been able to attain the order and harmony which are the goal of life.
Human individualism, unrestrained subjectivity have prevented the
establishment of harmony, obscured the clarity of life, thus giving rise
to tragedy, and leading humanity astray from its one, essential path.
Art, on the other hand, has found this harmony and has been able to

objectivism

23

express it objectively and visually because it has now, at last, broken down the barriers raised by individualism. Now art has a new task: it precedes life and therefore must show life the way to the realization of universal harmony. The vision of art as pioneer and pilot was constantly before the De Stijl group and it was this principle that they expounded in their journal. This vision, it is true, is as Utopian as it is revolutionary. But for Mondrian himself the Utopia was the reality in which he breathed and created throughout his life. The earliest sign of his Utopian and visionary view of reality is the dedication on the title page of his pamphlet *Le néoplasticisme* of 1920: *aux hommes futurs*.

Painting was to be the forerunner of the life of the future, and would even be able to hasten its approach and realization. The great purpose of De Stijl's painting was to bring to mankind the light of true purity. In formulating this belief Mondrian was fully conscious that its realization would inevitably lead to the end of painting, but he was not much troubled by this: as long as universal harmony was not yet established in everyday life, he wrote, painting would be needed to provide a temporary substitute for it. But in the future, when once harmony had permeated all areas of life, then painting would have fulfilled its task and become superfluous — so much the better for painting and for life. Mondrian had an unfaltering, precise conception of this harmonious future life. The order, equilibrium and harmony which he had first established in his pictures would reign in every sphere of human life: in politics, architecture, music and the theatre. He tried to envisage exactly how future forms in all these spheres would appear to onlookers. He was sure of one thing: never again would individualism, chance, and the tragedy resulting from them, be able to rupture this harmony once it was established. In the future to which painting showed the way, mankind would have regained Paradise.

This magnificent Utopian vision, a Nirvana of radiant purity and brilliant light, was Mondrian's contribution to De Stijl's world view. In his pictures the visions become visible signs, pointing the way not only to the purity of the future, but also to personal purification of the onlooker's view of reality. The same visions are the subject of his articles in *De Stijl*, the important, comprehensive essay published during the first year and the subsequent dialogues which define his conception of the ideal potentialities of this painting. All his later writings, including his pamphlet *Le néoplasticisme* (1920), draw on these original articles or elaborate particular points first mentioned in them. The first attempt to sum up his ideas was

24

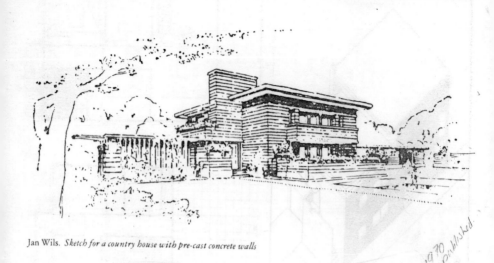

Jan Wils. *Sketch for a country house with pre-cast concrete walls*

not written until 1931, in *Art and life*, after *De Stijl* had ceased publication. Without Mondrian's Utopian vision De Stijl would never have been able to develop the universal validity, the great power of conviction which it still radiates today. But if there had not been another force at work in the movement, if this sublime vision of the future had not evoked a response, De Stijl would probably never have progressed beyond the dream and, splendid vision though it was, we would hardly remember it today.

To make the dream come true called for a personality of a different order from Mondrian, the ascetic and visionary who created a model for the future in his paintings. To fix the dream in the contemporary world was a task for someone with the courage to attack and change reality as it was, and that person was Theo van Doesburg. For him it was not enough to be sure that the world of the future would be altered to conform with the principles of De Stijl: and inner compulsion drove him to alter and renew the world here and now. That is why this talented painter became an architect, that is why, from the very earliest days of De Stijl — of which he was the driving force and founder — he drew architects into the group: Oud, Van 't Hoff, Wils and later Rietveld, Van Eesteren and Kiesler. His constant desire was to build solid realities, to see the structures of his imagination rise against the forms of the past as witnesses of the new age. Van Doesburg was an innovator, a pioneer, and his works are the proof of his vigour and energy: not his pictures alone, which from 1924 show a new and extraordinary dynamism, but above all his architectural works —

25

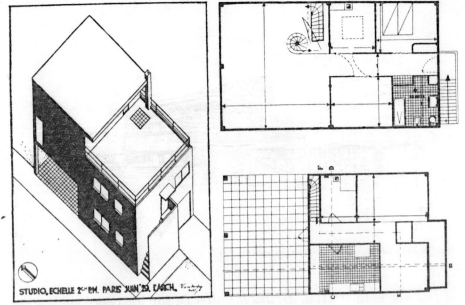

Theo van Doesburg. *Design and ground plan for a studio in Paris.* 1929

the models he made in 1923 with Van Eesteren and Rietveld, the Aubette in Strasbourg of 1928, now unhappily lost to us, and finally his own house in Meudon, started in 1930 but not completed till after his death, which is an authentic plastic expression of the spirit of the twentieth century. It was Van Doesburg who, over the years, made architecture, building, solid construction, of greater importance for the De Stijl movement than the Utopianism of his painting.

This gradual change of emphasis is made clear in the articles printed in the journal. The issues published in Leiden during the first three years are dominated by the painters; the few contributions by architects are in tune with the general trend set by them. The volume for the third year contains the second manifesto, on literature, and Van Doesburg's first article on poetry (under the first of several pseudonyms, I. K. Bonset). This shows the first signs of the influence of Dada, which did not affect all the members of De Stijl but was very strong on Van Doesburg himself. Then in the fourth volume, which was published in Weimar, with a new typographical make-up, a change in direction becomes apparent, due not so much to the influence of the Bauhaus — on the contrary, De Stijl's influence on the

26

Bauhaus was by far the stronger—as to the fact that Van Doesburg was writing far more and expounding his new ideas. The gradual development, which for example brought more and more illustrations of engineering work to the journal's pages, culminated in Van Doesburg's article in the sixth volume, *Von der neuen Aesthetik zur materiellen Verwirklichung* ('From the new aesthetic to its material realization').

For this was Van Doesburg's purpose: the realization of De Stijl's principles in material form, not just in the carefully sheltered world of painting, but in architecture, which played a tangible role in the modern, external world. De Stijl had been concerned with architecture from the very beginning, and its importance for the movement increased as time passed. To begin with it was Oud, Wils and Van 't Hoff in particular who put the principles of De Stijl to work, in their designs rather than in actual buildings; after 1923 a new group came to the forefront, due largely to Léonce Rosenberg's commission for a private dwelling and an artist's studio: Van Doesburg himself began his architectural activities at this point, his colleagues on the project being Van Eesteren and Rietveld. They never carried out Rosenberg's commission, but the creative ideas worked out in

Robert van 't Hoff. *Ground plan of 'Huis ter Heide'*

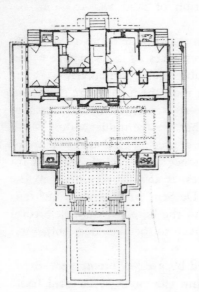

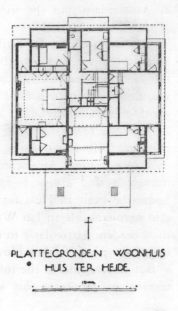

PLATTEGRONDEN WOONHUIS
HUIS TER HEIDE

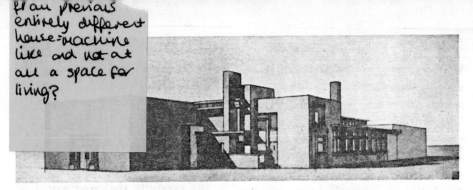

fr an previous entirely different house-machine like and not at all a space for living?

- J. J. P. Oud. *Factory at Purmerend.* 1919

studies and plans for it are evident in Rietveld's Schröder house of 1924, in a lapidary form that convinces by its very economy. Since 1924 this second generation of De Stijl architects has put up one milestone after another. The list includes Van Doesburg's Aubette in Strasbourg and the house in Meudon which he designed for himself and De Stijl in 1930, Van Eesteren's town-planning schemes — the re-development of Unter den Linden in Berlin and the Rokin in Amsterdam — Rietveld's last buildings — the Dutch pavilion at the Venice Biennale, the Zonnehof in Amersfoort — as well as the designs which, since his death, have not yet been carried out, for the School of Art in Amsterdam and the Van Gogh museum, and in another dimension Van Eesteren's magnificent plans for the redevelopment of Amsterdam and the use and organization of land and space in the Netherlands as a whole.

The first wave of De Stijl architects devoted their energies in the early years, from 1917, to combating the excrescences of a decorative architecture which had recently become fashionable again, particularly with the so-called Amsterdam school. Their reaction took them to where the dominant forces were technical sobriety and severe structural honesty, and so Berlage and Frank Lloyd Wright became the decisive influences on Van 't Hoff and Wils in particular, and to a lesser degree on Oud also. The influence of the great American, whose importance Van 't Hoff had seen for himself during a visit to the United States, is already very plain in the houses he built in Huis ter Heide before De Stijl was founded; but it is also unmistakable in Jan Wils' alterations to the hotel De dubbele Sleutel in Woerden, particularly in the emphasis given to the extended, horizontal eaves, so typical of Frank Lloyd Wright.

But in addition to the influence exercised by great contemporary architecture, an important part was played within the circle of De Stijl itself

28

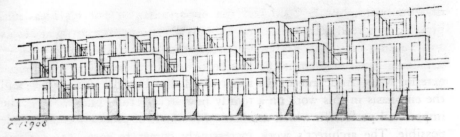

C 1:900

J. J. P. Oud. *Design for a seaside promenade*

by the dominance of painting. The balance and harmony which was being achieved in the work of Mondrian, Van der Leck and Van Doesburg became a goal for the architects to aim at; Oud's first designs which were published in *De Stijl* are a proof of this. His 1917 design for a seaside promenade is more reminiscent of Cubism, but the decisive step was taken by 1919 when Oud published the design for a factory for Purmerend, where he was born: the left wing, with the large, boldly framed door, still owes much to Berlage, while the right wing, with its predominantly horizontal lines, shows the unmistakable influence of Frank Lloyd Wright. The central block, between two large, smooth walls is pure De Stijl, a transposition of the principles of De Stijl painting into the third dimension, the language of architecture. The transposition is by no means a purely mechanical one of formal elements only; the principles of the visual language first formulated by the painters in the De Stijl movement are applied here with full regard to the requirements and meaning of architecture.

Rietveld's armchair of 1918 is also a quite independent product, owing nothing to Mondrian's forms, but a totally original creation, closest if anything to Bart van der Leck's pictures of the same period — a relationship which can be explained by the fact that they both worked for some time with the same Utrecht architect, P. C. Klaarhamer. Oud's earlier designs and Rietveld's armchair are both characterized by the deliberate purging of all alien influences and formal complexes — this idea of purgation, autonomy and independence derives from the painters. Thus it was the principle rather than the forms of painting which exercised the most influence upon the De Stijl architects.

This first phase of De Stijl architecture, from 1918 to 1923, is most typically represented in the work of Oud. His earliest designs — the seaside promenade and the Purmerend factory — never got further than the

29

drawing-board, but he soon had the opportunity to put his ideas into practice on a really large scale and in a social context, in apartment blocks and housing estates in Rotterdam and at Hook of Holland; his point of departure in all of them is the tension between the house and the street's exterior walls. And, true to the spirit of all that De Stijl stood for, he laid the emphasis in this work on a totally new architectural phenomenon: the impersonal perfection which mechanical methods of production now made possible. The architect's work increasingly comes to mean composition with objects designed for a specific function: his blueprint becomes as complete a creation as a musician's score. And he will take care to restrict the opportunities for chance and human idiosyncrasy to a minimum, by basing his design on the fundamental facts of building.

Oud's buildings of the early 'twenties, and his principles, which reached their maximum of purity and architectural precision a few years later in the Kiefhoek estate in Rotterdam, are one of the acknowledged starting points of 'functional architecture' in Europe. Above all else it was Oud's connections with the Weimar Bauhaus which caused the idea of logical functionalism, which owed its conception to De Stijl to become a generally accepted principle in European architecture. Firm roots in the human environment and the anonymous perfection of mechanization were the characteristic features of the new architecture, which was thus a typical expression of the principles of De Stijl: the defeat of subjectivity.

About a year before Oud began work on the Kiefhoek estate — probably his outstanding achievement within the framework of De Stijl — the second architectural phase of De Stijl got under way as the result of the commission from the Parisian art dealer Léonce Rosenberg, who first approached Oud himself. Oud refused — and the reason is typical of the practical architect he happened to be — because Rosenberg had not yet found a site and it would therefore be futile to take up so theoretical a commission; an architect could not possibly design a building without knowledge of its site.

Oud referred the commission to Van Doesburg, who took it up in collaboration with Van Eesteren and Rietveld, and used it, theoretical as it was, as a starting point for a thorough analysis of the principles of architecture, an analysis which gave rise to the fifth manifesto *Vers une construction collective* in 1923 ('Towards a Collective Construction'), published in the sixth volume of *De Stijl*. This manifesto, like all the earlier ones, was in every respect the result of creative application, practice forming the basis for theory. Van Doesburg and his two friends and colleagues

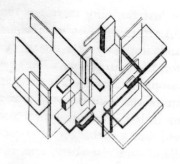

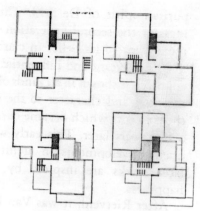

Theo van Doesburg–Cornelis van Eesteren. *Plan for a private or artist's house*

took the hypothetical commission as the starting point, not in order to design a house which would actually be built, but to investigate the basic principles of architecture and space down to their smallest details and so to produce a universal work in accordance with the aims of De Stijl, not a specific design modified by circumstances. They were not concerned with one particular house, which in De Stijl's terminology would be an arbitrary construction, subject to the vagaries of chance, on any one site chosen at random, but with the general problems of space for living in. The three artists solved these problems in a series of designs, drawings as well as models, in which they revealed the possibilities offered to architects by open planning, as opposed to the division of space in separate, box-like units in traditional architecture. They demonstrated the attractions and good sense of using colour as an integral part of the design, again in contrast to traditional practices, and in all these ways opened up new architectural horizons.

In 1924, the year following the completion of the designs for the Rosenberg houses, Rietveld and Madame Schröder-Schräder built a house on the Frederik Hendriklaan in Utrecht. In it Rietveld put into practice all the architectural solutions which the three artists had together worked out on paper. In particular, the treatment of space as one continuous unit reveals an important progression beyond the first stage of De Stijl architecture; the interplay of interior and exterior, the tense, uncompromising form of the structural elements, unmistakably embody the immaculate,

31

puritan spirit of De Stijl. This house is the first building to reflect the ideas of the second generation of De Stijl architecture, and has become the monument to its belief in clarity, openness and simplicity. It is one of the most significant and influential architectural works of our century. The new approach is shown in all kinds of details; for example, the use of colour to give meaning and character to the spatial structure of the building anticipates the concepts which became current in painting in 1917, and in architecture a few years later. This early work by Rietveld was a harbinger of subsequent developments in architecture in Holland and elsewhere, and his later works are inspired by the same freedom, brilliance and radiant happiness.

After Rietveld, it was Van Eesteren who made the most significant contribution to the second phase of De Stijl architecture in the work he did in Paris. His influence on the group's ideas about architecture and space, even on Van Doesburg, was of the greatest importance, particularly in the opportunity he created for fundamental re-thinking about the elements of architectonic construction and form. His 1923 design on the creation of the Paris architectural models for a house on a river bank show how advanced his ideas were in many respects. But his most important work was on a larger scale, in the field not of single buildings, but of town planning. In the early years of De Stijl the modern city was a major source of inspiration to the artists; now it was re-made according to De Stijl's principles by one of the group's members. Van Eesteren applied De Stijl's ideas to the organization of space in large units — cities or whole provinces; his designs for areas within cities, such as Unter den Linden in Berlin and the Rokin in Amsterdam, were forerunners of the designs made many years later for the expansion of Amsterdam. In this Van Eesteren brought to fulfilment one of De Stijl's major concerns, the harmonious ordering of space embodied in the forms and structures of a city, equilibrium of function and form.

In this way De Stijl changed contemporary surroundings according to the principles which had come to the fore in the group over the years, and made a lasting impression on many different areas of the human environment. This essentially moral influence of De Stijl proceeded in the first place from the untiring, dynamic activity of Theo van Doesburg, but all the members of the group played a part in its spread, and not least Mondrian, who in later life won over the United States. The influence was not restricted to isolated areas of the arts: it was felt in typography and film-

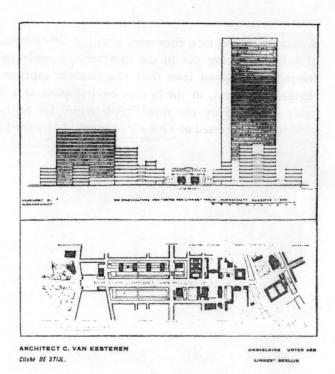

ARCHITECT C. VAN EESTEREN
Cliché DE STIJL.

OMBEELDING UNTER DEN
LINDEN BERLIJN

Cornelis van Eesteren. *Project for 'Unter den Linden'*, Berlin 1925

making, in architecture and in the design of everyday objects, and, in the most general sense, in the ambience of our life today. Nor did only minor artists succumb to it: it is at its most evident in the work of Le Corbusier and the Bauhaus.

The essential effect of De Stijl lies in a wider sphere: the artists worked for years in isolation, obscurity, even poverty, without thinking of making a name for themselves. Only later did people discover that their ivory tower was a spiritual and intellectual beacon for a whole generation to steer by. The artists of the De Stijl group tried to redefine the role of art in the present and the future; they saw the need for a universal language of visual terms, and they based it on the elementary rules of balance and harmony. They drew up a grammar and a syntax for this language which expressed the human urge towards order and regularity. After 1917, while Holland was reclaiming land from the Zuiderzee and the ordering of new

33

spaces was literal fact, they were winning new provinces for the old empire of art and setting out in the new areas a model of human order, of the triumph of human laws over the random caprices of nature. In art, in design in general, in the human environment as a whole, in all the many fields embraced by the word 'civilization' De Stijl put into practice the ideal it had expressed as 'One serves mankind by enlightening it.'

Holland
~ puritan view
constructivist
iconoclastic outlooks

De Stijl 1917–1918

Piet Mondrian

Neoplasticism in Painting

1 *Introduction*

The life of modern cultured man is gradually turning away from the natural: it is becoming more and more *abstract*. As the natural (the external) becomes more and more 'automatic', we see life's interest centering more and more around the inward. The life of *truly modern* man is directed neither toward the material for its own sake, nor toward the predominantly emotional: it is rather the autonomous life of the human spirit becoming conscious. Modern man — although a unity of body, soul and mind — *shows* a changed consciousness: all expressions of life assume a different appearance, a more *determinately abstract* appearance.

Art too, as the product of a new duality in man, is now expressed as the product of cultivated outwardness and of a deeper, more conscious inwardness. As pure creation of the human *mind*, art is expressed as pure aesthetic creation, manifested in abstract form.

The truly modern artist *consciously* perceives the abstractness of the emotion of beauty: he *consciously* recognizes aesthetic emotion as cosmic, universal. This conscious recognition results in an abstract creation, directs him toward the purely universal.

That is why the new art cannot be manifested as (naturalistic) concrete representation, which — even where universal vision is present — always points more or less to the particular, or in any case conceals the universal within it.

The new plastic cannot be cloaked by what is characteristic of the particular, natural form and colour, but must be expressed by the abstraction of form and colour — by means of the straight line and determinate primary colour.

These universal plastic means were discovered in modern painting by the process of consistent abstraction of form and colour: once these were

discovered there emerged, almost of its own accord *an exact plastic of pure relationship*, the essential of all emotion of plastic beauty.

Thus the new art is the determinate plastic expression of aesthetic relationships.

The contemporary artist constructs the new plastic expression in painting as a consequence of all previous creation — in painting, precisely because it is least restricted. The growing profundity of the whole of modern life can be purely reflected in *painting*. In painting — in *pictorial* not *decorative* painting — naturalistic expression and naturalistic means become more inward, are intensified into the abstract.

Decorative art did no more than to *generalize natural* form and colour.

Thus the feeling for the aesthetic expression of relationship was brought to *clarity* in and by pictorial painting. In painting — which incorporates existing decorative art, or rather, becomes 'true' decorative art — the *free* construction of pure relationships can nevertheless remain somewhat limited; for although the essence of all art is *one* — and the feeling for aesthetic relationships increasingly seeks more determinate expression in all the arts — not every art can express *determinate relationships* with equal consistency.

Although the content of all art is one, the possibilities of plastic expression are different for each art. These possibilities must be discovered by each art and remain limited by its bounds.

Therefore the possibilities of one art cannot be viewed from those of another, but must be considered independently, and only in relation to the art concerned. Every art has its own emphasis, its particular expression: this justifies the existence of the various arts. We can now define the emphasis of the art of painting as the *most consistent* expression of pure relationships. For it is painting's unique privilege to express relationships *freely* — in other words, its means of expression (when consistently intensified) allow extreme opposites to be expressed as the pure relationships of *position* — without resulting in forms, or even in the appearance of closed forms (as in architecture).

In painting, the duality of relationships can be shown in juxtaposition (on one plane), which is impossible in architecture or sculpture. Thus painting is the most purely 'plastic'. The free plastic expression of position is unique to painting. The sister arts, sculpture and architecture are less free in this respect.

The other arts are even less free in *transforming their plastic means*: music

is always tied to sound, however much sound may be tensed into 'tone'; dramatic art employs natural form as well as sound, and necessarily the word; literary art is expressed through the word, which strongly stresses the particular.

Painting is capable of *consistent* intensification and interiorization of its plastic means *without overstepping their limits.* Neoplastic painting remains pure *painting*: the plastic means remain form and colour — interiorized to the extreme; straight line and plane colour remain the pure pictorial means.

With the advancing culture of the spirit, all the arts, despite their different expressions, become more and more the *plastic creation of equilibrated, determinate relationship*: for equilibrated relationship most purely expresses the universality, the harmony, the inherent unity of the spirit.

Through equilibrated relationship, unity, harmony, universality are plastically expressed amid separateness, multiplicity, individuality — the natural. When we concentrate upon equilibrated relationship, we can *see* unity in the natural. In the natural, however, unity is manifested only in a veiled way. Although inexactly expressed in the natural, all appearance can nevertheless be reduced to this manifestation [of unity]. Therefore the exact plastic expression of unity *can be created, must be created*, because it is not directly apparent in visible reality.

Whereas in nature equilibrated relationship is expressed by *position, dimension and value* of natural form and colour, in the 'abstract' it is expressed through *position, dimension and value* of the straight line and rectangular (colour) plane.

In nature, we perceive that all relationship is governed by one relationship above all others: that of extreme opposites.

The abstract plastic of relationship expresses this basic relationship determinately — by duality of position, the perpendicular. This relationship of position is the most equilibrated because it expresses the relationship of extreme opposition in complete harmony and includes all other relationships. If we see these two extremes as manifestations of the inward and the outward, we find that in Neoplastic the bond between spirit and life is unbroken — we see Neoplastic not as denying the full life, but as the *reconciliation* of the matter-mind duality.

If through contemplation we recognize that the existence of all things is aesthetically determined for us by equilibrated relationships, then the idea of this manifestation of unity already had its seed in our consciousness: unity.

When man's consciousness grows from vagueness to determination his understanding of unity will become more and more determinate. The advanced consciousness of an age that has become determinate (the consciousness to which the time has arrived — the spirit of the age) *must necessarily express itself determinately.* Thus art must *necessarily* express itself *determinately.*

If unity is seen 'determinately', if attention is focussed purely on the universal, then particularity, individuality will disappear from the expression as painting has shown. Only when the individual no longer stands in the way can universality be purely manifested. Only then can universal consciousness (intuition) — wellspring of all the arts — express itself directly; a purer art arises. However, it does not arise before its time. The consciousness of an age determines the art expression: the art expression reflects the age's awareness. Only that art is truly alive which gives expression to the contemporary — the future — consciousness.

If we see man's consciousness — in time — *growing* toward determination, if we see it — in time — *developing* from individual to universal, then logically the new art can never return to form — or to natural colour. Then, logically, the consistent growth and development of abstract plastic *must* progress to its culmination.

While one-sided development, lack of aesthetic culture, or tradition may oppose it temporarily — an *abstract*, a *truly* new plastic is necessary for the new man.

Only when the new consciousness becomes more general will the new plastic become a universal need: only then will all factors be present for its culmination.

However, the *need* for a new plastic exists because it has come into being through the contemporary artist: the essentials for the new plastic of the future are already there.

If the essential of all art, that which is characteristic in each art expression, lies in the *intensification of the plastic means*, then we clearly see this essential in Neoplasticism's intensification of the means of expression. The new means testify to a new vision. If the aim of all *art* is to *establish relationships* only a more conscious vision can bring this aim to clear expression — precisely through the *plastic means*.

If the proper intensification and use of the plastic means — composition — is the only *pure plastic* expression of art, then the plastic means must be in complete consonance with what they express. If they are to be a *direct*

39

expression of the universal then they *cannot* be other than universal—abstract.

Composition leaves the artist the greatest possible freedom to be subjective—as long and insofar as this is necessary. The *rhythm* of relationship of colour and dimension (in determinate *proportion* and *equilibrium*) permits the absolute to appear within the relativity of time and space.

Thus the new plastic is dualistic through its composition. Through its exact plastic of cosmic relationship it is a direct expression of the universal; through its rhythm, through its material reality, it is an expression of the subjective, of the individual.

In this way it unfolds a world of *universal* beauty without relinquishing the 'universally human'.

[*Vol. I, No. 1, pp. 2–6*]

2 Neoplasticism as Style

The art of painting—essentially one and unchangeable—has always manifested itself in very diverse expressions. The art expressions of the past—characterized by so many *styles*—differ only by reason of time and place, but fundamentally they are one. However they may differ in appearance, all arose from a single source: the *universal*, the profound essence of all existence. Thus all historical styles have striven toward this single goal: to manifest the *universal*.

Thus all *style* has a *timeless content* and a *transitory appearance*. The timeless (universal) content we can call the *universality of style*, and its transitory appearance the *characteristic* or the *individuality of style*. The style in which individuality best serves the universal will be the greatest: the style in which universal content appears in the most *determinate plastic expression* will be the purest.

Although all painting has a timeless content, it is strictly *plastic* art; it can reveal style only insofar as this content actually becomes *plastic*.

In painting style must be *manifested* visually: it cannot be expressed through subject-matter or representation.

The universal in style must come to expression through the individual in style, *i.e.*, through the *mode* of stylistic expression.

The mode of stylistic expression belongs to its time, and represents the relationship of the spirit of the age to the universal. This gives to each art expression its specific character and distinguished historical styles.

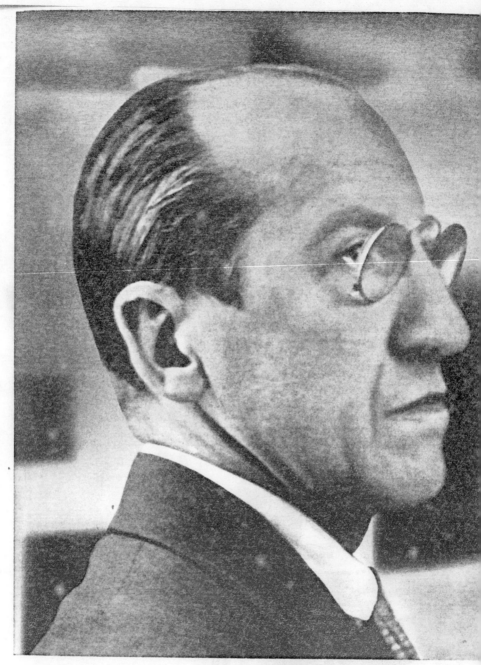

1 Piet Mondrian. 1929

2 Theo van Doesburg. 1923

Theo van Doesburg in his studio. 1923

4 Jacobus Johannes Pieter Oud. c. 1925

5 Bart van der Leck. c. 1925

6 Cornelis van Eesteren. 1923

7 Gerrit Thomas Rietveld. c. 1925

et Mondrian. *Still-life with ginger jar II.* 1912

et Mondrian. *Trees in blossom.* 1912

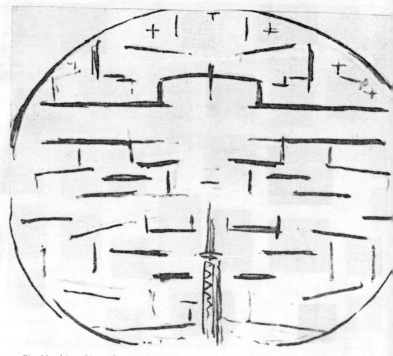

10 Piet Mondrian. *Pier and ocean*. 1914

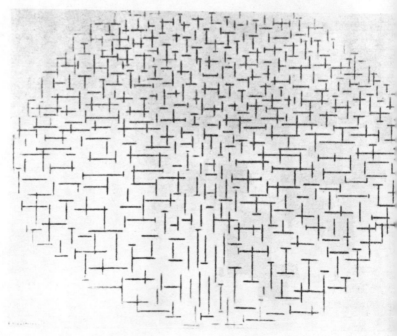

11 Piet Mondrian. *Pier and ocean*. 1915

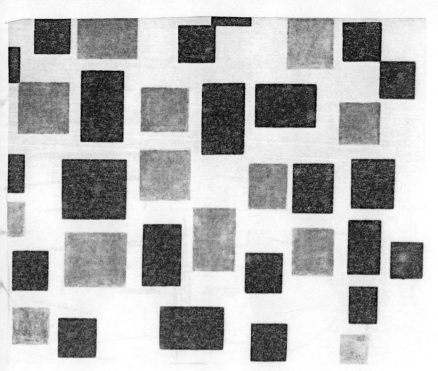

Piet Mondrian. *Composition with pure colour planes on white ground.* 1917

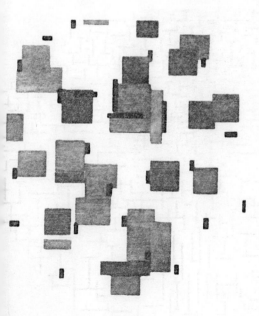

et Mondrian. *Composition in blue B.* 1917

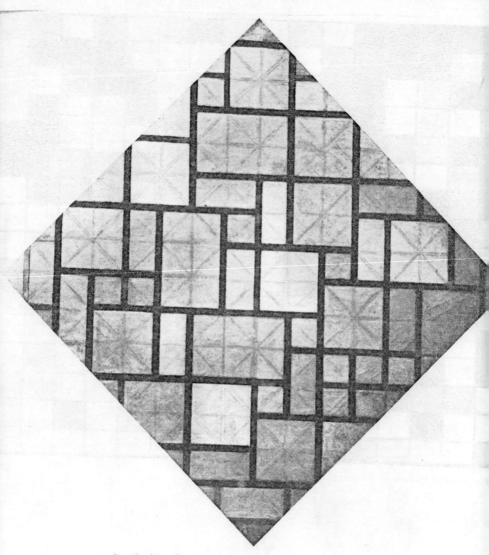

14 Piet Mondrian. *Composition: Bright colour planes with grey lines*, 1919

Piet Mondrian. *Composition: Checkerboard, bright colours,* 1919

The universal in style, on the other hand, is eternal and makes every style *style*. It is the representation of the universal, which, as philosophy also teaches, forms the very core of the human spirit even though it is veiled by our individuality. The universal expresses itself *through* nature as the *absolute*, the absolute in nature is concealed or veiled by the expression of natural colour and form. Although the universal is plastically expressed as the absolute — in line by *straightness*, in colour by *planearity* and *purity*, relationship by *equilibrium* — it is revealed in nature only as a *tendency* toward the absolute — a tendency toward the straight, the plane, the pure, the equilibrated — through *tension* of form (line), *planearity, intensity, purity* of natural colour and natural *harmony*.

The aim of art is to emphasize the absolute, this is the content — universal and individual — of all style. The universal in a style makes the absolute *visible* through the individuality of that style. Because individuality of style provides the *mode and the degree* in which the absolute is made visible, it shows the spiritual outlook of the time it makes a style appropriate to its period, and constitutes a style's vitality.

Individuality of style therefore cannot be separated from universality of style (we discuss style as a duality to gain a pure conception of its meaning).

Painting can express the absolute in two ways: determinately (as it does *not* appear in the external world), or veiled in form and natural colour, as it is expressed in nature. In the first, style appears entirely *in the manner of art*; in the second, always more or less *in the manner of nature*.

In the manner of nature, for nature also shows style. Indeed nature like art reveals the universality of style through the particular, the individual; for everything manifests the universal *in its own way*. Thus we can say that nature also shows individuality of style, but quite differently than art. In nature, individuality of style is *completely bound* to the particular, to the *natural appearance of things*; whereas in art individuality of style must be *entirely free* from this and is bound only by time and place. Therefore art can express style precisely, whereas in nature style remains for the most part veiled. To express style *precisely*, art must free itself from the natural appearance of things so as not to represent them: only in an *abstract appearance* can it represent the tension of form, the intensity of colour and the harmony revealed by nature.

Nevertheless, in one way or another, painting always brings the visible style of nature to an expression that moves man. Painting always more or

less transforms the style of nature into the style of art. The artist perceives style in nature so strongly that he is automatically compelled to express style. Style in nature unites, as it were, with the artist's sense of style: from the union of style without and style within, the work of art is born. Thus style in nature is so expressed by painting as to become (relatively) perceptible and visible to all.

Artistic temperament, *aesthetic* vision, thus perceives style; ordinary vision, on the other hand, sees it neither in art nor in nature. Ordinary vision is the vision of the individual who cannot rise above particularity. As long as materiality is seen as particular, style cannot be perceived. Thus ordinary vision obstructs all art: it does not *want* style in art, it demands a detailed reproduction. The artist on the other hand *wants* and *searches* for style; this is his struggle. But through this struggle against individuality within and without, his style conception grows: he expresses more and more consciously the universality, which, deep within him, is expressed spontaneously and intuitively, does *not struggle*, but effortlessly unfolds.

The universal in the artist causes him to see through the individuality that surrounds him, to see order free from individual expression. This order, however, is veiled. The natural appearance of things has evolved more or less capriciously: although reality shows a certain order in its division and multiplicity, this order is not often asserted clearly, but is dominated by the conglomeration of forms and colours. Although this natural order may not be immediately discernible to unpractised eyes, it is, nevertheless, this *equilibrated order* that arouses the deepest emotion of harmony in the beholder. If profundity of emotion depends upon the degree of his inner harmony, then equilibrated order will be conscious to that degree. When the beholder has achieved some consciousness of cosmic harmony, then he — the artistic temperament — will require a *pure expression* of harmony, a *pure expression* of equilibrated order.

If he is an artist then he will no longer follow order in the *manner of nature*, but will represent order in the *manner of art*: he transforms order, as we perceive it visually, to its *utmost consequence*. Equilibrated order, limited by our individuality and veiled in individuality, then appears as it actually is — as *universal* order: plastic expression shows *universality of style determinately*. At present, equilibrated order in plastic expression is still very relative; the imperfect cannot reflect the perfect.

In style in the manner of nature, on the other hand, order is always more or less bound to the appearance of nature and therefore cannot be expressed

precisely as *equilibrated* order. Style in the manner of nature was required in traditional painting because it directly expressed the particular together with the universal.

For instance in portraiture, a particular *type* cannot be expressed without naturalistic form or naturalistic colour. Neither can a particular landscape nor a still-life — all particularity.

Because all particularity-of-appearance has a particular content and produces a sensation of particularity, which, when expressed through the naturalistic appearance of things, does not move us with the force of reality itself, modern time has been obliged to adopt *other* modes of expression. But as *style*, these modes will have vitality in the future only *insofar as they assert the expression of the universal over the individual* more determinately. If this is actually achieved, then exact representation of the particular disappears. Thus representation in the manner of nature is *the* painting for particular appearance, and has to remain style in the manner of nature as long as particular appearance is demanded in plastic expression.

On the other hand, if consistency of style in the manner of art excludes particular appearance from the plastic, this is not a negation of the objects themselves. For it expresses the *universal* — the core of all things, and thus actually represents things more completely.

Consistency of style in the manner of art is a product of dissatisfaction with the representation of natural colour and form. Naturalistic representation, from the viewpoint of the particular, always remains inferior to actual appearance; from the viewpoint of the universal it is always individual. No art has ever been able to express the power and grandeur of nature by imitation: all true art has made the universal more dominant than it appears to the eye in nature.

Thus, finally, there had to emerge an *exact plastic expression of the universal*. In order to recognize this plastic as style, it is necessary to perceive that style in art is *aesthetic plastic interiorization*, whereas style in nature manifests itself as plastic outwardness.

In this opposition resides art's relationships and nature's appearance. What is usually seen as exaggeration of style in nature generally creates style in art. In the old art, tension of form (line), the intensity and purity of colour and natural harmony were accentuated — sometimes exaggerated. In the new art this exaggeration grew to the point where *form and colour themselves became the means of expression*. When the means were freed of the naturalistic they could be seen in pure light for the first time and the

limitations of form and natural colour became obvious. Then followed rapidly the *breaking of form and the determination of colour*. In this way the universal plastic means were discovered.

The new plastic — consistency of style in the manner of art — begins when form and colour are expressed as unity in the rectangular plane. With this universal means, nature's complexity can be brought to *pure plastic, determinate-relationship*.

Neoplasticism, the style of the future, expresses not only man's deeper inwardness, but his *maturing* outwardness (naturalness). Only this more equivalent evolution of inwardness and outwardness, a more harmonious relationship between this inseparable duality, can create the new style. Our maturing naturalness has transcended the natural and approaches the abstract; it thus becomes homogeneous with the inward, which is abstract. Only the maturing externality within man can produce an abstract vision of the externality outside him. Thus is born an expression which is abstract but nevertheless real. It is real because the content and the appearance of things are unveiled: content, because it is expressed determinately; appearance, because it arises from the natural and yet preserves the essence of the natural.

Thus the culture of the *whole* man was necessary to lead him to a plastic in which natural reality was interiorized into abstract reality.

Although the culture of man's naturalness accompanies his inner life, the former does not always keep pace with the latter.

This explains why abstract-real plastic has not appeared until *now*. Its appearance reveals that there has only just begun to be an equilibrium between man's outwardness and his inwardness, between the natural and the spiritual within him. This new relationship must bring forth a new style. Whereas style in art has always appeared more or less in the manner of nature, the latter is now decaying, now makes way for expression of style in the manner of art.

This style can appear only as the aesthetic vision of the determinately universal. Because the equilibrated relationship of position in the newly found universal plastic means made it possible to determinately express the universal, the new style could now be established.

A certain degree of culture, a certain stage in the evolution of the universal, becomes apparent in the masses only after there has been a preparation and maturation in *the individual* of the preceeding period: the style appears long after it has been in existence.

Style, therefore, is discernible even in an uncultivated period. We do not need a cultured period in order to discern style in the individual. If our time is uncultured (culture understood as unity of the masses), the basis of a culture is nevertheless already developed and expressed in the individual: ready to be manifested as culture — culture to be expressed in art as the *new style*.

In an uncultivated period the style of the future can be recognized as that mode of expression which is the most direct, the most clear reflection of the universal — even though it appears only in a few individuals. In an uncultivated period, however, we must not try to see the future style in the expression of the masses: as long as culture is not general, the masses' expression will have an obsolete character.

Only in a time of true culture can we expect a generally homogeneous expression in art.

The new culture will be that of the *mature individual*; once matured, the individual will be open to the universal and will tend more and more to unite *with* it.

The time is approaching when the majority of individuals will be capable of this.

Formerly, periods of culture arose when a particular individual (standing over and beyond the people) awakened the universal in the masses. Initiates, saints, deities brought the people, as from without, to feel and recognize the universal; and thus came the concept of a purer style. When the power of one of these Universals was spent, the sense of the universal decayed, and the masses sank back into individuality until new power from other Universals could again enter them from without. But precisely because of this relapse into individuality, individuality matured within *man-as-individual*, and he developed a consciousness of the universal within himself. Thus in art today the individual can be expressed as the determinately-universal.

[*Vol. I, No. 2, pp. 13–18*]

3 The New Plastic as 'Abstract-Real Painting': The Plastic Means and Composition

The new plastic can be called abstract not only because it is the direct expression of the universal, but because its expression excludes the individual (or naturalistic concreteness). We can call its exact expression of relationship abstract — in contrast to expression through natural appearance, which it *abstracts*.

If we call the new plastic abstract, the question arises whether the abstract can be visually represented. If it is to be expressed determinately, it is illogical to identify the new art with the vaguely plastic — as is often done.

After long culture, the consciousness has grown in painting that the abstract — the universal — can be clearly represented. Through the very culture of representation through form, we have come to see that the abstract — *like the mathematical* — is *actually* expressed in and through all things, although not determinately; in other words: the new painting achieved of its own accord a determined plastic expression of the universal, which, although veiled and hidden, is revealed in and through the natural appearance of things. Through painting itself, the artist became conscious that the appearance of the *universal-as-the-mathematical* is the essence of all feelings of beauty as pure *aesthetic* expression. (The artist developed his awareness through practice; but in the deeper sense he gives conscious expression to the spirit of his age.) As awareness grew, he learned to construct appearance through the precise plastic representation of individual things — precisely by abstracting it more and more. He learned to represent *exactly* what is merely *suggested* in nature, he *reduced and destroyed the concreteness* of appearance (by simplification), yet he did no more than carry the *conception of art* to its logical conclusion. And so our age came to *abstract-real* painting. Neoplasticism is *abstract-real* because it stands between the absolute-abstract and the natural, or concrete-real. It is not as abstract as thought-abstraction, and not as real as tangible reality. It is aesthetically *living plastic representation*: the visual expression in which each opposite is transformed into the other.

Abstract-real painting can create in an aesthetic-mathematic way because it possesses an *exact mathematical means of expression: colour carried to determination.*

To determine colour involves: first, *reducing naturalistic colour to primary*

colour; second, *reducing colour to plane*; third, *delimiting colour — so that it appears as a unity of rectangular planes.*

Reduction to primary colour leads to the visual internalization of the material, to a purer manifestation of light. The *material, corporeality, (through its surfaces)* causes us to see colourless sunlight as *natural* colour. Colour then arises from *light* as well as from the *surface*, the *material*. Thus natural colour is *inwardness* (light) in its most outward manifestation. Reducing natural colour to primary colour changes the most outward manifestation of colour back to the most inward. If, of the three primary colours, yellow and blue are the most inward, if red (the union of blue and yellow — see Dr H. Shoenmaekers, *The New World Image*) is more outward; then a painting in yellow and blue alone would be more inward than one in the three primary colours.

But if the near future is still far from this internalization, and if today the time of natural colour is not yet over, then abstract-real painting must rely upon the three primary colours, supplemented by white, black and grey.

In abstract-real painting *primary colour* simply means *colour in its most basic aspect*. Primary colour thus appears very relative — the principal thing is *for colour to be free of individuality and individual sensations, and to give expression only to the serene emotion of the universal.*

The primary colours in abstract-real painting *represent* primary colours in such a way that they *no longer depict the natural, but nevertheless remain real.*

Colour is thus *transformed* not arbitrarily but in complete harmony with all principles of art. Colour in painting owes its appearance not only to visible reality but also to the vision of the artist: he intensified colour inwardly and *interiorizes* its outwardness.

If colour expression results from a reciprocal action of the subjective and the objective, and if the subjective is growing towards the universal, then colour will increasingly express the universal — it will be manifested more and more *abstractly*.

If it is difficult to understand that expression through line can be abstract-plastic, then it is even more difficult to recognize this in intensified colour-as-colour (as against colour as white and black — light and dark).

Neoplasticism's abstract colour is *meaningless* to subjective vision: for abstract colour leaves out individual expression of emotion — it still expresses emotion, but an emotion dominated by the spirit.

55

Neoplasticism succeeds in *universalizing* colour for it not only seeks the universal *in each colour-as-colour, but unites them mutually through equilibrated relationships.* In this way each single colour's particularity is destroyed: colour is *governed* by relationship.

In nature no less than in art, colour is always *to some degree dependent upon relationships* but is not always governed by them. In naturalistic expression, colour always leaves room for subjectification of the universal; although colour becomes *tone* through relationship (tonal or value relations), colour remains dominant.

Colour can be governed only through the exact expression of equilibrated colour relationships so that the universal can appear determinately.

If the emotion aroused by *colours themselves* is linked to feeling, and *conscious recognition of relationship* is linked to the spiritual, then spiritual feeling will make relationship increasingly dominant over colour.

As an exact plastic expression of *intensified colour* as well as relationships, Neoplasticism can express *complete* humanity, that is, equilibrium of mind and feeling. Equilibrium in plastic art, however, demands a most exact technique. Although Neoplasticism *appears* to have given up all technique, its technique has actually become so important that the *colours must be painted in the precise place where the work is to be* seen: only then can the effect of the colours and relationships be precise.

For they are interdependent with the entire architecture; and the architecture in turn must harmonize completely with the plastic. As the time is not yet ripe for its complete unification with architecture, Neoplasticism must continue to be manifested as painting: this must influence today's abstract-real plastic. Each artist must find his own colour-expression according to time and place. If he does not reckon with today's surroundings, his work will be *disharmonious* whenever it is not *seen simply in and for itself.* Perhaps this *disharmony* will open people's eyes to our actual surroundings — with all their traditionalism or arbitrariness.

[*Vol. I, No. 3, pp. 29–31*]

[contd]

Natural colour in Neoplasticism is intensified not only because it is brought to primary colour but also because it appears as *plane*.

Habitual vision does *not* perceive colour in nature as plane: it perceives things (colour) as *corporeality*, as *roundness*.

Actually things take their visual shape from a complex of *planes* which express plasticity through *angularity*; form always appears more or less as a confluent *angularity*. The angularity is not directly perceptible, however; sometimes it hardly exists *visually*, as a photograph or veristic picture shows. The technical development of the painter, even in academic teaching, consists largely in *learning to see* the *planearity* in the appearance of forms, and thus in the plastic, and to *exaggerate* it in representation.

Modern art follows ancient art in accentuating the *planearity* of natural-reality; it is only a more consistent expression of the same idea: the plastic conception. After the *accentuation* of planearity there began the breaking-up of the visual corporeality of objects in the painting (Cézanne — Kandinsky; the Cubist school — Picasso). Here the plastic conception already becomes more structural.

Neoplasticism, finally, *is the manifestation of this idea, the manifestation of the purely aesthetic idea.*

In general, then, painting creates *plastically* by accentuating angularity. The plastic is necessary in painting because it creates *space*. Because painting expresses space *on a flat surface* it needs another *plastic than the natural* (which is *not* perceived on one plane).

Painting has found this *new* plastic by *reducing the corporeality of things to a composition of planes which give the illusion of lying on one plane.*

These planes, by their dimensions (line) and their values (colour), create space without the use of visual perspective. Space can be expressed in an equilibrated way because the dimensions and values create *pure* relationship: height and breadth oppose each other without foreshortening, and depth is manifested through the different colours of the planes.

Neoplastic expresses the essentials of space through the relationship of one colour plane to the other; perspective illusion is completely abolished, pictorial devices (such as the rendering of atmosphere, etc.) are excluded.

Because the colour appears pure, plane and distinct, Neoplastic *directly expresses expansion*, i.e., directly expresses the cause of spatial appearance.

Expansion — the exteriorization of active primal force — creates corporeal form by growth, annexation, construction, etc. Form results when expansion is limited. If expansion is fundamental (because action comes from it) it must also be fundamental to plastic expression. To be *consciously recognized* as such it must be represented *clearly and directly*. If the time for this has come, then the *limitations of particularity must be abolished* in the plastic

expression of expansion; only then can expansion be expressed in all its purity.

If, in form-expression, the boundaries of form are established by *closed line* (contour), they must be tensed into *straight line*.

Then the most outward (the appearance of form) comes into equilibrated relationship with the *exact plastic expression of expansion* which becomes perceptible to the senses as *straight line*.

Thus by *expansion* and *limitation* (the extreme opposites), an *equilibrated relationship of position* is created — the perpendicular relationship. Thus, expansion is realized *without particular limitation*, purely through differences in the colour of the planes and the perpendicular relationships of lines or colour planes.

Perpendicularity delimits colour *without closing it.*

Thus, finally, the *rectangular* plane determines colour a third time, completely.

Just like the expression of colour as *plane colour*, rectangular delimitation of colour grew out of the *attempt to express the planearity of visual reality*, as found in the old art.

Neoplasticism has *realized* the old idea of art: *to make colour determinate.*

Indeed, art before Neoplasticism determined colour only *to a degree*: by intensification, by planearity, by firm stroke or surrounding line (contour). *Form* was delineated and filled-in with colour, or it was built up through colour (Cézanne). The value of a work before our time can be measured by its (relative) determination of colour. In times of intense inward (or spiritual) life, colour was plane and line tensed. But even in other times, when colour was modelled and line capricious, art gave colour its *definiteness* and line its *tension* in order to express inner force plastically.

The early modern school of painting is distinguished by strong linear expression (contour) — Van Gogh; and by planear use of colour — Cézanne. Later, when colour appeared as colour, and form as form in its own right (Cubism, etc.), colour became even more determinate. The precise expression of form resulting from colour's determination led, through the breaking of form, to the complete determination of colour. The breaking of form (contour) did not lead to vague or flowing colour, but to its essential determination: the straight.

Thus colour became the *plastic means of abstract-real expression*, because form (the concrete) is dissolved into colour, and colour is freed from the naturalistic.

This plastic means is already inherently universal because it expresses the basic relationship of position and intensified colour, but *abstract-real* plastic can become realized only through composition. Through composition, exact space-expression becomes both possible and real.

If Neoplasticism is dualistic through its composition, its *composition* also is *dualistic*. The composition expresses subjectivity, individuality, through its *rhythm* — which is formed by the relationships of colour and dimension, even though they are mutually opposed and neutralized; and it expresses the universal through its relationships of dimension and colour value by continuous opposition of the plastic means themselves.

It is precisely this *duality* of composition that makes *abstract-real* painting possible.

The universal plastic means would reappear as *its own kind of particularity* if it were not abolished by the composition itself; otherwise, being individuals ourselves, we would tend to see individuality again in the universal plastic means. That is why in Neoplasticism, composition itself demands full attention.

In all art it is through composition (as opposed to *rhythm*) that some measure of the universal is plastically manifested and the individual is also more or less abolished. Although composition has always been fundamental to painting, modern painting has generally been distinguished by a *new kind* of concern with it. In modern art, especially in Cubism, composition now comes to the forefront; and as the final consequence, in abstract-real painting *composition itself* is expressed. While in the art of the past the composition becomes *real* only if we abstract the representation, in abstract-real painting, composition is directly visible because of its truly *abstract* means of expression.

Through the *plastic expression* of composition, *rhythm, proportion* and *equilibrium* (which replaces regularity or symmetry) can be perceived clearly. The exactness with which Neoplasticism expresses these laws of harmony allows it to achieve the greatest possible inwardness. True, the old painting is also based on these laws, but it does not give them clear *plastic expression*. Whenever the old art stresses these laws, immediately there is a great inner intensification (as in the art of ancient India, China, Egypt and Assyria; early Christian art).

While their composition is *in the manner of nature* it nevertheless is strongly emphasized.

But the new art no longer realizes the laws of harmony *in the manner of nature*: they are manifested *more independently* than in nature. Finally, in Neoplasticism, they are manifested entirely *in the manner of art*.

In Neoplasticism the law of *proportion* leads the artist to realize properly the relationships of size and colour on the picture plane: *purely and simply through universal plastic means* and not by any pictorial device. Rhythm becomes determinate: natural rhythm is abolished.

Rhythm interiorized (through continuous abolition, through oppositions of position and size) has nothing of the *repetition* that characterizes the particular; it is no longer sequence but *plastic unity*. Thus it renders more strongly the cosmic rhythm which flows through all things.

Individuality typically manifests the law of repetition, which is nature's rhythm, a law characterized by *symmetry*. Symmetry or regularity emphasizes the *separateness* of things: it therefore has no place in the plastic expression of the *universal as universal*.

Abstract-real plastic has to transform symmetry into equilibrium, which it does by continuous opposition of proportion and position; by plastically expressing *relationships* which change each opposite into the other.

[*Vol. I, No. 4, pp. 41–44*]

4 *The Rationality of Neoplasticism*

Although Neoplasticism in painting is revealed only through the *actual* work — the work of art needs no *explanation* in words — nevertheless much *about* Neoplasticism can be expressed directly in words and much can be made clear by *reasoning*.

Although the spontaneous expression of intuition that is realized in the work of art (*i.e.*, its spiritual content) can be interpreted only by verbal *art*, there is also the word *without art*: reasoning, logical explanation, through which the *rationality* of an art can be shown.

This makes it possible for the contemporary artist to speak *about* his own art.

At present, the new plastic is still so new and unfamiliar that the *artist himself* is compelled to speak about it. Later the philosopher, the scientist, the theologian or others will, *if possible*, complement and perfect his words. At present the practice is perfectly clear only to those who evolved it through practice.

While it grows and matures, the new must speak for itself, must remain *self-explanatory* — but the layman is justified in asking for an explanation of the new art now, and it is logical for the artist, *after creating* the new art, to try to become *conscious* of it.

For *consciousness* in art is another new contemporary characteristic: the artist is no longer a blind tool of intuition. *Natural feeling* no longer dominates the work of art, which expresses *spiritual feeling* — that is, *reason-and-feeling in one*. This spiritual feeling is inherently accessible to understanding, which readily explains that intellect becomes as prominent as feeling in the artist.

Thus the contemporary artist has to work in a double field; or rather, the field of artistic activity, formerly vague and diffuse, today becomes clearly determinate. Although the work of art grows spontaneously, as if *outside him*, the artist has to cultivate the field — before and after growth.

Having become conscious of the newly discovered *laws* of growth, he has no choice but to defend their lawfulness: consciousness strengthens his intuitive feeling for these laws so that he can define them with certainty.

These laws of growth are an aesthetic manifestation of truth, and it is characteristic of truth that it should prove itself — even in words. *Truth is self-revealing*, says Spinoza, but the knowledge of truth can be speeded and strengthened by *words*.

Truth, then, *reveals* itself — and it is the beauty of life that *truth is always unconsciously* recognized, and its every manifestation is *finally* acknowledged — even when it seems otherwise.

That is why the contemporary artist gives explanations *about* his work but not *of* it.

Clarification demands strenuous effort, but at the same time it furthers one's own development. Explaining means that one has reached clarity along the path of feeling and intellect, by working and thinking about what has been achieved. To explain means to have gained consciousness, even through clashing thoughts — through conflict. Thus *explanation* about plastic expression indirectly makes it more profound and more precise.

Foremost to be stressed *about* Neoplasticism is its *reasonableness*. For the main question that modern man asks of anything is whether it is *rational*. He must see clearly the rationality of Neoplasticism as *art in general*, as well as its rationality *as an art for our time*.

If we define Neoplasticism as *a plastically determinate aesthetic expression* —

of the universal, or as a direct (aesthetic) *expression of the universal through subjective transformation of the universal* (see Introduction), then it satisfies the requirements of all art.

All art is *more or less* direct aesthetic expression of the universal. This *'more or less'* implies *degrees*, and it is precisely this difference of degree (deriving from the subjective transformation of the universal) that raises Neoplasticism to the purest manifestation of art.

The subjectivization of the universal is *relative* — even in art. A great *heightening* of subjectivity is taking place in man (evolution) — in other words, a *growing, expanding consciousness.* Subjectivity remains subjective, but it diminishes in the measure that objectivity (the universal) grows in the individual. Subjectivity ceases to exist only when the mutation-like *leap* is made from subjectivity to objectivity, from individual-being to universal-being, but for this there *must first be a difference in the degree of subjectivity.*

This difference in degree in the work of art makes Neoplasticism the most direct *aesthetic manifestation* of the universal possible in a period that is subjective.

The subjectivization of the universal in art brings the universal downward on the one hand, while on the other it helps raise the individual towards the universal.

Subjectivization of the universal — the work of art — can express the consciousness of an age either in its relationship *to the universal*, or in its relationship to *daily life,* to the *individual.* In the first case, art is *truly religious*, in the second, *profane.* A high degree of the universal in the consciousness of an age, even if it is spontaneous intuition, can elevate its art above the commonplace; but *truly religious art* already transcends it by its very nature. For the universal — although its germ may be in us — towers far above us; and far above us is that art which directly expresses the universal. Such an art, like religion, is one with life at the same time as it transcends (ordinary) life.

This unity and separateness are made possible through unity and separateness of individual and universal in the consciousness of the age: the equilibrated relationship of the inseparable dual-unity, the inward and outward in man can produce only a *pure art — a direct plastic expression of the universal.*

As long as individuality is predominant in the consciousness of an age, its art remains *bound to ordinary life*, and remains primarily its expression.

However, when the universal dominates, the universal will permeate life so that art — so unreal in comparison to that life — will decay, and *a new life* — which realizes the universal in fact — will replace it.

The universal finds its purest, most direct plastic expression *in art* only when there is equilibrated relationship of individual and universal in the awareness of an age. For in plastic expression the individual can embody the universal: in art, the universal can become visually perceptible without being tied to the individual (to individual being).

Art — although an end in itself — like religion, is the means through which we can know the universal and contemplate it in plastic form.

Since contemplation springs from the universal (within us and outside us), and completely transcends the individual (Schopenhauer's contemplation), our individual personalities have no more merit than the telescope through which distant objects are made visible.

The artist, then, is only the more or less appropriate *instrument* through which a culture (*i.e.*, the degree of universality in the consciousness of an era) is expressed aesthetically. Aesthetically, because *all* people — insofar as they have matured in this respect — are part of the spirit of an age and, in one way or another, *all* represent it. Thus modern art, when it appears *completely in the manner of art*, is finally nothing other than the *exact plastic expression of a more inward culture.*

In this art, manifested as *style*, there subsists no particular expression of the individual: vision starts from the universal, and is coloured and subjectivized by the culture — whether this is generally apparent or not.

For at the beginning of a new cultural era, the new consciousness is *concealed* by the diversity of different awarenesses concealed behind a lingering past and an unrealized future. Yet it is clearly discernible: it actually manifests *itself as living reality.*

If art is to be a *living reality* to modern man, it has to be a pure expression of the consciousness of the age. Art can become a living reality for him only if, by contemplation, he can become one with the universal it expresses; but art has not yet become one with his *whole being.*

For an art to be discernible as style, it has to be *one with our entire human nature*, and therefore also with the natural in us. *Our entire humanity* is expressed in life and must be reflected in art.

If Neoplasticism is to interpret the new spirit, it must show itself homogeneous with the new spirit's *every manifestation* in life.

Can these be called abstract-real?

Can our age of material reality be simultaneously an age of abstract reality?

If we fail to see in today's awful turmoil a storm that will bring our outer life into harmony with our inner life, whose *rebirth* began quietly long ago; if we fail to perceive concrete reality as an opposition to that which is not concretely manifested — then ours is not an abstract-real age. But if we can detect the *true* life behind the tumult, if we can see *the consciously abstract spirit* at work behind all concrete phenomena, then our age is indeed abstract-real. Modern life is no longer *natural* — but abstract-real. And it *reveals* this in fact.

All modern life bears the stamp of abstract-real life: its whole outward manifestation *plastically expresses* the abstract spirit.

The man of truly modern culture lives in concrete reality, *which his mind transforms into abstractions; his real life moves into the abstract — but in turn, he makes the abstract real.*

The artist also does this, and thus creates *abstract-real* art.

Despite all external opposition, the true life of modern man *shows* the deeper thought which is the sign of culture. It *shows* the more determined awareness of our time, *shows* that the universal can be seen and known with greater clarity.

In all fields life grows increasingly abstract while it remains real. More and more the *machine* displaces natural power. In fashion we see a characteristic tensing of form and intensification of colour, signifying the departure from the natural.

In modern dance steps (boston, tango, etc.) the same tensing is seen: the curved line of the old dance (waltz, etc.) has yielded to the straight line, and each movement is immediately neutralized by a countermovement — signifying the search for equilibrium. Our *social life* shows this too: autocracy, imperialism with its (natural) rule of power, is about to fall — if it has not fallen already — and yields to the (spiritual) power of law.

Likewise, the new spirit comes strongly forward in *logic, science and religion.* The imparting of veiled wisdom yields to the wisdom of pure reason; and knowledge shows increasing exactness. The old religion, with its mysteries and dogmas, is increasingly thrust aside by a clear relationship to the universal. Purer knowledge of the universal — insofar as it can be known — makes this possible.

All expressions of life manifest this same concept — and this is formulated by *logical thought.*

Long before the new was manifested determinately in life and in art, the logic of philosophy had clearly stated an ancient truth: *being is manifested or known only by its opposite.*

This implies that *the visible, the natural concrete is not known through visible nature, but through its opposite. For modern consciousness, this means that visible reality can be expressed only by abstract real plastic.*

{Vol. I, No. 5, pp. 49–54}

[contd]

It might seem *old-fashioned* to illuminate the rationality of a new truth by citing an ancient one but it only seems so: new truth is nothing other than a *new manifestation* of universal truth, which is immutable.

This enduring *truth* was given various formulations in ancient times. One of them perfectly defines *the true meaning of art: opposites are best known through their opposites. We all know that nothing in the world can be conceived in or by itself; everything is judged by comparison with its opposite* (Philo of Alexandria; Bolland, *Pure Reason*). Only in our time — with its maturing and growing equilibrium between the inward and the outward, the spiritual and the natural — has the artist come consciously to recognize this ancient truth already re-emphasized by logical thought (Hegel). The artist came to this awareness *through the way of art, an outward way.*

Art — as one of the manifestations of truth — has always expressed the truth of oppositions; but only today has art realized *this truth in its creation.* We recognize the division between old and new painting as soon as we see that naturalistic painting manifested *this truth in a veiled and disequilibrated way,* whereas Neoplasticism *represents it plastically, determinately and in equilibrium.*

Painting has always *transformed* the visible (from which it proceeds) into a beauty that moves man — by bringing to plastic expression within the naturalistic *the very opposite of the visible.* But not all painting has shown this opposite in *equilibrated relationship with the natural.*

Clearly, the *plastic* opposite of the *natural concrete* cannot be the most *extreme thought-abstraction*: the plastic opposite of the *most outward* cannot be the *most inward*; it appears in nature by means of the natural (the most outward) *relationships of position, size and value — as a plastic expression of*

relationship which is nothing in itself, but manifests the *plastic core* of all things.

Relationship, indeterminate in nature, is basically *exact, abstract;* but consistent with this character, can be purely expressed only by an *exact, abstract plastic means.* Only then can the mutual interaction of the opposites, inward and outward, attain equilibrated expression.

The *most* external manifestation of things, the natural, veils the pure and direct externalization of the inward (the universal), and so veils exact relationship. The latter can find clear plastic expression only in an outwardness which — although not the extreme opposite of the natural — is free enough of (individual) limitation to express purely plastically both the *direct externalization of the most inward and the essence of the most outward.*

Exact relationship can find plastic expression only through the abstraction of natural form and colour — *colour brought to determination.* This universal plastic means destroys the naturalism of the plastic: the *natural is crystallized into exact relationship, which conversely can be seen as crystallized inwardness. Thus both the most outward and the most inward are neutralized in an exact plastic of relationship, and these opposites are plastically expressed as unity in a single outwardness* (the work of art).

— If we see this unity, then we clearly see the unity of Abstract-Real plastic with visible reality: then we see this plastic, not as an aimless array of colour-planes and lines, but as an equilibrated expression of man and nature, of inward and outward, in their deepest, their most beautiful and *external* significance. Ancient wisdom represented the fundamental inward-outward relationship by the cross. Neither this *symbol*, however, nor any other symbol, can be the plastic means for Abstract-Real painting: the symbol constitutes a new limitation, on the one hand, and it is *too* absolute on the other.

In moving from Naturalistic painting to Abstract-Real painting, art has realized the law of opposites. All Naturalistic painting served this evolution from an expression of the natural to an expression of the abstract and thus to an *equilibrated plastic of extreme opposites* (see Introduction).

Seen in its evolution in time, the plastic means of painting were at first *out of harmony with the law of opposites*, for the (most) outward was expressed through the (most) outward; then the naturalism of expression was gradually destroyed; and finally, we see the (universal) *plastic means in complete harmony with the law.*

The truth contained in the law of opposites manifests itself in space

66

and time: in time the inward (within man) grows through the outward (in space): in time the more outward conception of space grows into a more inward one; *in time, opposite becomes known by opposite.*

If we see the necessity of Naturalistic painting (as preparation for Abstract-Real painting), we will not regard it as an error — no art, no true artist has ever erred: the universal (the source of all art) does not err. The universal is independent of time: seen objectively it *manifests* itself according to the law of opposites.

And now painting attains what has always been its essence, but which has never before found clear outward expression: *plastic realization of the unity of the mutual interaction of opposites.* Just as the plastic of Abstract-Real painting is not *abstract* in the ordinary (scientific, intellectual) meaning of the word, so its *expression of relationship* is not the *opposite* of naturalistic plastic. For the *exact plastic expression of relationship* is also an *outwardness*, and as such still *part of the outward.* But as the *least outward*, it is the *opposite or antithesis of the most outward* (natural appearance).

If, however, we see the exact plastic of relationships as a *direct representation of inwardness* (the universal), then it is an (exteriorized) *part of inwardness*, and as such a *plastic opposite* of the natural.

In order to understand Neoplasticism's exact plastic relationship, it is necessary to see the exact plastic of relationships as the (exteriorized) opposite of naturalistic plastic expression. This is *possible* because *the inward, which is not visible in the plastic nevertheless takes form in it.* (Thus a radius which is inward and not actually visible becomes a vertical line in the plastic).

Starting from the visible: *space* is expressed in Neoplasticism not by naturalistic plastic but by the (abstract) plastic of the plane; *movement* is expressed by movement and counter-movement in one; *naturalistic colour* is expressed by plane, determined colour; and the *capriciously curved line* by the straight line. Thus the relative finds plastic expression through the *determined* — a direct externalization of the absolute. Starting from the non-visible, from the inward: *expansion* is expressed by a (new) space expression; *rest*, by equilibrated movement; *light*, by plane pure colour. Thus in Neoplasticism, the *absolute* is manifested through the *relative* (in the composition and the universal plastic means).

Although every age has expressed the law of opposites, the cultivated man of our time, the true modern man distinguishes himself by being *conscious* of the truth of this law: *by endeavouring to realize it in himself.*

By *seeing the outward purely*, the contemporary artist learns to *express the inward purely*. Thus by seeing the universal in the outward, he learns to express it plastically, obscuring it as little as possible by the (individual) self.

Thus he learns to perceive that the apparently unbeautiful can be beautiful — that outward beauty is not the highest beauty. *He learns to see this* after having cultivated the natural. It is a mark of the uncultivated man, of the man attached to individuality, to seek the highest beauty and good in what appears as beautiful and good *to him*. This is due to disequilibrium between the inward and outward, between spirit and nature. And this disequilibrium forms the obstacle to a true understanding of Neoplasticism: in an age that does not know equilibrium between inward and outward, an *equilibrated plastic of relationship* cannot exist as *style*.

To appreciate Neoplasticism *completely* one must know something of the nature and interaction of inward and outward (within us and outside of us); only then do we perceive how inward and outward can be plastically manifested as *a unity of equivalent duality*.

[*Vol. I, No. 7, pp. 73–77*]

5 *From the Natural to the Abstract: From the Indeterminate to the Determinate*

The reciprocal action of the opposites, inward and outward (spirit and nature), can lead us to see life — and therefore art — as a constant recurrence (in different ways) of the same thing, as continual *repetition*.

Such a vision of life and art impedes development, for it excludes every idea of growth as *evolution*, as *ascending development*. While not denying *change* in life and art, this vision denies their *continuous tendency to depart from the natural: their evolution to the abstract*. Precisely the firm belief in *the spirit's rising development through the maturing of the natural in man* (a belief based on *observation*), is necessary in order to see life and art purely.

However, a true conception of the *meaning* of inward and outward, of spirit and nature, shows this *perpetual return* as the recurrence of *one and the same thing*: the *universal inward* which, although perfect, matures in man precisely through the reciprocal action of nature and spirit. It permits us not to despair of the *evolution of the human spirit* even if each stage of its development founders on outwardness. Conversely, it tells us not to despair for the preservation of the outward (the physical, the natural)

in man — for it is precisely the human spirit that keeps it intact. While becoming less primitive, the outward remains strong enough to become equilibrated with man's spiritual life.

A true conception of the essential *meaning* of spirit and nature in man shows life and art as a perpetual sacrifice of inward to outward and outward to inward; a conception which enables us to recognize this process as exclusively in favour of the inward and *serving to broaden man's individual inwardness (spirit) toward universal inwardness.*

Thus understood, the opposition of spirit and nature in man is seen as constantly forming a *new unity* — which *constantly reflects more purely* the original unity out of which the opposites, spirit and nature, manifest themselves — in time as a duality.

Pure vision shows us this original unity as the *enduring force* in all things, as the *universally shared force that* permeates all things. This *deepest universal element* was termed by Aristotle substance — *that which is*; the *thing-in-itself*, existing of itself, independent of those accidents of size, form, or qualities, which constitute only the *outwardness* by which substance is manifested. It is only substance that makes externality into what it is for us.

If substance is the enduring force, then a *direct representation of the universal* (or direct plastic expression of substance) is not merely justified but *required*. For the *constant* force is the valuable one.

In nature the accidents of substance — size, form, qualities — are indispensable, for substance is not directly perceptible to the senses. In nature, form (corporeality) is necessary: in nature everything exists for us through form which is made visible through (natural) colour. *Thus nature misleads us into thinking that form is necessary in art too; nature makes us forget that substance is actually expressed by means of the universal, manifested through form and through colour.*

In art we have *direct plastic expression of the universal* (the equilibrated plastic of relationships), non-corporeal in its manifestation, free of the temporal that obscures the eternal. Although this manifestation is not form, it can nevertheless be plastically expressed. In art the accidents of substance can be dispensed with: they *must* remain outside of plastic expression if we are to achieve pure expression of the universal, i.e., of substance.

Properly understood, the reciprocal action of the opposites, inwardness and outwardness, shows life and art as *recurring stages of growth on the one hand, and of decline on the other.*

To discern this general truth, we must extend our observation over long periods, go far back into the past and look far into the future, in fact we must see life as not beginning or ending with this universe. But since in this physical world the physical does not change significantly once it has matured, and since spirit develops only in man, we can limit ourselves to tracing the *evolution of spirit* (*i.e.,* of *consciousness*) in man.

The evolution of consciousness creates form after form — in life as in art. In its evolution of form, art can precede life: so that its *form becomes manifestation* — the *natural* becomes abstract. If the natural in our consciousness is ripening, if man's individual inwardness is becoming more determinately conscious — then consciousness is growing from the natural to the abstract, and the expression of art will necessarily be abstract. When the individual's consciousness expands into the universal, then the natural — although it remains unchangeable in nature — will *change* for man. The artist is no longer content with the most outward means of expression: he needs a *universal means.* He achieves it by intensifying form and colour — consistent with the intensification of consciousness. Thus, he reduces the natural to the abstract; thus — so far as it can be plastically expressed — he *consciously* expresses the opposite of the natural. *In Abstract-Real Plastic man has an opposition to the natural through which he can know nature and so gain knowledge of the spirit. In this way art becomes truly religious.*

June 1918 [*Vol. I, No. 8, pp. 88–91*]

[contd]

If we see that the trend to abstract plastic expression in modern painting results from the evolution of the consciousness of our time to the *abstract,* then the striving of modern art in general, and of Abstract-Real painting in particular, will not be seen as a *degeneration,* but we will then recognize that from this striving a new style *must* be born.

If modern painting is generally permeated by an intensifying and accelerating quest for *freedom from individuality* — and (in Neoplasticism) *is becoming a clear expression of the universal,* then Neoplasticism is the plastic *expression of the contemporary age* — although it is in advance of its time.

Our age has reached the climax of individualism: the mature individual can now increasingly find equilibrium with the universal. When our

mentality actually *attains* this equilibrium, it will also be clearly expressed in every aspect of outward life too, just as it is expressed *abstractly* in Neoplasticism.

Evolution from the naturalistic to the abstract causes man to see nature differently: he may unconsciously reject the *individual in nature*, but this does not cause him to reject *the natural*.

Although he may destroy nature's most outward appearance in his plastic expression, it is still *through nature that the universal becomes living in man*.

By reducing the natural to the abstract in the plastic, modern man expresses the natural in all its fullness: *for thus both inward and outward find plastic expression*. Thus he shows himself to be truly modern man, *who sees the outward as inward and penetrates the inward through the outward*.

Formerly one only perceived either the outward or the inward: the world was divided into the profane and the so-called believers. Modern man, however, is capable of seeing the inward in equilibrium with the outward, and conversely; through relationship he knows both opposites. Precisely in this way the truly modern man sees things as a *whole* and accepts life *in its wholeness*: nature and spirit, world and faith, art and religion — man and God, as *unity*.

The evolution of consciousness causes beauty to evolve *into truth*. We can say that beauty is truth *aesthetically-subjectively* perceived. If beauty is subjectivized truth, then art would be destroyed if its subjectivity were completely destroyed. Likewise, the ideas of plastic expression would be destroyed, for plastic expression implicitly assumes *subjectivization* (and therefore beauty).

Plastic expression of the purely objective (of truth) is an *other* beauty: a beauty that transcends art. The truth that is manifested subjectively in art is the *universal*. It is therefore true *for everyone* in opposition to that truth which, in every pure search, forms the true way for each *individual*. Neoplasticism exists as *style*, as *universality*, since it clearly expresses *universal* truth. Art must stress this universal truth if it is to plastically express beauty-as-truth.

'The beautiful is the true in the perceptual mode. And truth is a multiple unity of opposites: if we can find the beautiful in the true, then it must be found as a unity-in-diversity of opposites. We find the beautiful inherent in the unity of linguistic and mathematical (essences) in proportional relationships' (Bolland, *Pure Reason*). In Neoplasticism it is precisely the proportional relationships

(of line and colour) that are manifested purely. In Neoplasticism beauty consists of the equilibrated, equivalent expression of the opposites, inwardness and outwardness.

'The concept of beauty is a relational one — of aesthetic relations, of perceptually agreeable and thus emotionally satisfying relationships, and consequently not a mere linguistic or mathematical concept, but something more, commensurable in a variety of relationships or principles, etc.' (Bolland, *Pure Reason*).

Thus we see that rational thought is in accord with the actual goal of the new painting — whether rational thought recognizes it or not. Both seek beauty not for the beautiful feelings it may arouse, but for beauty *as truth*, i.e., as plastic manifestation of pure aesthetic relationship.

Neoplasticism, while strongly emphasizing truth, nevertheless continues to express *beauty*. Therefore, like all art, it remains relative, and to some degree still *arbitrary*: if it were to become as absolute as the universal plastic means allow, it would overstep the limits of art; it would pass from the sphere of art into that of truth.

Neoplasticism expresses beauty *as truth* through the absoluteness of its plastic means: it expresses truth *as beauty* (i.e. relativized by beauty) through the rhythm of its composition and the relativity in which its plastic means are manifested.

Art *remains* relative, even though, the consciousness of our time is rising toward the universal, from which intuition — the source of all art — derives; the *artist*, because he unites inward and outward, always remains *human* and cannot completely transcend the subjective.

The adult no longer possesses the objective vision of the child. Children and primitive peoples can still objectify their inwardness (their unconscious) purely; however, they lack the consciousness of the adult, for they lack culture.

Through their unconsciousness they intuitively express the *general*, but not the abstract — or what is here called the *universal*, i.e., the most profound manifestation of *all* things.

Beauty *as truth*, then, cannot be expressed *determinately* by naturalistic means: form and natural colour limit expression to the individual, and veil the truth to such an extent that it can only be expressed vaguely.

From the plastic point of view, form and natural colour *bind* expression to the individual and shackle the pure vision of the universal. Moreover our particular sensations and thoughts (in turn based on particular experiences) become associated with what we see.

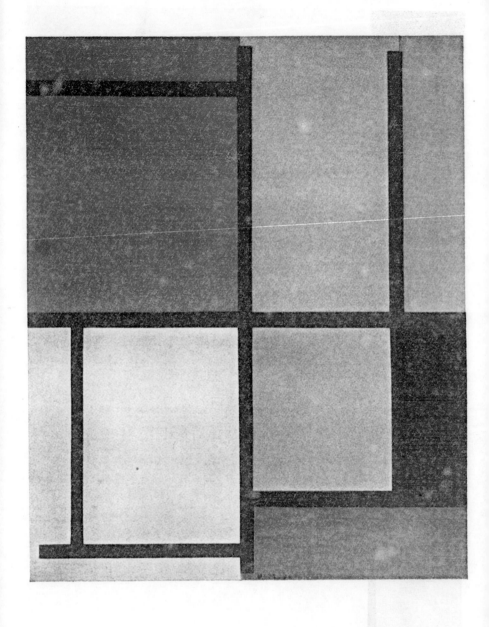

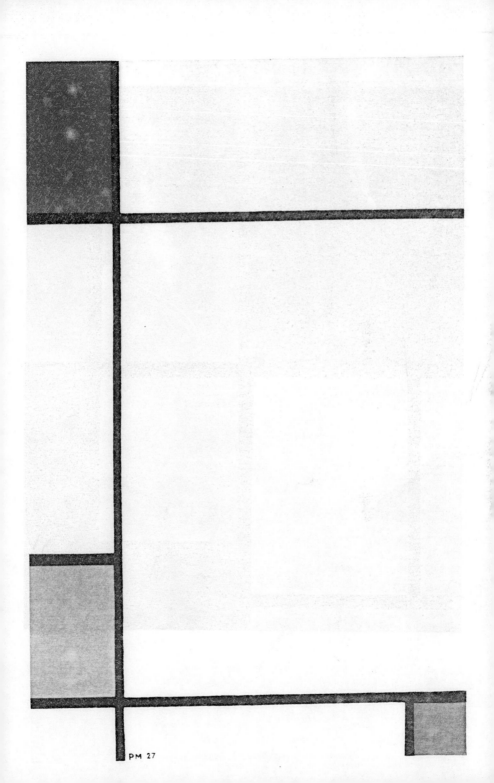

PM 27

Although the observer partially determines the impression of what he sees, what is seen also says something specific because of the form of its appearance. Even the most perfect, most general geometrical forms express something specific. To destroy this limitation (or individuality) of expression as far as possible is the task of art, and forms the essential content of all style.

Art, then, is a field of combat against the individual. In life, as in visible nature, there is struggle between universal and individual; but — in time — the universal remains more closely bound to the individual in outward life than it does in abstract life, of which art is the plastic manifestation.

The union of the universal (as far as it has developed in man) with the individual (as far as it has matured in man) gives rise to the tragic; the struggle of one against the other forms the tragedy of life. Tragedy arises from *inequality in the appearance of the duality by which unity manifests itself — in space and time.* The tragic exists both in inward and in outward life.

Although the greatest tragedy is due to the inherently unequal dualism of spirit and nature, there is tragedy also in outward life. Due to disequilibrated mutual relationships, the tragic exists between male and female, between society and individual.

The premature union of opposites causes the tragic. Yet only the continual and repeated union of opposites can bring about the new progress; for new form arises from opposites dissolving into each other.

Thus plastic expression of pure (exact) relationship is possible only when the natural in man and the spiritual in him dissolve into each other: his vision of the natural is transformed, *i.e.,* it becomes *abstract.*

If the tragic can be destroyed only through (final) unification, this is far less possible in outward than in abstract life. Art can realize the union of opposites abstractly: that is why art precedes real life.

Unity in real life must await the equivalence of opposites. By equivalence we mean the equivalence of (relatively) *pure* opposites. Only after this equivalence develops are the opposites resolved *into* one another and true *unity* is really attained.

In advance of its time, Neoplasticism plastically manifests the turning point of human development — the era of equivalence of opposites. When this time actually comes, art will be transformed into real life.

Until then, even in art, universality will continue to be dominated by the individual (the subjective) — even though art (through intuition) already expresses equivalence.

11 Piet Mondrian. *Composition: Grey structure with colour planes.* 1918

If beauty is truth (the universal) subjectively apprehended, then beauty must always express the tragic. And if truth (as universal) is objective — then truth must be free of the tragic. *Although in Neoplasticism subjective vision is reduced to a minimum*, it nevertheless remains subjective — and still must express *something* of the tragic. It does this through the rhythm of the composition, etc.

We experience beauty, and therefore the tragic, through emotion, but its actual manifestation is plastic. *Because it is manifested plastically, the human spirit, which is expressed by aesthetic plastic, seeks its visual manifestation free of the tragic.*

The human spirit, then, seeks *truth* (which is free of the tragic), but in beauty it finds it always relativized, and therefore more or less tragic. Art nevertheless *leads us* along the path of beauty toward truth, to visual manifestation free of the tragic.

Art has the *intention* of plastically establishing complete freedom from the tragic: but its *expression*, the *plastic*, created by and for man, lags behind art's intention. How far behind, depends on the culture — on the stage of development that the universal has reached in the masses. Culture, then, determines how far individuality is actually annihilated in expression.

So long as art continues to use natural appearance as its plastic means, its expression will *emphasize the tragic*. Whereas *style in the manner of art* results in the least tragic, *style in the manner of nature* results in the most. As much as naturalistic painting may try to neutralize the individual in it by establishing equilibrated relationships, natural appearance will always constitute a *limitation* through form — and therefore express the *struggle of inwardness for freedom*, the struggle of *expansion and limitation*.

The tragic adheres to all form and natural colour, for the struggle for freedom is expressed by the tensing of line and the intensification of colour as a striving against a stronger counter-striving. Only when line is tensed to the rectilinear and naturalistic colour is intensified to pure plane-colour — only then can tragic expression be reduced to a minimum.

Culture, then, (more or less) *opposes* the natural, just as the universal opposes the individual.

The natural — in time — stands *opposed* to the spiritual; from the plastic viewpoint, natural appearance stands *opposed* to man's spirit. *The former acts on the latter through emotion.* Emotion will therefore remain subordinated to the natural until man's spirit becomes more conscious. Only then will

it become spiritual emotion, and be able to represent outwardness purely. The outward will be in equilibrium with the inward in consciousness, and conversely; and then the tragic will be transcended.

Where natural emotion dominates plastic expression, art always expresses the tragic in a pronounced way. Art expresses the tragic whenever it stresses sorrow or joy, as in the art of Van Gogh.

Culture transforms emotion and therefore nature: *it brings unity between spirit and nature.*

The natural, the visible in general, expresses the tragic to the extent that it has not been transformed (to universality) by the human spirit. The tragic *in nature is manifested as corporeality* — and this appears plastically as form and natural colour, as roundness, naturalistic plastic, the curvilinear, capriciousness and irregularity of surface.

The *atmosphere* in which we see corporeal things veils their planear character and heightens their tragic expression. But even when the corporeal is clearly expressed in art, when it is made more inward by an exaggerated tension of natural line, and somewhat neutralized by flatness of colour, etc. — even then the visible expresses the tragic through form, position and size.

The plastic expression of natural appearance — like visible nature itself — is therefore always tragic.

No matter how the duality of inward and outward is manifested — as nature and spirit, man against man, male and female, *or* in art as the plastic against representational content — so long as this duality has not achieved equilibrium and recovered its unity, it remains *tragic*. If this duality in art requires equivalent *plastic expression*, then the artist must be able to abolish tragic expression (so far as this is possible).

Only *unity in the expression of content and its appearance* can abolish the tragic in the work of art and this unity is approached through the *exact, equilibrated* plastic of relationship. *Exact* expression of relationship (through universal plastic means) is necessary, since relationships expressed through form and through natural colour still have tragic expression; *equilibrated* expression of relationship is necessary, for only the equilibrium of position and size (through the universal plastic means) can diminish the tragic.

All painting has endeavoured to plastically express the universal, but has not always achieved it to the same degree.

All painting has sought to abolish the individual in expression, but has not succeeded to the same degree.

Disequilibrated expression of the universal and individual gave rise to tragic plastic throughout all painting. Naturalistic painting has the strongest tragic expression; Neoplasticism is already almost free of it.

If abolition of the tragic is life's goal, it is illogical to reject Neoplasticism.

Then it is illogical to always demand the expression of *form* in painting — *naturalistic* form at that — to insist that it alone can express the spiritual.

To the contrary when one observes the continuous development of the expression of relationships in art, it is hard to imagine how the evolving element in painting could ever revert to the plastic of form which obscures relationships.

[Vol. 1, No. 9, pp. 102–108]

[contd]

Neoplasticism as manifested in *Abstract-Real painting* (as the expression of *abstract-real life*) is on the one hand only a different vision of the natural, and on the other a determinate plastic expression of the universal. Similarly, *abstract-real life* itself is only another stage of natural life on one hand, while on the other it is *conscious spiritual life*.

Abstract-real life, which vitalizes life in its wholeness and fullness — *in actuality*, that is *abstractly* — and in turn realizes this life, is almost unnoticed today amid intellectual-abstract and outward life. Life today generally centres around outwardness and merely remains *on the surface of life*; whereas abstract-real life experiences the outward (the individual) *universally* (abstractly) — that is, *in its most essential nature*. Abstract-real life, then, by its very nature realizes itself as *the plastic expression of the universal* — whatever form it may take. It has manifested itself as such in Abstract-Real painting; and by Abstract-Real painting, the characteristics of abstract-real life are made *perceptible*.

Abstract-Real painting reveals the *abstract vitality of full and complete life, by intensifying the naturalism of its plastic to the really abstract, i.e., by making it determinate, and by establishing equilibrated composition (or proportion); its vitality becomes real through the rhythm of the composition and through the relativity in which abstractness appears.*

It plastically expresses the interiorization of nature through the duality which forms the essence of the natural (matter and spirit). It plastically expresses the unity of this duality, through its equilibrated composition. Thus it expresses man's natural individuality in equilibrium with his spirituality, his universality.

Abstract-Real painting, therefore, expresses *purified nature and purified spirit in one*. In it we see the transition from the naturalistic to the abstract as a transition *from (outward) impure nature to pure inward nature, and from impure spirit to pure spirit (the universal)*. Furthermore, Abstract-Real painting shows that although this duality contains unity it remains — in time — relative, and is a *very distinct duality*. For in the duality of position of the straight (line), we see *exact opposition;* in the duality of perpendicular opposition we see the most extreme opposites: the natural (female) element and the spiritual (male) element.

Thus we see that because the duality contains *two distinct elements*, their unity can come into being only through their *equal manifestation i.e.*, the *degree of equal purity in which the two extremes are opposed*.

Equality cannot exist *as an element* — in time. Therefore — in time — in life too, unity (or equilibrium) must be found in *the manifestation of the elements, i.e., in relatively pure nature and relatively pure spirit*. In time, however, the elements transform each other into final unity; in other words, since they evolve in time, even the equality of their manifestation is always very relative. Their unity can be really enduring only if the elements continue to transform one another in the same degree.

Yet Abstract-Real painting shows that unity — difficult as it may be to realize in life — has to be sought through *purification of the elements, nature and spirit*.

In time these elements are confused in the unconscious; only through consciousness can their purity be restored. If the new mentality is characterized by greater consciousness, it must be capable of reflecting the elements more purely.

Thus the new life can better equilibrate nature and spirit, and greater unity will become possible in the state, in society and in all of life's relationships. For this, it is only necessary that the new mentality develops freely: that it *annihilates the old mentality and domination by the individual, natural (or female) element*; that it frees itself of tradition and dogma and sees only *pure relationships* by seeing the elements purely.

So long as the old mentality is the dominative influence, nations must continue to destroy each other — there must be conflict and suffering: only *pure manifestation of the elements* (in equilibrated relationship) can reduce the tragic in life and in art.

[*No. 10, August 1918, pp. 121–124*]

Outward life must evolve into *abstract-real life* if unity is to be achieved. Today it forms the transition from the old era to the new. Abstract-real life is no longer exclusively natural life, although it is not unnatural. Nor is it exclusively spiritual life, although its content is the spiritual. It is the state of *contemplative realization* after a protracted clinging to nature, and a premature striving toward the spiritual. Abstract-real life is not found exclusively in art, science or religion: it can be realized in them, but can also be *lived* in any of life's activities.

Because equilibrium between nature and spirit can be realized in abstract-real life, it can be the phase in which man will become *himself*. He will be *equilibrated and completely human* both in his own duality and in relation to the life around him. He perceives and experiences this life *abstractly* and is therefore not tied to its limitations.

Abstract-real life is the life of *truly modern man* through whom the new mentality is expressed. Truly modern man *consciously experiences* the deeper meaning of individuality: he is the *mature individual*. Because he sees the individual-as-universal, he combats the individual-as-individual. Triumphant over outward individuality, he is thus the *independent individual*; *the conscious self.*

If Abstract-Real painting is the expression of abstract-real life, this life is based on the truths brought forward by Abstract-Real painting. These are *very ancient* truths, but their exact realization has only become possible today. To those thoroughly convinced of these truths through observation, they appear no more *dogmatic* than they do to those who evolved Neoplasticism out of Naturalistic painting. To them they are irrefutable truths — truths which they became conscious of through the process of working. For them these truths can never be *preconceived dogma*, since they were arrived at *only by way of conclusion*.

Thus Abstract-Real painting has shown that if *equilibrium and therefore unity are to exist in life, the spiritual must be manifested determinately and the natural must be interiorized so deeply that it reveals its pure essence.*

External life must be interiorized to the abstract: only then can it become one with inward life, which is abstract, spiritual, universal. This is possible because life itself transforms the natural in man to relatively pure naturalness, releases the spiritual (universal) in him, frees it of individuality — thus creates relatively pure spirituality.

Only purified naturalness and purified spirituality can create pure relationships of opposites; only purified duality can make life enduringly harmonious. Thus human duality can evolve to unity.

To know unity in all of life, we must acknowledge duality. For whoever sees unity — in time — as a single phenomenon, still sees it as vague and undetermined. Only by seeing it as duality can we see how unity (or equilibrium) is achieved. Therefore Neoplasticism does not express a dualistic view of life: to the contrary, its expression of a matured, conscious sense of unity, forms the basis of the new awareness.

In perceiving man's duality, we distinguish, besides his spiritual and natural life, the life of the soul — although they all interpenetrate. The life of the soul is related on one hand to nature, and on the other to spirit: it acts both through emotion and through intellect. To the extent that nature dominates it, soul is outward emotional life; to the extent that spirit predominates, it is deepened or spiritual, emotional life. Abstract-real life is the *deepened life of the soul becoming one with spiritual life, but nevertheless coloured by the qualities of the soul.*

All life has its outward manifestation through which it is known, and conversely, through which it exists. Abstract-real life finds abstract manifestation in Abstract-Real painting, but has yet to find its palpable manifestation in life. The (superficially) abstract life of modern society has its own outward manifestation — it forms the appropriate ground upon which abstract-real life can grow, but on the other hand it is exactly what stands in the way of its *pure* exteriorization. Social and cultural life find their most complete outward expression in the *metropolis*. Abstract-Real painting developed under the influence of the completely modern cultural life of the metropolis: logically immature life could not engender this art.

If man matures through reciprocal action of outward and inward life, his *environment* must be extremely important. The artistic temperament is particularly sensitive to the impact of life's *visual* manifestation — through which the artist comes to know life and thereby truth: it constantly transforms visual outwardness to abstraction — coming constantly closer to truth. The plastic *artist realizes* visual insight: he constantly destroys it — he constantly realizes truth more purely. He lives by *perception* — by inward as well as outward perception. By nature and training, therefore, he is most capable of rapidly evolving toward the *abstract*. Thus painting attains what the new mentality has yet to realize in outward life.

[Continued in separate sub-chapter in *De Stijl* listed as Part IV]

The transition from the natural to the abstract will be seen either as progress or as regression, according to whether one views nature or spirit as the goal of evolution. With Voltaire among others, one may hold that man perfects himself in the measure that he removes himself from nature, or that one may view the trend to abstraction as a progressive disease. Understandably, the abstract seems abnormal when we fail to discern the unity of nature and spirit; or if we fail to see that (in time) spirit does not exclude nature but can only be realized through it.

Neoplasticism most clearly shows that the abstract spirit takes both into account, *nature and spirit*: that *unity of the two* is the ideal of those in whom the new mentality is developing.

The *conception of unity* implicit in the new mentality and stressed in Neoplasticism, is not understood by the masses—who fail to see nature *in its totality*. They fail to see the natural as the most outward manifestation of spirit, as the unity of spirit and nature.

If a determinate vision of the unity of nature and spirit is characteristic of the new mentality, we find it manifested by groups, and these *groups* form around individuals. Consciousness is generally advanced by *groups*, and even among them there are various degrees of developing consciousness. Each group goes its own way, supporting or contesting the others, even consciously or unconsciously they all have the same aim.

Even within groups, there are diverse paths, and, although common progress is certain, it is often impossible to avoid misunderstanding the ways of others. Because of individual differences in temperament and experience a single way is hard to agree upon—even among more or less equally advanced minds. Thus a *common conception of art* would be virtually unachievable—except for the fact that it is possible to examine rationally what has been achieved in art. Anyone similarly attuned—even not an artist—will have more or less the same aesthetic capacity and therefore the potentiality for artistic insight into art.

By cultivating their capacity to experience the *purely (abstract) plastic*, vital plastic vision, the whole group can succeed in following a *single* path despite the differences of their lives.

Therefore unity is no longer an unattainable ideal in life and in art.

In earlier times everyone followed the same path, for—in each cultural era—a single religion was dominant. Today the image of God no longer lies

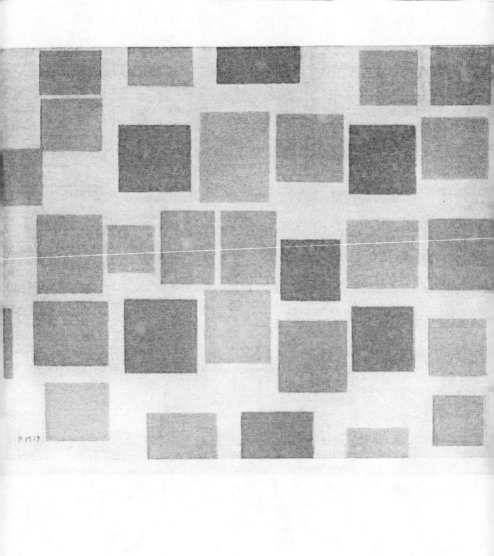

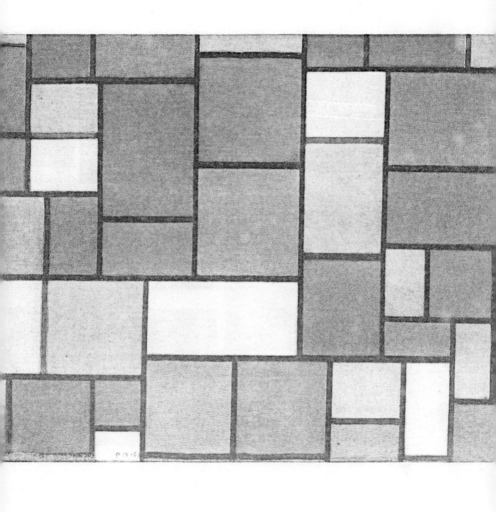

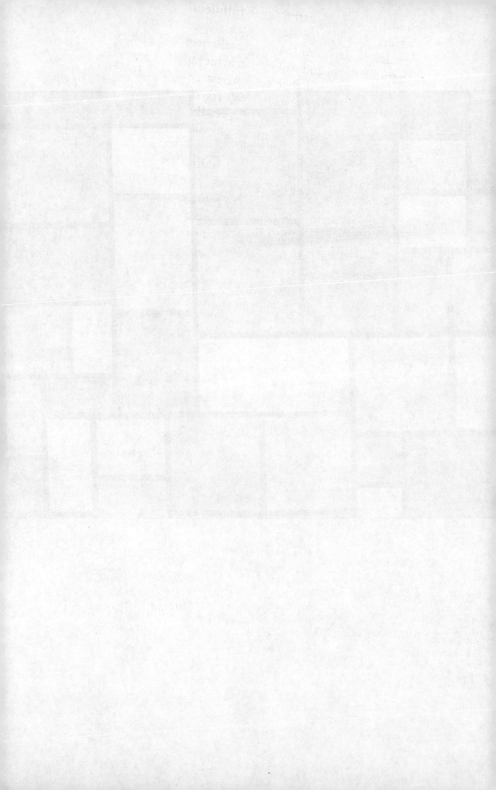

outside man: the mature universal *individual* emerges, who, perceiving the universal more determinately, is capable of *pure plastic vision*. Thus the new era will differ from the old by its *conscious perception*, which will spontaneously realize itself everywhere as *universal*.

If art manifests the universal clearly then it will establish itself as *universal art*.

Plastic vision is not limited to art: basically, it penetrates all expressions of life. Thus the general unity of *life* is possible. Pure plastic vision leads to the comprehension of the structure that underlies existence: it enables us to see pure relationships. Thus the new mentality is based on fundamental relationships that are veiled in nature but which are nevertheless visible. If this more inward plastic vision is the content of the new mentality, then it must manifest itself increasingly, because man's consciousness is evolving and it automatically destroys every obstacle such as tradition, etc. We can be sure that the future will bring greater unity in the expression of art: the unity of *abstract-plastic that is nevertheless real*.

Abstract-Real plastic evolved through and from naturalistic plastic: it emerged directly from an art that was still of the previous generation. The modern artist carried out the arduous task of creating a mode of expression for the future generation, after destroying that of the previous one. The artist of the future will not have to follow the path of gradual liberation from natural form and colour: the way has been cleared for him; the mode of expression is ready; he has only to perfect it. *Line and colour as plastic means in themselves* (*i.e.*, free from particular meaning), are at his command so that he can express the universal determinately.

Increasingly, then, the artist of the future will be able to begin from the universal, whereas the artist of today had to start from the natural (the individual). Our age forms the great turning point: humanity will *no longer move from individual to universal, but from the universal to the individual through which it can be realized*. For individuality becomes *real* only when it is transformed to universality.

If it begins with the universal, the expression of art must necessarily be *abstract*. So long as it begins with the individual, it can only *approximate* abstract expression and can even relapse into comparative naturalism — as we see *historically*. Moreover, man lives alternately in the universal and in the individual as long as his individuality remains immature. Only when his life becomes an unbroken progression, just as life — the life we cannot see — is an unbroken progression, only then can art become *permanently abstract*.

IV Piet Mondrian. *Composition with Red, Yellow and Blue*, 1927.

Evolution from the naturalistic to the abstract was fulfilled in painting when it developed from natural (unfree) to free (abstract) plastic expression. Once free, painting gradually departed from naturalistic appearance; gradually, by abstracting natural form and colour, it achieved its consequence: abstract plastic. It can be observed that the earliest efforts of free painting are already being recognized as *established art*. Its most extreme outcome — Abstract-Real plastic — is now far from universally accepted as '*painting*'; how could it be acceptable at a time when the old still thrives and the new is still so poorly known?

What made free painting possible was the unique vitality of modern life, which was strong enough to break with *form*. Since pure *destruction* is impossible, modern life had to *construct* the new: a pure, equilibrated plastic expression of relationships. Free painting was able to develop because our time brought with it the recognition that *every expression manifesting life — including art — is good and justified; that all expressions of real life are completely justified, even in their imperfection*. Rightly so — for man spontaneously takes the *right way*, the way of progress. In art too: the artist is always a pure reflection of the new consciousness. Each artist is the consequence of another before him, whom he thus completes. If today the artist speaks in riddles, so far as the masses are concerned, when the modern spirit cloaks the work of art in an unfamiliar appearance — even then he is completely justified.

Until the modern era, the plastic means of all painting were the *natural appearance of objects* rather than *natural form and colour*. This was transformed by the prevailing sense of style, but always in such a way that the natural remained recognizable. Thus we can understand the astonishment and anger aroused in recent times, when form and colour began to be used autonomously, and natural appearances were no longer recognizable. One was confronted with the necessity of accepting a new way of seeing. A more conscious vision, which saw form and colour as means in themselves, resulted from *conscious* perception of what was previously perceived unconsciously: that beauty in art is created not by the objects of representation but by the relationships of line and colour (Cézanne). Despite its more conscious nature, even the new era was slow to accept this, so deeply rooted was naturalistic vision.

The increasingly thorough *transformation* of naturalistic form and colour rendered each new expression of modern painting more and more incomprehensible to traditional feeling.

Already the Impressionists had begun to deviate from ordinary visual appearances. The Neo-Impressionists followed, and Pointillists and Divisionists went even beyond them in breaking free of 'normal' vision. Perception seemed to be moving deeper and deeper within.

Once painting was freed from the imitation of nature, it automatically sought further freedom. It has liberated itself somewhat from natural colour — and also to some extent from natural form: now the *breaking up* of natural colour and natural form had to follow — Expressionism, Cubism, Orphism, etc. Finally form came to its dissolution in the straight line, and natural colour in the pure colour-plane (Abstract-Real painting).

Throughout modern painting we see a trend to the straight line and planear, primary colour. Shortly before Cubism we see the broad outlines emphasized as strongly as possible and the colour within them made flat and intense (Van Gogh and others). The technique of painting was correspondingly transformed: the work took on a new appearance, although the inner impulse came from the same source. Naturalistic plastic was increasingly intensified: form was tensed, colour strengthened. This art often shows less affinity with the art of its direct predecessors than with the old Dutch and Flemish, with the Renaissance art such as Mantegna, with early Christian, ancient Eastern or Indian art. But among the ancients, intensification had a deeper character. In fact the modern age rapidly abandoned the old way of intensifying nature and tended rather to start from the decorative.

At the same time the ideas that Cézanne had already stated — that everything visible has a geometric basis, that painting consists solely of colour oppositions, etc. — were increasingly stressed, and cleared the way for Cubism. The plastic of Cubism is no longer naturalistic: it seeks the plastic — the plastic above all — but in an entirely new way. Cubism still represents particular things, but no longer in their traditional perspective appearance. Cubism breaks forms, omits parts of them and interjects other lines and forms: it even introduces the straight line where it is not directly seen in the object. Form is brought to a more *determined* expression, to its *own* expression: far more than the old art, Cubism expresses composition and relationship directly. *In Cubism the work of art therefore actually becomes a manifestation which has grown out of the human spirit, and is thus integral with man.*

Cubism broke the closed line, the contour which delimits individual form; but because this *breaking* is plastically expressed, it falls short

of pure unity. While it achieves greater unity than the old art, because its composition has strong plastic expression, Cubism loses unity by following the fragmented character of natural appearance. For objects remain *objects*, despite their broken form.

This breaking of form had to be replaced by *the intensification of form to straightness*.

But, in order to achieve this, Abstract-Real painting had to follow the same path as Cubism: by abstracting *natural appearance*.

The path of partial or complete abstraction was followed by the entire Cubist school, although in very diverse ways. Perhaps the closest forerunner of Neoplasticism was a plastic of more or less homogeneous (abstracted) forms, with tense curved lines rhythmically composed (Léger). Its line had only to be made more tense — until it became *straight*. (This *straightening* also resulted logically in a more equilibrated composition.)

Alongside Cubism, many other expressions arose, more or less using line and colour exclusively (some based entirely on colour), and all free of natural appearance.

Thus *by learning to perceive nature more and more purely*, painting came to abstraction. By representing the visible, painting came to plastically express determinately that which manifests itself through the visible — *pure relationship*.

[*Vol. I, No. 11, pp. 125–135*]

6. Conclusion: Nature and Spirit as Male and Female Elements

The extreme opposites which find their plastic expression in Abstract-Real painting can be seen not only as outwardness and inwardness, as nature and spirit, as individual and universal, but also as female and male elements. With regard to art, it is important to see the duality of all life in this way, for this duality is then perceived from the viewpoint of *life itself*, and thus the unity of *life and art* are clearly discerned. Conversely, the concept of female and male elements, as they are manifested in life, become alive in us when they are seen *plastically*. Anything concerning inwardness and outwardness that Neoplasticism makes perceptible through its plastic manifestation, also clarifies the female-male relationship and its significance — in life too.

If Neoplasticism expresses determinately the content of the new

consciousness (greater equilibrium in the duality of life), then it also shows determinately what makes this equilibrium in life possible: it shows how the male element must become related to the female element and conversely; and what appearance they must assume.

In Neoplastic means and composition, we see the male element represented in whatever expresses the universal, the inward; and the female in whatever expresses the individual, the outward. In Neoplasticism we see that equilibrated relationship is achieved by *interiorizing the individual and determining the universal — that is, by intensifying the natural (or female), and by bringing forward the spiritual (or male)*.

If the plastic of equilibrated relationships is the purest expression of harmony, then this expression of harmony consists of the *interiorization of the female and the determination of the male*. If we see the female and male as two forces in one, which determine life, Neoplasticism demonstrates that — outward as they may be — by *interiorization*, both reveal their original unity in life; and thus determinately bring to the fore the inner harmony of all life. It can then be seen that only *purified* female and *purified* male elements can bring this about in all of life's relationships.

The purified female element is the *interiorized* female element, but remains *female*: never — in time — does it become male. It is only stripped of its most outward character; or rather, the most outward female is crystallized to a *more pure* female.

The purified male element is the male element free from the dominant influence of outwardness — of the female element.

Exteriorization therefore diminishes the purity of both female and male elements.

Exteriorization is necessary for the growth of inwardness; but the most outward exteriorization becomes increasingly weakened as the inward becomes more determined. As the male develops in man, the female in him is deepened; and conversely. By its very nature, however, the female element remains essentially *outward*. Therefore it can only mature through *culture of the outward*.

If we see, plastically, that the purified female is purified *outwardness*, and it clearly cannot — in time — become inwardness, despite its interiorization. *Interiorization* of the female is made perceptible in Neoplasticism by intensifying naturalistic colour and increasing the tension of form *to the extreme. It is, therefore, the controlling and tensing of the capricious, the determining of the fluid and vague*. Just as intensified natural colour, and fully tensed

naturalistic line remain *outward*, despite their deepening, so the interiorized female remains outward despite its interiorization.

It is important to understand this — for only as outwardness can the female element oppose and unite with the male.

The male element, on the other hand, remains *inwardness* despite its exteriorization. The most purified male comes closest to *the* inward; while the most purified female shows the least outwardness. In this way both express *inwardness* most purely.

If the female element is to mature *within us*, it must be through cultivation of the *outward* in us. It is the male element that cultivates, and by so doing cultivates itself; realizing itself, it is wrecked each time on the outward. Thus outward culture keeps pace with the inward.

Now that the consciousness of our age has attained greater maturity, the era of a *more equilibrated culture of outward and inward is beginning*. Throughout the ages attention alternated between the two. The outward was expressed in purely *Realistic* painting, the inward in *Idealistic* painting and *Romanticism*. Had man always confined himself to outward culture, evolution would have taken much longer; whereas if the reverse had occurred, the universal would never have firmly realized itself.

One cannot cultivate the inward exclusively. Whoever tries this, discovers its sterility — as we see in much of our so-called religious and social life. True social life involves outward culture in the first place, but also contains culture of the inward. This means that the outward must be *constantly in process of cultivation:* life does not tend to the outward *for the sake of the material*, but only as *a means for its development*. Thus true socialism signifies *equilibrium* between inward and outward culture.

If art, like society, is an outwardness which has to be cultivated, or rather, which *cultivates itself*, then there is one necessity: not to go against this culture. Just as female outwardness becomes purified in life, so art develops from the naturalistic to abstract-real plastic. But whoever concentrates solely on culture of the inward inevitably comes to negate the evolution of art — a sign that life is only being half lived.

External life, however, compels man to take part in culture; this is what reconciles us with life.

If the female element in man becomes more pure by interiorization, it becomes more pure by growing *towards* the male, so that it can then *oppose the male more freely*. And if the male element in man becomes purer by interiorization, it becomes purer by turning towards the female, so

that it can *oppose the female more freely.* This growing freedom of both elements creates a new vision of nature. Neoplasticism manifests this insight through the perpendicular duality of its plastic means. (In naturalistic painting, female and male elements are confused — in form).

Thus the mutual action of opposites brings about a new unity of a higher order: the purified female and the purified male.

If female *outwardness,* in passing from female to male, remains the deepened *female,* it can remain as such even while absorbing the male — for the male, or spirit, is pure. It can become impure only by absorbing male outwardness, *i.e.,* the male veiled by female outwardness. And the male does not become obscured by uniting with the purified female — but only by uniting with the outward female.

Seen plastically, the purified male can be called *abstract outwardness,* for this comes closest to *the inward,* which is not manifested. Abstract outwardness is *determined* inwardness, equivalent with the most intensified outwardness. The impure male, on the other hand, is manifested as the outward female.

The male is completely pure only when it *realizes itself through the deepened* female. If, consequently, this is *abstract,* then only the *realization of the male in the abstract is completely pure.*

The female and male elements, nature and spirit, then find their *pure expression, true unity, only in the abstract.* This is attainable, relatively, in *abstract-real life,* just as it can be plastically expressed, relatively, in *Abstract-Real painting.* Relatively since — in life — time always upsets complete equilibrium; and — in art — *rhythm* relativizes the pure expression of relationship.

Complete equilibrium, unity, becomes *determinate* expression only through purified female and purified male elements, for only then does this duality appear in its equivalent character, and in complete mutual opposition. When unity is manifested as a (closed) unity — as form — as in the naturalistic appearance of things, then unity can merely be felt. Just as *natural* harmony exists in the visible in life, harmony exists between nature and spirit, between female and male; but it is oppressed by the individual.

Natural harmony is only the most outward manifestation of *pure equilibrated relationship,* which is not expressed in the visible (nature); for in nature both pure female and pure male are manifested in a very veiled way. *Harmony* exists, however — precisely because both elements are equally

veiled. But in nature, the female element (as outwardness) has the strongest plastic *expression*, so that harmony is *felt* rather than *seen*. The task of art is to give the felt harmony a more or less direct plastic expression.

In life, too, harmony is possible between the unpurified female and the impure male elements — again because of relatively equal degrees of impurity. In the course of their purification, disharmony arises due to the differences in their relative degree of purification.

Because harmony in the visible (nature) and in outward life is very relative, *man is compelled to bring it to a constant and determinate expression* — in one way or another. Thus in Abstract-Real painting harmony found determinate expression *as pure equilibrated relationship*.

The new mentality is marked on the one hand by the maturing consciousness of the natural, the individual, and on the other by the maturing of the female element. If another sign of this is the greater determinateness of the universal, then *the male element is indeed becoming active in our consciousness as spirit, as the universal*. In the new mentality, there is therefore a unity of evolution which *must* realize itself.

But in our time the universal has been manifested as little in the male element as mature individuality has been manifested in the female. The old mentality continues to be influential, notwithstanding the presence of the new consciousness.

By viewing art historically we see most clearly that the old mentality not only contained impure masculinity, but that it was also dominated by the outward, immature female. This is revealed in its plastic expression — as well as in its *representation* (or *subject-matter*). In naturalistic painting, the plastic expression was predominantly female outwardness, for natural colour and the capricious undulating line were the expressive means. Only during periods of intense inner life, inspired from without, did colour become more plane and primary, line more tense, the composition more equilibrated. In the representation (already female by nature), woman had an important place, and almost always woman was a vehicle for the concept of beauty. However, her portrayal changed only with the prevailing spirit of the times: she is seen, for example, as a worldly beauty or as a madonna. Although the expression of woman was typical, this was not what made the *representation* expressive of the outward female; representation of *any* kind, the *portrayal of nature in general — whether landscape, interior, still-life, etc.* — can be defined as predominantly female in character. If it is argued on behalf of naturalistic painting that the inward male element finds its expres-

sion precisely through the female, this — today — is an inverted truth. *Pure plastic vision* recognizes that the inward, the male element, can never find *pure plastic expression* when veiled by the female, as it is in natural appearance. Female outwardness can animate the male in our spirit, but it is the male, once purified, that expresses the outward female as the purified female. Because the male element is not expressed determinately in female outwardness (the natural appearance of objects), the latter must be annihilated in the plastic, and replaced by a plastic of deeper female and more determined male character.

As long as the female element dominates, the male has not yet become determinate, the female can dominate *only if the male element is indeterminate*. In painting, domination by the female element was abolished when the male element in our mentality became more determinate. Then art changed its expression: *representation* faded and the *plastic itself* grew increasingly towards female-male equilibrium.

[*Vol. I, No. 12, pp. 140–147*]

Bart van der Leck

The Place of Modern Painting in Architecture

The modern painter wishes to abolish the 'separateness' of painting, both in its internal and external aspects.

More strongly than before, the notion is beginning to take root that painting has no other purpose than plasticism: to express plastically without fantasizing or mood and without ephemeral conflict.

No longer is it isolated or piecemeal applied painting for purposes of illustration, no longer is it decoration or beautification, but the plastic expression of reality.

Painting has developed independently during the course of time, separately from architecture, and through experiment and the destruction of the old and the natural, it has come to develop its own particular character, both formally and spiritually. It always requires the plane surface, however, and it will always remain its ultimate wish to make direct use of the necessary practical plane created by architecture. More than that, in its extension from the individual to the universal it will claim from the building, as its rightful domain, the whole of the colour concept and that

part of the form concept appropriate to painting. If architects are looking for a painter who can supply the desired image, the modern painter is no less seeking an architect who can offer the appropriate conditions for the joint achievement of a true unity of plastic expression. We ask of the architect 'self restraint', because he has so much in his hands that does not really belong to architecture and which, in its execution, must be understood completely differently from the way the architect understands it.

Building is quite clearly something different from painting and stands in a quite different relationship with the infinite. We list below five ways in which building differs from painting, from painting as, in the last analysis, it really is.

1. Modern painting is destruction of naturalistic plastic expression as against the naturalistic plastic constructional character of architecture.
2. Modern painting is open, in contrast with the combining, closed nature of architecture.
3. Modern painting is colour and space-imparting, in contrast with the colourless and plane surface character of architecture.
4. Modern painting is plastic expression in spatial flatness: extension, in contrast with the space-restricting flatness of architecture.
5. Modern painting is plastic balance, as against the constructional balance (load and support) of architecture.

Modern painting reduces corporeality to flatness and, through the space concept, arrives at the destruction of the natural associated with the plane, and so at spatial relationship.

Architecture constructs organic corporeality in closed relationships.

The architectural plane is the delimitation of light and space.

In modern painting, colour is the plastic expression of light; primary colour is the direct plastic expression of light. Colour is the visual sculpture of light. In modern painting direct relationship is the plastic expression of the multiplicity of spatial relationships. The plastic representation of light and space is colour and relationship. Where architecture is limitation of space, colour and the plastic expression of spatial relationship make complete the cosmic nature of architecture.

Architecture is, like the earth, sculptural, and requires, to complete its plastic expression, the plasticism of light and spatiality.

Now this is the positive result of the destructive element in modern painting — that it carries forward the depiction of visual reality, with its tragedy, into the cosmic values of space, light and relationship, into which

therefore, all earthly relief or 'the particular case' is assimilated and its existence presupposed.

[*Vol. I, No. 2, pp.* 6–7]

J. J. P. Oud

The Monumental Townscape

The concept 'monumental' is of an internal and not an external nature. It can manifest itself in small as well as in big things. Material factors play no part in this respect.

It is, therefore, superficial to maintain that a small country cannot have a monumental style. In the Netherlands there is a place and a need for a monumental style. Evolution in architecture, as in painting, is moving in the direction of the universal and monumental. In this it follows the line set by the Berlage School and is opposed in principle to the Amsterdam School, in which the monumental has been corrupted into what is essentially decadent.

In order to achieve style, only the universal is of importance. Acting through purity of means, a monumental style will be able to arise through the cooperation of the different art forms, because cooperation is possible only where each art form moves within its own field and admits no impure elements. The characteristic feature of each art form then becomes apparent and the need for cooperation is clearly felt.

The characteristic feature of architecture is relief. Architecture is plastic art, the art of the definition of space and, as such, is most universally expressed in the townscape: in the single building and in the grouping of buildings and the setting off of one building against another. The town plan is generally dominated by two elements: the street and the square. The street as a string of houses; the square as a focus of streets.

The townscape is mainly determined by the street picture.

In determining the character of the modern street picture, the starting point will have to be, for theoretical and practical reasons, the street picture as a whole. On theoretical grounds, as has been shown above; on practical grounds, because in modern urban development private enterprise will

play an increasingly small part and building in blocks or large groupings will take the place of the building of the individual house.

In sharp contrast to the old street picture, therefore, in which the houses are arbitrarily grouped together, the modern street picture will be dominated by building blocks in which the houses will be placed in a rhythmic arrangement of planes and masses.

Accordingly, the most important task for the modern architect is the block of dwellings. This task, in the fulfilment of which the authorities will have to play a part, demands its own appropriate solution, one not yet found in the blocks so far erected, where traditional influences have been maintained.

The beauty characteristic of the modern building block will be expressed in a strong emphatic rhythm and in the acceptance of modern materials.

A prominent feature will be a radical break with the pitched roof, resulting in the acceptance of the flat roof and all that it implies: the solution of horizontal spans by means of constructions in iron or concrete, the treatment of wall surfaces and wall openings with modern materials.

In this way, the architecture of the building block will determine to a large degree the character of the modern aesthetic in architecture.

Leiden. 9 July 1917 *[Vol. I, No. 1, pp. 10–11]*

J. J. P. Oud

Art and Machine

Paradoxically, it may be said that the struggle of the modern artist is a struggle against feeling.

The modern artist strives to attain the universal, while feeling (the subjective) leads to the particular.

The subjective is the arbitrary, the unconscious, the relatively indeterminate, which can be sublimated through the conscious mind to relative determinateness. To this end, the subjective must be ordered by the conscious mind so that, in its relative determination, style is achieved.

The aim of the modern artist is to carry out this organization and obtain this determinate style.

If we understand by 'monumentality' the organized and controlled

relationship of the subjective to the objective, it follows that, in a higher sense, the struggle of the modern artist will lead to a monumental style.

Two principal trends may be distinguished in the effort to achieve style.

The one is a technical and industrial trend, which may be called the positive trend, and which tries to give aesthetic expression to the products of technical skill.

The second trend which, for purposes of comparison, may be called negative (although its manifestations are equally positive), is art, which tries by means of reduction (abstraction) to arrive at functionalism.

The unity of these two trends is the essence of the new style.

Great art stands in a causal relationship with the social striving of the age. The longing to make the individual subservient to the social is to be found in everyday life as well as in art, reflected in the need to organize individual elements into groups, associations, confederations, companies, trusts, monopolies, etc. This parallelism of intellectual and social striving which is a necessity for culture, forms the basis for style.

In each period, the universal element in art has its own outward form, which is a reflection of three factors: spirit (seen as a unity of intuition and consciousness), material and method of production.

Much has been written about the spirit of the modern work of art, but we shall have to give equal weight to the two other factors, material and method of production, for in order to give determinate plastic expression to the spirit, the means must first of all be made determinate and what means is more determinate and more of this age than the machine? Must the spirit be realized in this age by the hand or the machine? For the modern artist the future line of development must lead inevitably to the machine, although at first the tendency will be to regard this as heresy. Not only because the machine can give more determinate plastic expression than the hand, but also from the social point of view, from the economic standpoint, the machine is the best means of manufacturing products which will be of more benefit to the community than the art products of the present time, which reach only the wealthy individual.

Where architecture has already long been achieving plastic expression through the machine (Wright), painting is being impelled inevitably towards the same plastic means and a unity in the pure expression of the spirit of the age is making a spontaneous appearance.

It was the cardinal error of Ruskin and Morris that they brought the machine into disrepute by stigmatizing an impure use of it as its essence.

As soon as the machine is used to imitate another method of production, a sin is committed against the factors which determine pure form (which, because it appears in purity, is always able to achieve aesthetic results) and it is committed not only against the method of production, but also against the spirit and the material.

Impurity in art, as in religion, arises whenever the means are mistaken for the end. Thus painting was able to give representation without art; architecture, detail without art; religion, ceremony without belief; philosophy, pure reason without wisdom.

The artist of the past thought too much in sham values. It can be said of the modern artist that he proceeds too much from the essence to be able to put on an external artistic display.

That the pure application of the machine can lead to aesthetic results has already been proved by buildings, the aesthetically designed book (printed by machine), textile work, etc. Severini says of the spirit of the modern work of art: 'The precision, the rhythm, the brutality of machines and their movements have, without doubt, led us to a new realism which we can express without having to paint locomotives.

Summarizing, we come to the conclusion (although this is for the future) that the two other form-determining factors can also be brought into harmony with the modern way of life and that the work of art will be produced by the machine, although with quite different materials, and the unique article, as we know it, will no longer exist.

[*Vol. I, No. 3 (4), pp. 25–27*]

De Stijl 1918–1919

Theo van Doesburg

Notes on Monumental Art with reference to two fragments of a building
(hall in holiday centre at Noordwijkerhout)

The one cannot exist without the other.

The consciousness of the new plasticism implies cooperation of all the plastic arts in order to attain a pure monumental style on the basis of balanced relationship.

A monumental style implies proportional division of labour among the various arts.

Proportional division of labour means that each artist restricts himself to his own field.

This limitation implies plasticizing with the means appropriate to that art.

Plasticizing with the appropriate means implies true freedom; it frees the architect, for example, from much that does not belong to his plastic means such as colour and about which he will have other views from a constructional and aesthetic viewpoint than the painter.

These theories have already long been proclaimed by important architects, but in practice with a few exceptions the old ways continued to be followed: the architect also performed the role of the painter and sculptor, which was naturally bound to lead to the most arbitrary results, as, for example, to a pictorial, sculptured or, in one word, destructive architecture.

Each art, architecture, painting or sculpture, requires the whole man. Only when this is again realized, as in antiquity, will a development towards a monumental architecture, towards style, be possible.

When that happens the concept of applied art will also automatically disappear, as will every example of one art being subservient to another.

It is fortunate that young artists in architecture not only see this, but are also putting it into practice, so that they encourage and facilitate not only the culture of the house, but also the culture of monumentality.

The concept of monumentality has changed significantly in favour of

99

the feeling for style since architects no longer delight in the capricious play of the baroque with its excesses and excrescences.

There has also been, in relation to painting and applied to architecture, beyond Cubism and Futurism, a significant deepening of the concept of monumentality in favour of architecture, especially through conquest of the plane, the flat colour, the plane space and the concept of relationship.

Our spiritual climate no longer permits puppet-like figures painted on a wall — preferably accompanied by an appropriate motto ... in the manner of chocolate box mottos — and bearing no organic relationship to that wall, to be regarded as monumental painting appropriate to the spirit of the age. Representation or symbolism is not the same as giving plastic expression and must be considered as belonging to a stage in human consciousness of one-sided reality, in which the spirit was afraid, as it were, to imprint itself in the concrete material as form, colour or relationship of opposites.

Such 'monumental' art, which, in reality, is no more than the decorative appearance of monumentality, perhaps fitted into the weak, feminine architecture of the past, but there will be no place for it in the masculine architecture of the future.

The 'styling' of the natural form into ornamental form, based upon the observation by the senses of natural forms devoid of any plasticism, based

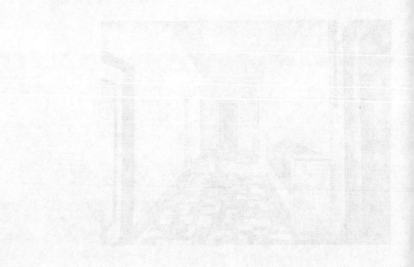

upon natural symmetry and natural multiplication, has nothing to do with plasticism through aesthetic relationships deriving from internality.

As the notion gained ground that Concept must express itself in Form and Form in Means, monumental art underwent an important change. It had to reject its illustrative and ornamental character as being wholly in conflict with its essence, which is to create through colour relationship, aesthetic space (extension) on the constructionally closed plane. (Note: The relationship of the decorative to the plastic is referred to again in more detail in an article entitled 'The Style of Relationship'.)

Architecture produces constructional, that is, closed, relief. In this respect it is neutral in relation to painting, which gives open relief by means of flat colour plasticism. Architecture joins together, binds. Painting loosens, unbinds. The very fact that they have to fulfil essentially different functions makes possible a harmonious combination. The latter arises, not from similar characteristics, but precisely from opposite characteristics. In this opposition, in this complementary relationship of architecture and painting, of plastic form and flat colour, pure monumental art finds its basis.

Not only does painting oppose the loose and open to the constructionally closed, extension to enclosure, it also releases organically closed relief from its confinement, opposing movement to stability.

This movement is, of course, not optical and material but aesthetic and, because it is aesthetic, this movement, which is plasticized in painting by means of colour relationship, must be brought to rest by a counter-movement.

The neutral character of architectural relief also works in this direction.

This has now been successfully realized in the fragments of buildings reproduced here. In the first illustration we see how architecture, proceeding from a functional and constructional basis, is able to achieve an aesthetically monumental, organic relief. Precisely through the sacrifice of all external ornament and sculptural detail that does not serve architecture (figures, mouldings, etc.) the plastic rhythm of the architecture finds its most complete independent expression. This expression is independent and free because it is not tied to ornament and so does not take on the appearence of being something other than it really is—architectural and not sculptural expression. The idea is expressed in the form and the form is impressed in the material. Consequently the observer is compelled to see architectural relief.

The ascending staircase, the breached walls, the side benches and the bench in the upper passage all have a logical functional importance which, comprised in a single organic form, is plastically externalized. This form produces, from whatever side it is seen, a surprising rhythmical effect.

Both in the composition of the tiled floor and in the painting of the doors, etc., an aesthetic spatial effect through destruction has been achieved by other means, i.e., by means of painting-in-architecture. It is true that the floor is the most closed surface of the house and therefore demands, from an aesthetic point of view, a counter-gravitational effect by means of flat colour and open spatial relationships. It has been carried through consistently here from the entrance through the whole of the lower and upper halls and passages. A small part of this may be seen in the second illustration.

The development and working out of this whole composition—constructional-destructional—can be seen only at the place itself, where, unfortunately, because of the too-dark stained glass windows, the light, one of the chief factors in the art of monumental space, cancels out much of the effect.

Through the consistent carrying forward and development of this complementary combination of architecture and painting, it will be possible to achieve in the future on a purely modern basis the aim of monumental art:

to place man within (instead of opposite) the plastic arts and thereby enable him to participate in them.

In what we show here much has already been achieved and yet more . . . learnt. Nevertheless, this must still be regarded as a beginning of monumentality.

[*Vol. II, No. 1, pp. 10–12*]

Piet Mondrian

The Determinate and the Indeterminate (Supplement)

The determinate is positive for us, absolute, insofar as we can establish it objectively. We can speak objectively only of *the* determinate — which is universal, *the* universal. Subjectively we know diverse *determinations*, all of which are more or less individual.

If the universal — outside of time — is *the determinate*, then the individual, in and through which the universal appears in time, must be *indeterminate* and so must be our vision of it.

The indeterminate has the appearance — in time — of being determinate; the determinate — in time — of being indeterminate. We always more or less subjectivize the one determined; and for us this subjectivization is *the determined*. We perceive — in time — the *one* determined with varying degrees of clarity, and each degree is — in time — *determinate for us*. As the individual in us matures, and the universal in us predominates, our various individual determinations grow towards the *one* determined.

Each individual determination — in time — is neither more nor less valuable than another: each individual determination is to us *the true one* — for the time being. That is why each subsequent individual determination annihilates the previous one, and the degree of clarity with which — in time — we perceive the *one* determined is not arbitrary: *what seems determinate to us varies with the time.*

In individual vision, the (one) determined *appears as vague*, and the indeterminate as real. In time, the (one) determined is abstract: the indeterminate, *concrete*. Objectively seen — as far as this is possible — in time — the (one) determined is abstract-real.

Depending upon the character of our consciousness we see either the objective or the subjective as *the determinate*, the universal or the individual,

the abstract or the concrete. *Thus our life and our art depend upon our idea of the determinate.*

The determinate — in general — demands determination and clarity: it must be clearly expressed if it is actually to be manifested as *the determinate*. In keeping with this requirement, art is expressed with greater or lesser *clarity* either through the (one) determined, or by whatever means it manifests itself.

In art, the relatively determinate (that is, the greater or lesser determination in which the (one) determined finds expression) *must be clearly expressed plastically*. Every age has clearly expressed its (relative) determination, and thus, more or less, the (one) determined. This is the power of art: All art *has striven* for clear plastic expression of the one determined: within its unclearness *some degree of determination was nevertheless expressed.*

If it is established by plastic expression of the determinate (the concrete) it had to find concrete *plastic manifestation*. It is manifested as the immutable, and this immutability is *equilibrated relationship*.

Whereas the indeterminate (concrete) is manifested through *corporeality*; the (one) determined is plastically expressed as equilibrated relationship through position, dimension and value of colour and plane (line).

Because *equilibrated relationship* is capable of finding actual *visual plastic expression* (although veiled), we can experience the deepest aesthetic emotion; it is the *plastic, the bringing to determination of this relationship*, that makes all art, art.

Naturalistic painting, therefore, can express things either in their *clarity* or in their *vagueness*; the essential is that it bring equilibrated relationship to determination. Thus the vagueness of *Thijs Maris* is no longer mere vagueness: he represents *things* vaguely, but their vagueness shows a certain degree of determinateness. Similarly, in *Jan Steen*, the representation of objects is not simply plastic expression of their visual appearance: he gives their corporeality a certain degree of determinateness.

In art — unconsciously or consciously — the *determinate* (*i.e.*, that which is plastically determinate) is the objectively determinate; it is always the plastic expression of relationship that matters, not the representation of things.

The emotion of beauty is strong to the degree that relationship is plastically expressed determinately; and it is profound to the degree that its plastic expression is equilibrated.

In the course of its culture, painting carried this truth to its most

extreme consequence: it has finally achieved the plastic expression of *pure relationship*. *Pure* relationship in painting does not mean relationship and nothing else, for such an expression would not be 'art'. The plastic expression of relationship must fulfill every aesthetic demand if it is really to be 'art' and is to awaken our aesthetic impulse.

Having evolved to the point of plastically expressing aesthetic relationship purely (in the above sense) painting is ready to merge with architecture. Since ancient times architecture — by its very nature (the mathematical-aesthetic expression of relationships) — far surpassed its sister arts. Although it did not always consciously express this, and although its forms were always the outcome of necessity and practical demands, it went far beyond the naturalism of painting and sculpture.

Up to the present moment, sculpture has known no more than a tensing of its form (Archipenko). It was painting (Neoplasticism) that brought the expression of *pure relationship* to the forefront.

This does not make Neoplastic painting merely *accessory* to architecture: for it is not *constructional* like architecture. Structural without being *constructional*, and free in its *ability to express expansion*, Neoplasticism is the most equilibrated plastic of pure relationship. Architecture always presupposes enclosure: the building stands out as a *thing* against space (the play of masses destroys this to some extent). Moreover, being constructional in character, and tied to the demands of its materials, architecture cannot maintain as consistently as painting the constantly self-annihilating oppositions of position, dimension and colour (value).

If the determinate demands *determination*, then the plastic expression of relationship in art must be carried to determination. This is achieved in painting by determining *colour itself* as well as the *colour planes*; this consists in counteracting the blending of colours by establishing boundaries of one kind or another — by opposing plane (value), or by line. *Line* is actually to be seen as the *determination of (colour) planes*, and is therefore of such great significance in all painting. Nevertheless, the plastic is created by planes; and *Cézanne* could say that painting consists solely of oppositions of colour. Plastic can nevertheless also be seen from the standpoint of line: planes in sharper opposition form lines. Naturalistic painting thus arrives at the concept of 'form', and (with *Gauguin* and others) we can say of determinate *colour* that *from creation* is the essence of painting. Form, in this sense, determines colour: the more tense the form, the more determinate the colour.

If form is expressed through line, then the most tense line will determine colour most strongly; line that has reached straightness will determine colour to the maximum. By *consistently executing colour determination*, we leave behind the capricious and the naturalistic.

Accentuating the plastic of relationships led to the exaggeration of the plastic expression of relationships, to abstraction from the natural (Pointillism, Divisionism, Expressionism, Cubism), and finally to the plastic of *pure relationship* (Neoplasticism).

If we see the plastic of pure relationship gradually developed in the successive *schools* of naturalistic painting, we can also trace its evolution in the development of the founders of Neoplasticism. They strove to free themselves from the indeterminate (the visual appearance of things) and to achieve a pure plastic of the determinate (equilibrated relationship). While still expressing the indeterminate, they were drawn to those aspects of nature in which the determinate (equilibrated relationship) appears *determinately* — where relationship is veiled — and they exaggerated these (visual) relationships. Was it by chance that they found a most appropriate subject-matter through which to express their feeling for determinate relationship in an un-forshortened (non-perspective) view of a farmhouse, with its mathematical articulation of planes (its large doors and groups of windows) and its primary (basic) colours?

Was it by chance that they were attracted to *straightness*, and — to the chagrin of habitual vision — dared to represent a wood simply by its vertical tree trunks? Was it surprising that, once they had abstracted these trunks to lines or planes, they spontaneously came to express the horizontal — hardly visible in nature — thus creating equilibrium with the vertical? Or, that in a rhythmic linear composition of the predominantly horizontal sea, they again expressed the — unseen — vertical in appropriate opposition? Did they do more than *exaggerate* what all painting has always done? Again, was it by chance that they were more deeply moved by the leafless tree with its strong articulation of line or plane, than by the tree in leaf where relationship is blurred? And is it surprising that in the course of their work they abstracted natural appearance more and more, so as to express relationship more and more explicitly? And that the ensuing composition was more mathematical than naturalistic? Was it, finally, by chance, that after abstracting all that was capricious, they abstracted *curvature* completely, thus achieving *the most constant, the most determinate plastic expression of equilibrated relationship* — composition in rectangular planes? . . .

Art had to free its plastic expression of the indeterminate (the natural) in order to achieve pure plastic expression of the *determinate*. This was done by Neoplasticism, passing through Cubism. This is intuitively seen and felt by the sensitive observer: it becomes clear to him through logical thinking. It becomes convincing in practice, whenever one compares Neoplastic with other painting.

Comparison is the standard which every artist consciously or unconsciously uses: it shows him how to express (his) truth as determinately as possible. He compares each new work with a previous one, in his own production or in that of others; he compares it with nature as well as with art. To compare is to exercise one's vision of relationships; one is brought to see and compare *basic oppositions*: the individual and the universal. From a clearer and clearer perception of their relationship, a purer and purer mode of expression emerges. And so Neoplasticism logically arose.

[*Vol. II, No. 2, pp. 14–19*]

Theo van Doesburg

Thought — Perception — Plasticism

The development of the plastic arts is determined by the perceptive urge.

The old plasticism revealed the perceptive urge through relationship experienced in nature.

The new plasticism reveals the perceptive urge through relationship experienced in plasticism.

It is a mistaken point of view to equate the essence of thought with perception, just as it is mistaken in relation to perception to equate it with the plasticism of nature through the senses. The latter is a concept of Classical and Roman Catholic origin against which Protestantism took issue (iconoclasm).

Three stages may be distinguished in the nature of thought:

1 pure abstract thought: thought for thought's sake;
2 concrete thought: thought about perception; and
3 a stage between these two: deformative thought.

In pure abstract thought all sensuous associative observation (of nature) is abstract. Its place is taken by relationship of ideas. The latter can be made

perceptible as exact (mathematical) figures, and employed in mathematics. It can also be made perceptible in numbers. In these figures, the concept, the content of pure thought, is given plastic expression. In this instance, where it is the content of pure, conceptual thought which is given plastic expression, one may already speak of plastic perception.

I call concrete thought, thought relating to images derived from sensuously associative observation, such as a remembered scene, in which the intellect is not involved and, therefore, does not appear.

I call deformative thought, thought which does relate to images — even remembered scenes — but in which such images are affected and deformed by the intellect.

The images are associated with concrete phenomena, but they exist in an amorphous condition.

Although we must always proceed more or less speculatively in the abstract sphere, I nevertheless have serious reason to accept as truth in respect of the visual arts that this latter visionary mode of thought shows correspondence with a dream image, and that the amorphous character of these ideas or thought images is caused by the effect of the emotions — disturbances of mental repose — upon the intellect. We might, therefore, also speak in this instance of emotional thought.

The serious reason why I accept as truth these three stages of thought relating to the visual arts rests upon the fact that we find these three stages of thought projected in the visual arts — or rather, in art. Secondly, because my own development in plasticism has passed through these three stages during a period of twenty years. Everyone who has sought for truth in the field of the visual arts will individually find this development of thought projected in his work in the same way as this development has revealed itself in art generally.

This development does not show a regular passage in art history, nor does it, perhaps, in the individual, but this does not invalidate the fact that these three stages of thought can be observed in plasticism.

Ordinary concrete or objective thought revealed itself in representational art. Let us take as an example the art of Van der Helst (the question whether simple representation is art is not discussed here). This stage of human thought is reflected in physioplastic art from the Paleolithic culture until our own time.

Deformative thought, which involves both sensuously associative images and intellect, but in which neither appears determinately, reveals itself

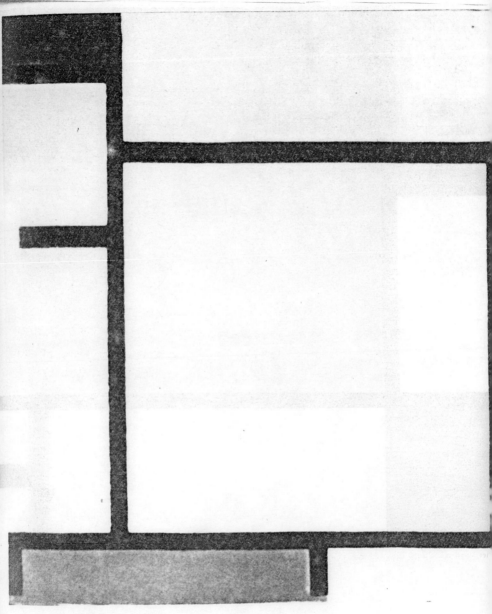

16 Piet Mondrian. *Composition*. 1922

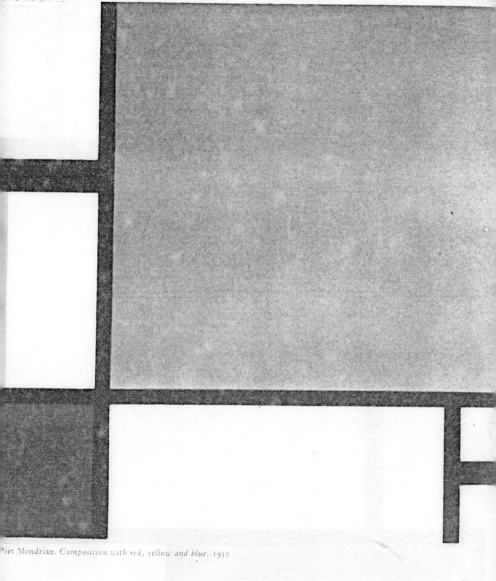

Piet Mondrian. *Composition with red, yellow and blue*. 1930

18 Bart van der Leck. *The Storm.* 1916

19 Bart van der Leck. *Geometrical composition I.* 1917

...rt van der Leck. *Horseman.* 1918

21 Theo van Doesburg. *Russian dance.* 1918

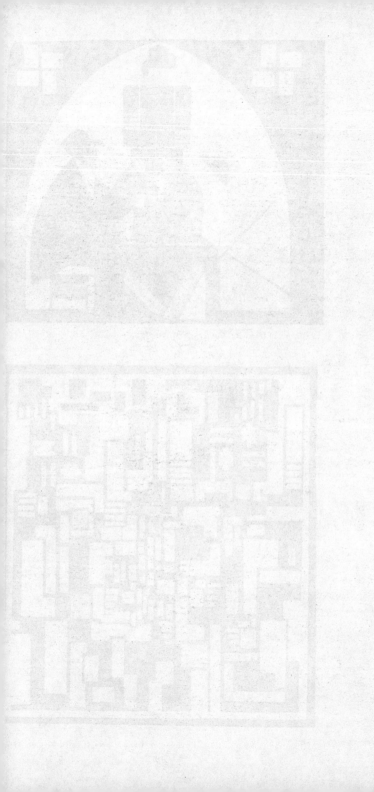

22 Theo van Doesburg. *Card-players*. 1916–17

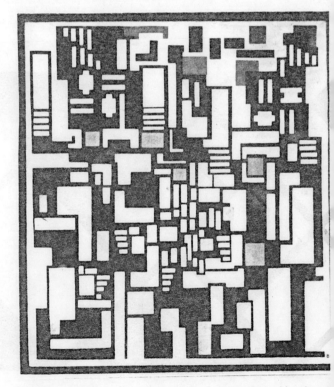

23 Theo van Doesburg. *Abstract version of 'Card-players' (Composition 9)*. 1917

Theo van Doesburg. *Composition II.* 1918

Theo van Doesburg. *Contra-composition of dissonances XVI.* 1925

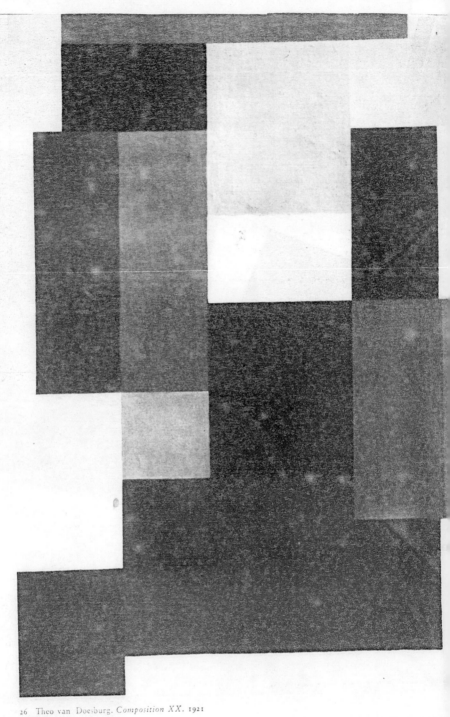

26 Theo van Doesburg. *Composition XX.* 1921

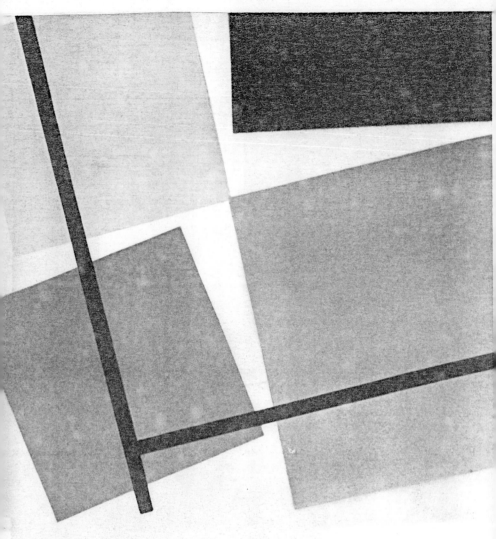

Theo van Doesburg. *Arithmetical composition.* 1929

with many gradations in the majority of works of art from the ideoplastic art of the Neolithic culture to Van Gogh. This stage of thought appears particularly suited to the production of art, which is to say at the same time that, in art, the intellect is the decisive factor.

Pure thought, in which there are no images deriving from actual phenomena, but in which there appear in their stead number, dimension, relationship and abstract line, is revealed through the intellect — as rationality — in Chinese, Greek and German philosophy and through the medium of beauty in the new plasticism of our own age.

The artist thinks in plastic relationships. The painter in colour, the sculptor in form, the architect in spatial relationships. It may be that these relationships are associated with naturalistic representation, but, in this case, such an association indicates the stage of thought and its effect upon the quality of the perceptive urge.

Since not everyone has reached the same stage of thought, it is obvious that it is possible to point to works in our age (and perhaps in every age) which project one of these three stages of thought, to the extent that the development of thought is reflected in art.

The question as to which stage of thought is the true one gives rise to conflict in all spheres of thought. This conflict will not cease until one of these stages is fulfilled, *i.e.*, when a new mode of thought gives guidance to the whole of life and to our attitude towards life.

All judgment or criticism of the revelation in plasticism of a cultivated mode of thought is of no value because (philosophical, aesthetic, religious, political, scientific) truth is externalized in time as real life.

October 1918 [*Vol. II. No. 2, pp. 23–24*]

Piet Mondrian

A Dialogue on Neoplasticism

A: A singer *B*: Neoplastic painter

A: I admire your earlier work. Because it means so much to me, I would like to understand your present way of painting better. I see nothing in these rectangles. What are you aiming at?

B: At nothing different than before. Both have the same intention but my latest work brings it out more clearly.

A: And what is that intention?

B: The plastic expression of relationships through oppositions of colour and line.

A: But didn't your earlier work represent nature?

B: I expressed myself by means of nature. But if you observe the sequence of my work carefully, you will see that it progressively abandoned the naturalistic appearance of things and increasingly emphasizes the plastic expression of relationships.

A: Do you find, then, that natural appearance interferes with the plastic expression of relationships?

B: You will agree that if two words are sung with the same strength, with the same emphasis, each weakens the other. One cannot express both natural appearance as we see it and plastic relationships, with the same determinateness. In naturalistic form, in naturalistic colour and in naturalistic line, plastic relationships are veiled. To be plastically expressed determinately, relationships can be represented only through colour and line *in themselves.* In the capriciousness of nature, form and colour are weakened by curvature and by the corporeality of things. To give the means of expression of painting their full value in my earlier work, I increasingly allowed colour and line to speak for themselves.

A: But how can colour and line in themselves, without the form we perceive in nature, represent anything determinately?

B: The plastic expression of colour and line alone is to establish *oppositions* by means of colour and line; and these oppositions express plastic relationship. Relationship is what I have always sought, and that is what all painting seeks to express.

A: But painting was always plastically expressed through nature, and elevated us to the ideal through the beauty of nature.

B: Yes, to the ideal through *the beauty* of nature; plastic expression of the ideal is quite another thing than the simple representation of natural appearance.

A: But doesn't the ideal exist only in us?

B: It exists in us and outside us. The ancients said that the Ideal is everywhere and in everything. In any case, the Ideal is plastically manifested aesthetically as beauty. But what did you mean a moment ago by 'the beauty of nature'?

A: I had in mind a statue containing all the beauty of the human form.

B: Well. Think for a moment of masterpieces of the so-called realistic schools which show none of this ideal beauty and nevertheless express beauty. Comparing these two types of art, you easily see that not only the beauty of nature but also its so-called ugliness can move us, or, as you say, elevate us toward the Ideal. Neither subject-matter, the representation, nor nature itself creates the beauty of painting. They merely establish the type of beauty that determines the *composition, the colour and the form.*

A: But that is not how a layman thinks of it, although what you say seems plausible. Nevertheless I cannot imagine relationships expressed otherwise than by means of some subject-matter or representation, and not just through a composition of colour and line alone; just as I can't appreciate sounds without melody — a sound-composition by one of our modern composers means nothing to me.

B: In painting you must first try to see *composition, colour and line,* and not the representation *as representation.* You will finally come to feel the subject-matter a hindrance.

A: When I recall your transitional work, where colour that was not true to nature to some extent destroyed the subject-matter, I do see more clearly that beauty can be created, in fact even more forcefully created, without verisimilitude. For those paintings gave me a far stronger aesthetic sensation than purely naturalistic painting. But surely the colour must have a form?

B: Form or the illusion of form; anyway, colour must be *clearly delimited* if it is to represent anything. In what you call my transitional work you rightly saw that the subject-matter was neutralized by a free expression of colour. But you must also see that its plastic expression was determined by form which still remained largely true to nature. To harmonize the colour and the form, the subject-matter of the painting — and therefore its form — was carefully selected. If I aimed, for instance, to express *vastness and extension,* the subject was *selected* with this in mind. The plastic idea took on various expressions, according to whether it was a dune landscape, or the sea, or a church that formed the subject. You remember my flowers: they too were carefully 'chosen' from the many varieties there are. Don't you find that they have yet 'another' expression than my seascapes, dunes and churches?

A: Indeed. To me the flowers conveyed something more intimate, as it

were; while the sea, dunes and churches spoke more directly of 'space'.

B: So you see the importance of form. A closed form, such as a flower, says something other than an open curved line as in the dunes, and something else again than the straight line of a church or the radiating petals of some other flowers. By comparing, you see that a particular form makes a particular impression, that line has a *plastic* power, and that the most tensed line most purely expresses immutability, strength and vastness.

A: But I still don't understand why you favour the straight line and have come entirely to exclude the curved.

B: In searching for an expression of vastness, I was led to seek the *greatest* tension: the straight line, because all curvature resolves into the straight, no place remains for the curved.

A: Did you come to this conclusion suddenly?

B: No, very gradually. First I abstracted the capricious then the freely curved, and finally the mathematically curved.

A: So it was through this abstracting that you came to exclude all naturalistic representation and subject-matter?

B: That's right, through the work itself. The theories I have just mentioned, concerning these exclusions, I developed afterwards. Consistent abstracting led me to completely exclude the visible-concrete from my plastic. In painting a tree, I progressively abstracted the curve; you can understand that very little 'tree' remained.

A: But can't the straight line represent a tree?

B: True. But now I see something is lacking in my explanation: abstraction *alone* is not enough to eliminate the naturalistic from painting. Line and colour must be composed *otherwise* than in nature.

A: You mean that what the painter calls composition also changes?

B: Yes, an entirely different composition more mathematical but not symmetrical — is needed to plastically express equilibrated relationship *purely*. Merely to express the natural with straight lines still remains *naturalistic* reproduction even though the effect is already much stronger.

A: But won't such abstracting and transformed composition make everything look alike?

B: That is a necessity rather than a hindrance, if we wish to plastically express what all things have in common instead of what sets them

apart. Thus the *particular*, which diverts us from what is essential, disappears: only the universal remains. The expression of objects gives way to a pure plastic expression of relationships.

[*Vol. II, No. 4, pp. 37–39*]

[contd]

A: It became clear to me from our talk yesterday that abstract painting grew out of naturalistic painting. I think I saw it more clearly because I know your earlier work. I gather that abstract painting is not just intellectual, but is as much the product of *feeling*?

B: Of both: deeper feeling and deeper intellect. When feeling is deepened, in my eyes it is destroyed. That is why the deeper emotion of Neoplasticism is so little understood. But one must *learn to see* abstract-real painting, just as the painter had to learn to create in an abstract-real way. It represents a process of life that is reflected in the plastic expression of art. People too often view the work of art as an object of *luxury*, something merely *pleasant*, even as a decoration — something that lies *outside* life. Yet art and life are *one*; art and life are both expressions of truth. If, for instance, we see that equilibrated relationships in society signify what is just, then one realizes that in art, too, the demands of life press forward when the spirit of the time is ready.

A: I am very sympathetic to the unity of art and life: yet *life* is the main thing.

B: All expressions of life — religion, social life, art, etc. — always have a common source. We should go into that further, but there is so much to say. Some have felt this strongly and it led one of us to found *De Stijl*.

A: I have seen *De Stijl*, but it was difficult for me to understand.

B: I recommend repeated reading. But the ideas that *De Stijl* expounds can give you no more than a *conception* of Neoplasticism and its connection with life: Neoplasticism's content must be *seen* in the *work itself*. To truly appreciate something new, one has to approach it with intuitive feeling, and one must look at it a great deal, and compare.

A: Perhaps so; but I feel that art will be much impoverished if the natural is completely eliminated.

B: How can its expression be impoverished if it conveys more clearly what is most essential and proper to the work of art?

A: But the *straight* line alone can say so little.

B: The straight line tells the truth, and the meaning you want it to have is of no value for painting; such significance is literary, didactic. Painting has to be purely *plastic*; and in order to achieve this, it must use plastic means that do not signify the individual. This justifies the use of rectangular colour-planes.

A: Does this hold for classical painting — in fact, for all previous painting — which has always represented appearance?

B: Indeed, if you really understood that all pure painting aimed to be purely plastic. Then the consequent application of this idea not only justifies *universal* plastic means, but *demands* it. Unintentionally, naturalistic painting gives too much prominence to the particular. The universal is what all art seeks to represent. Neoplasticism is justified, then, in relation to all painting.

A: But is Neoplasticism justified in relation to nature?

B: If you understood that the new plastic expresses the *essential* of everything, you would not ask that question. Art, moreover, is a duality of nature-and-man, and not nature *alone*. Man transforms nature according to his own image; when man expresses his deepest being, thus manifesting his *inwardness*, he must necessarily make natural appearance *more inward*.

A: You don't despise nature?

B: Far from it: for Neoplasticism too, nature is that great manifestation through which our deepest being is revealed and assumes concrete appearance.

A: Nevertheless, to *follow* nature seems to me the true path.

B: The appearance of nature is far stronger and much more beautiful than any *imitation* of it can ever be: if we wish to reflect nature fully we are compelled to find *another* plastic. Precisely for the sake of nature, of reality, we avoid its natural appearance.

A: But nature manifests itself in an infinite variety of forms; do you show nothing of this?

B: I see reality as *unity*; what is manifested in all its appearances is one and the same: the *immutable*. We try to plastically express this as purely as possible.

A: It seems reasonable to base oneself on the immutable: the changeable offers nothing to hold on to. But what do you call *immutable*?

B: *The plastic expression of immutable relationships: the relationship of two straight lines perpendicular to each other.*

A: Is there no danger of becoming *monotonous* by so consistently ex-pressing the immutable?

B: The danger exists, but the *artist* would create it, not the *plastic method*. Neoplastic has its *oppositions*, its *rhythm*, its *technique*, its *composition* — these not only give scope for the plastic expression of life, or movement, but they still contain so much of the changeable, that it is still difficult for the artist to find pure plastic expression of the immutable.

A: Nevertheless, in what little I have seen of Neoplasticism, I noticed just this monotony; I failed to experience the inspiration, the deep emotion that more naturalistic painting gives me..It is what I fail to hear in the compositions of modern music; as I said earlier, the recent melody-less tone-combinations fail to stir me as music with melody does.

B: But surely an equilibrated composition of pure tone-relationships should be able to stir one even more deeply.

A: How can you say that, not being a musician!

B: I can say it because — fundamentally — all art is one. Painting has shown me that the equilibrated composition of colour relationships ultimately surpasses naturalistic composition and naturalistic plastic — if the aim is to express equilibrium, harmony, *as purely as possible.*

A: I agree that the essence of art is the creation of *harmony*, but . . .

B: But harmony does not mean the same thing to everyone, and does not speak to everyone in the same way. That is why it is so easy to under-stand that there are differences in the methods of plastic expression.

A: Then this leaves room for naturalism in painting and melody in music. But do you mean they will be outgrown in the future?

B: The more purely we perceive harmony, the more purely will we plas-tically express relationships of colour and of sound: this seems logical to me.

A: So Neoplasticism is the end of painting?

B: Insofar as there can be — no purer plastic expression of equivalent relationships in art. Neoplastic was born only yesterday and has yet to reach its culmination.

A: Then it could become completely different?

B: Not completely. But in any case, Neoplastic could not return to naturalistic or form expression: for it grew out of these. It is bound to the fixed law of art which, as I said, is *the unity of man and nature.*

123

If in this duality Neoplasticism is to create *pure* relationships and therefore unity, it cannot allow the natural to predominate: therefore it must remain abstract.

A: I see more and more now that I thought of painting as representation of the visible, whereas it is possible in painting to express beauty in quite another way. Perhaps one day I will come to love Neoplasticism as you do, but so far . . .

B: If you see both naturalistic painting and Neoplasticism from a *purely plastic* point of view — that is, distinct from subject-matter or the expressive means — in both you will see but one thing: the plastic expression of relationship. If from the point of view of painting you can thus see beauty in one mode of expression, you will also see it in the other.

A: Let us go on with our conversation. So it is *reality* that you wish to express plastically — I thought you wanted to express the *soul of things.*

B: Actually neither. If we mean by reality the external, the *appearance* of things, then this cannot be expressed plastically by itself; for man also is *inwardness*, that is, both soul and spirit. Nor — because man is at the same time outwardness — can the inward be expressed *by itself.* Painting has always taken the middle way, *more or less:* but because it expressed itself through form, it revealed mainly the *life of the soul.*

The life of the soul is the life of human *feelings.* To plastically express the *soul of things* means to express our *soul.* And this is not the highest goal of art.

A: Is it not the soul that makes man *human?*

B: The *soul?* The sages speak of the soul of *animals.* It is spirit that makes man *human.* But the task of art is to express the *super*-human. It is intuition. It is pure expression of that incomprehensible force which is universally active, and that we can therefore call the *universal.*

A: But you place such high value on *consciousness?*

B: Certainly. But I said '*art* is intuition'; the *expression* of art must be conscious. Only when the mind consciously discerns the true nature of intuition can intuition act purely.

In *unconscious* man, the 'unconscious' is vague and clouded; in *conscious* man it has become more clearly determined. Only *conscious* man can purely mirror the universal: he can *consciously* become one with the universal, and so can *consciously transcend* the individual.

A: Can he thus become *objective,* so to speak?

B: Precisely. With our *unconscious* we always *subjectify* the universal. If we designate the universal as the spiritual, then pure spirituality is only possible insofar as we can become objective about ourselves and everything around us.

A: And the Primitives — isn't their art purely spiritual?

B: Yes, but only to the extent that the Primitives express spirituality through objective *plastic*, through *composition*, through *tension of form*, and through *relative purity of colour*. Because of its *subject-matter*, however, it remains *religious* art.

A: Wouldn't profane art, then be just as spiritual?

B: All true art is spiritual, no matter what subject-matter it represents. It reveals the spiritual, the universal, as I have said, by its *mode* of plastic expression.

A: I am now beginning to prefer spiritual art — the angels and the saints of the Primitives bore me; they strike me as too sentimental. I prefer realistic painting.

B: Realism has the advantage of *purer* objective vision, and I see realism as the basis of the new painting. As a man of our time, you prefer realism rather than the Primitives because you see the predominating inwardness of the latter. But it is also because you do not see it *plastically*; you see the *subject-matter* too much. I too, if I stood quite far from one of the paintings and could no longer perceive the composition, the tension of form and purity of colour — I assure you, I too would see only the floating robes and the folded hands. But don't forget that this art was created in a religious age: *an age of limited form*.

A: Then is their art as antiquated as the religion of that time?

B: The art, like the religion, is not outdated for all; but only for those who are conscious of a new era. Both religion-in-form and art-in-form are still *necessary* for most people today. Religion-in-form and art-in-form are not only expressions of life but are its means of development; like abstract-real painting, they exist for the *living* of life.

A: Were the Primitives right for their time, then, just as you think your ideas are right for the future?

B: Most assuredly. To the religion-of-form there corresponds an art-of-form: subject-matter was of prime importance at that time. But just as the spirit of the age, and therefore religion, became more *abstract*, subject-matter had to disappear.

A: We have returned to our starting point: subject-matter! I still cannot accept art without subject, but it is now clear to me that this depends on the spirit of the age.

B: Then you will have to agree that logically the age's changing consciousness can cause subject-matter to disappear. I repeat: when the spiritual was dominant as *religion*, the spiritual was strongly expressed as such; later, in a more secular age, the world itself had to be predominant in art. Once again, this took place through *subject-matter*.

A: Now you blame everything on subject-matter! But didn't you say that all art expresses the universal *despite* subject-matter — and therefore also *in* subject-matter?

B: I also said that in the art-of-form, subject-matter contributes to the expression of harmony insofar as 'subject-matter' contains the determinants of composition, colour and line. For the sake of clarity, I spoke only of our objection to subject-matter for our time. But I was going to add that, as the spiritual merged with the secular, it became more and more apparent that the spiritual did not dwell in the religious subject-matter exclusively; otherwise, with the decline of religious subjects, all spirituality would have gone out of art. The realization that subject-matter served only to determine composition, colour and line, led to an increasingly pure *aesthetic plastic* vision.

Consequently, subject-matter vanished completely, leaving pure composition in colour and line — and thus relationship — to plastically express both the spiritual and the natural. Neoplastic expresses both the spiritual and the natural. Neoplastic expresses a more equilibrated relationship of nature and spirit, in the sense of the universal. The universal plastic means is just as much outwardness, nature, as is natural appearance, or subject-matter of any kind. But by being outwardness interiorized to the maximum, it can most purely manifest the inward, the universal.

February 1919 [*Vol. II, No. 5, pp. 42–53*]

How often does one hear, when modern works of art are being inspected, the remark: 'They are just little blocks', or 'Someone who cannot paint can do it just as well.' That this is an unspiritual, newspaper criticism level of observation and not an aesthetic one will be clear to anyone who compares the two works illustrated. In B a rectangular mass is divided into rectangular blocks of differing size and shade. The blocks are placed coldly one against another, and one can everywhere trace the dividing lines with the finger. The primary rectangle has been so divided that the grey, white and black blocks form six vertical and five horizontal rows. The blocks are often identical in position and dimensions, the whole is stiff, flat and lacking in any expression.

In A, too, a rectangular mass is divided into rectangular blocks of differing size and shade, but the blocks are arranged together differently from B. The lines separating the blocks can be followed across the whole surface neither vertically nor horizontally. The blocks are not placed in a regular sequence above and beside each other as in B. Because of the constant changes of position and dimensions of the blocks it is not even possible to count how many rows there are vertically and horizontally. Consequently, the whole does not give a flat, stiff impression.

By what means is this difference brought about? Although the same means of expression — *i.e.*, blocks of differing size and shade — are employed in both works, the difference in the value of the two products arises from the fact that in A something finds expression through these blocks which is not the case in B. While in B a few blocks have been set down haphazardly, in A each block has its own position and its particular shade, determined by the creative intuition of the maker. This creative intuition, which determines the content of the work of art — balanced aesthetic relationship — is controlled during the process of painting by the mathematical consciousness by which the blocks are brought into a geometrical relationship with one another, and all the blocks combined with the whole, so that the relationship of the whole figure is repeated again in each individual block in the same relationship. In this way unity is created in diversity.

The same holds for the colour or shade. Each shade is applied in an equal

127

A B

 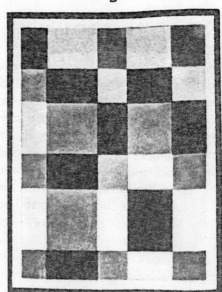

Vilmos Huszár. *Composition in grey.* 1918 *Uncomposed planes*

relationship, in a regular sequence from light to dark in the relationship
1-2-4, which again has the closest connection with the dimensional
relationship of the blocks. Thus the geometrical subdivision of the blocks
corresponds with the geometrical subdivision of the colours. In this way
a unity is created, a rational harmony through the geometrical relation-
ship of block to colour. Consequently, each block and each shade is given
a function to perform, the function being to contribute to the balanced
relationship and harmony of the whole. In A, therefore, there is harmony
which is not natural harmony, but artistic harmony (in this instance
painterly harmony), which is achieved by the consistently applied relation-
ship of one block to another, of one shade to another. It can be said of A,
therefore, that it lives through relationship; of B, on the other hand, that
it is dead because of lack of relationship. Thus one sees immediately, for
example, that black dominates and obtrudes, while in A nothing dominate
or obtrudes. In A the blocks are determinately established instead
bordered by one another, as in B. Although A appears flat, it does not app
flat in the sense that B does, as a useless piece of paper. In A, a cer
looseness and movement in space and, hence, a certain relief is

128

observed, which is completely lacking in B. B lacks space and therefore also relief. B is empty, lacking in space and lacking in movement. The relief in A is not natural relief, like that of a vase or a bowl, but a painterly relief.

That 'something' which finds expression in the blocks in A is that to which all art has wanted to give expression: namely, balanced relationship consistently applied to every part. Harmony. If ancient art did this naturalistically, that is to say, with the natural forms and colours of things, the new art does it artistically, *i.e.*, with the plastic means itself (in painting: masses, colours and lines). Indeed as long as one goes on seeing the masses in a modern painting as masses, one does not yet see what art is about and what it is that finds expression through the plastic means, namely, balanced relationship or harmony. Art is concerned, not with a natural, but with aesthetic harmony, *i.e.*, a harmony obtained through the mutual relationship of masses and colours, through the constant changing of position and dimension; and as ludicrous as it now appears to us that a painter should wish to give plastic expression to an aesthetic harmony in a painterly manner (*i.e.*, with masses), so ludicrous will it appear to posterity that we should have wished to do this in another manner, for example, through the external appearance of things, symbolic or literary. Every divergence from that external appearance which the visual artists of the past permitted themselves was a yielding to the creative need to transform a natural value into an artistic one. No matter which artist one chooses as an example, all have tried to make the object they painted subservient to the surface upon which they painted. All artists who were endowed with a creative faculty have felt the need to translate the subject into mass and relationship, but, because of tradition, this was not so easy. A whole culture of plastic values had to be gone through before art could be freed from all superfluity, *i.e.*, from everything which stood in the way of a purely plastic expression of the idea of art. This liberation could not occur without a radical destruction of the external appearance of things, beginning with the tautening of natural forms and ending beyond Cubism in a reconstruction of form and colour.

In this reconstruction according to the spirit, the new mode of plasticism finds its far-reaching cultural possibilities in every branch of art, industry and society.

The reason why the two works reproduced here differ so much from one another resides in this fact that A is preceded and permeated by the culture of painting, while B is only the material representation of the idea

which people have formed of the new mode of expression in painting: a few little blocks set beside each other, which anyone can do.

In spite of lack of contact of the mass of the people with the real spirit of the age and its modes of expression, those who have come, through work and understanding, into the possession of the true values of art will celebrate the festival of the new plasticism.

[*Vol. II, No. 4, pp. 42–44*]

Gerrit Th. Rietveld

Note on a Baby Chair

Proceeding from the familiar requirements — comfortable and firm to sit in, adjustable height, washable, not too strong and heavy — an attempt has been made to employ regularity as a clear plastic expression of the object itself, without extraneous detail. The wood is green, the straps are red, the pins which hold the straps in the holes in the wooden members are light

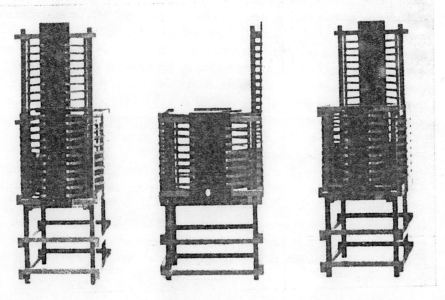

green. It is possible to hang a red leather cushion from the upper rail of the back rest. The little gate in front and the little table top are removable.

The ordinary dowelled joint, by which the post takes the rail, is still used for nearly everything. It is a very satisfying method of working and it is a fine thing to see, for example, a set of rails and posts with hole, peg and groove. Once the piece of furniture has been put together, however, no more is to be seen of this often very expensive jointing. This jointing sometimes gives rise to an unintentional plane surface. It is understandable that people should wish to emphasize this constructionally achieved form still more with decoration. The jointing employed here was an obvious choice because of its simplicity and clarity of expression. Moreover, it is particularly strong because the ends of the wood retain their full strength. It requires very little time to produce, which makes it appropriate to modern labour conditions. The greatest advantage is that it gives extreme freedom in the positioning of the rails, which achieve a greater expression of space, enabling one to break away from the constructionally tied plane surface.

[Vol. II, No. 9, p. 102]

De Stijl 1919 -1920

J. J. P. Oud

Orientation

When, spurred on by the expectations expressed on every side of an approaching unity in architecture, we try to arrive at the result of the various trends determining the picture of contemporary architecture, the outcome is less satisfactory than might appear.

We may thankfully note that formalism (the architecture of styles) has come to an end, and that architecture has again become a manifestation of creative life, but we must immediately add that this manifestation of life bears witness neither to an individual nor to a universal understanding of life. For, if we suppose the results of the various trends away from formalism synthesized into a single architectural manifestation, it will at once be apparent that this manifestation is no unfolding of the same attitude to life that is realized in early Classical purity in our daily life (and this comparison is permissible because technology and clothing, like architecture, arrive at beauty by way of utility), in locomotive and motor car, in electrical and sanitary goods, in machinery, in sportswear and men's clothing, etc. On the contrary, the old attitude towards life still appears to predominate and to be expressed in a romantic and baroque manner, while the necessity for the new form is recognized, but is not accepted in its practical consequences. The latter fact is very closely related to prevailing ideas about beauty in architecture. For as long as even in the most favourable instances beauty is equated with ornament and the slogan 'all ornament founded upon construction' has not been supplanted by its corollary that construction itself must achieve aesthetic form beyond its material necessities, for so long will the artistic beauty of the expressions of the socio-aesthetic spirit mentioned above continue to be denied and architecture will remain as something apart from the general impetus of the spirit of the age. For it is beyond all doubt that the motor car, machine, etc., correspond more closely to the socio-aesthetic tendencies of our own age and the future than do the contemporary manifestations of architecture. It is not

132

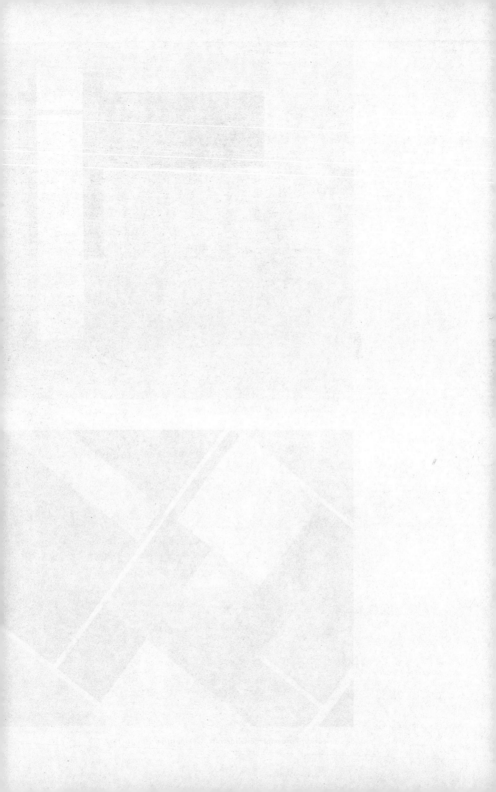

28　El Lissitzky. *Proun GBA No. 4.* c. 1923

29　Friedrich Vordemberge-Gildewart. *Composition No. 31.* 1927

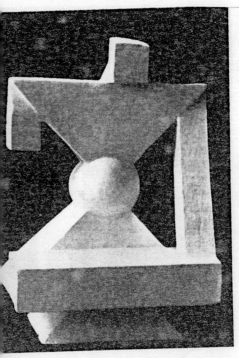

Georges Vantongerloo. *Construction in the sphere.* 1917

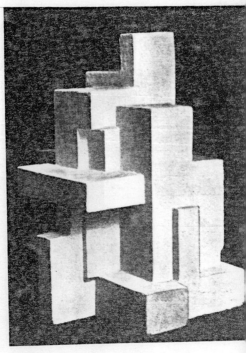

31 Georges Vantongerloo. *Composition.* 1924

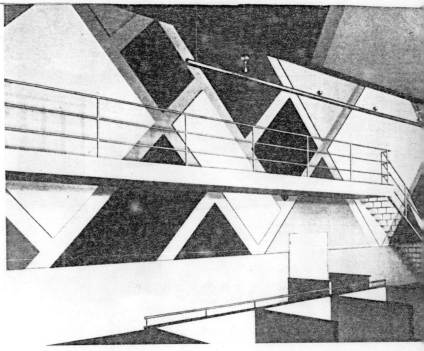

32　Theo van Doesburg. *Restaurant Aubette, Strasbourg.* 1928

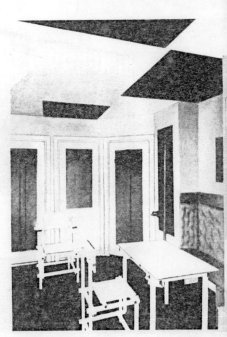

33　Theo van Doesburg. *Interior.* 1919 with furniture
by Gerrit Thomas Rietveld

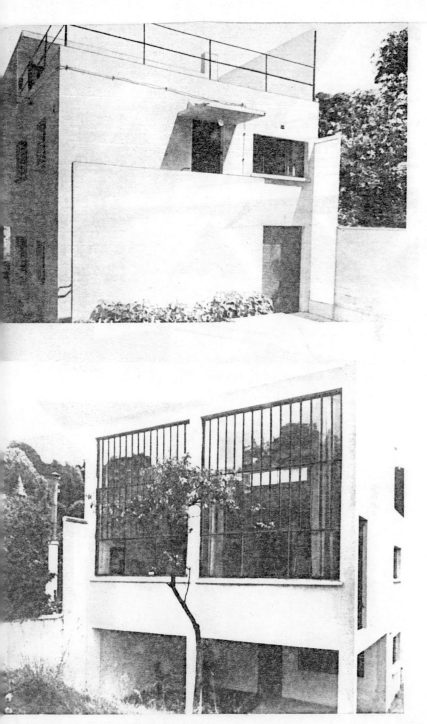

Theo van Doesburg. *House with studio, Meudon.* 1930

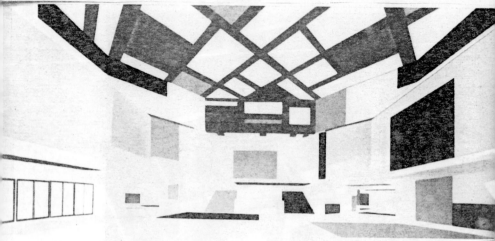

36 Theo van Doesburg and Cornelis van Eesteren. *Design for a hall in a university.* 1923

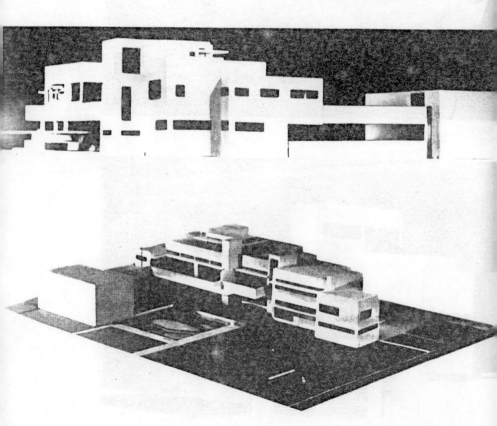

37–8 Theo van Doesburg – Cornelis van Eesteren – Gerrit Thomas Rietveld. *Project for private house.* 1923–4

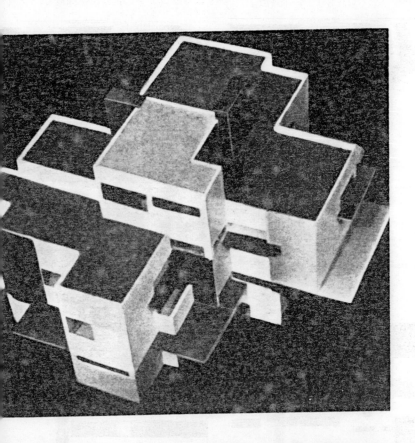

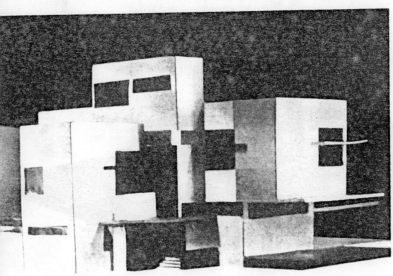

Theo van Doesburg and Cornelis van Eesteren. *Project for private house.* 1923

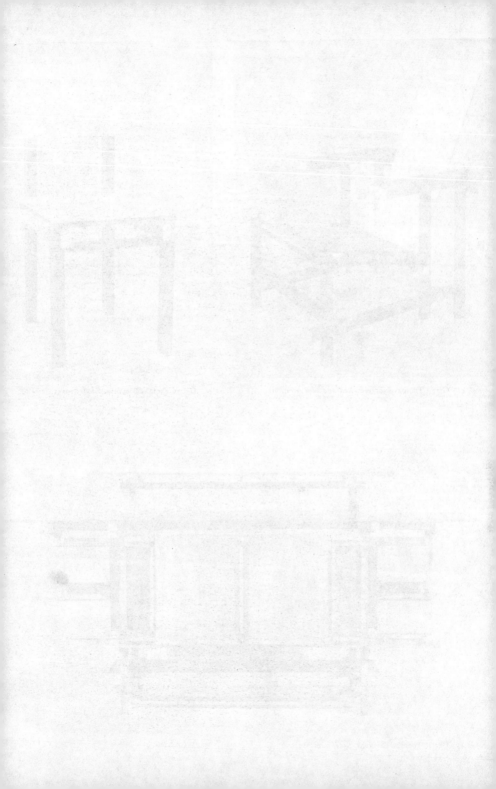

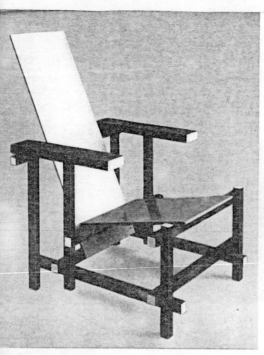

41 Gerrit Thomas Rietveld. *Red and blue armchair.* 1918

42 Gerrit Thomas Rietveld. *Chair.* 1923

43 Gerrit Thomas Rietveld. *Sideboard.* 1919

Gerrit Thomas Rietveld. *Consulting room for Dr. Hartog, Maarssen.* 1920

a question of denying their aesthetic value on the grounds of the fortuitous element in these expressions of social necessity, for the new concept of style itself is based upon the abolition of all separateness, in this instance, of art and utility. I quote in this connection from a technical article [in *De Nieuwe Amsterdammer*, 8 Nov. 1919] by J. Rozenraad: 'A worthy "pendant" of these prehistoric biplanes are the beastly, ugly Blackburn "Kangaroos". It is almost inconceivable that these visually offensive monstrosities should have seen the light of day in England, the country where they otherwise (in the technical field, too) have a good eye for line and form.' From this it appears, without prompting, that aesthetic considerations enter *a priori* into the determination of form and line of technical products. It cannot, therefore, be otherwise than that where precision of execution so greatly determines the final result, where each detail is there for a reason, and where feeling for relationship and form is a necessary element (consider, for example, the determination of the line of the hull in ships), a very pure understanding of form and relationship must be present.

The comparison made in one of his essays dealing with a visit to a Greek theatre by Henry van de Velde, the Belgian architect who abandoned his earlier baroque ideas in favour of more purely socio-aesthetic concepts, is therefore comprehensible and applicable to every age: 'Fools may say that the spirit from which Greek art arose is dead. The spirit that produced this theatre, with its surprisingly logical conception, seems to be even more logical today when all ornament is lacking. It is the same spirit that produced this wonderfully perfect object, the port-hole on the steamer that brought me here; the same spirit that invented the electric light bulb and the glass globe covering the gas lamp, the same spirit that made it possible to produce the butter knife we use on board, etc.'

It is indeed no longer the technical imperfection, 'the small imperfections of all works of man', as one of our architectural journals recently stated with approval, which brings about the aesthetic emotion, but precisely the miracle of technical perfection ('the grace of the machine') in bringing the aesthetic to determinate beauty.

Life and art have acquired in the present age a different, more abstract, accent, so that a more intimate contact exists between them than one might superficially be inclined to think. This can be seen in technology as well as in clothing. With regard to the latter, it is generally reputed to be ugly and lacking in aesthetic intention. Both assertions are superficial. It may be demonstrated on a cultural historical basis that the emphasis of beauty in

clothing has been displaced from the sensual attraction of jabot, ruff and frilly cuffs to the more spiritual attraction of severity of form and line. It speaks well for the value that is attached in clothing to this aesthetic intention that, after the quality of the material, it is especially the cut, *i.e.*, the aesthetic accent, that determines the price. That the aesthetic intention is not recognized in these and in so many other expressions of modern life is no proof, therefore, that it is not present. It might be said, with a variation on Nietzsche, that we live 'with the optical illusion that, where nothing is seen, nothing exists . . .'

Thus, in general, the accent no longer falls upon the sentimental, the clouded, the sensuously pleasing, but upon the internalized emotion, the clear, the spiritually moving, which is more difficult for the complicated man of today to comprehend. It is no longer sensuous values such as tone, ornament, etc., but more spiritual values such as relationship, clear form and pure colour, that must become the artistic means.

This heralds a beauty of a higher order in which, for example, the aesthetic value of a vase is determined by the purity of its relationships (within itself and in relation to the space enclosing it) and the tension of its bounding surfaces, and not on the basis of externally applied decoration, artificial technical imperfections or quasi-accidental mottling of the glaze; the aesthetic value of a building from the purity of its relationships, the clarity of the spatial expression by its masses, planes and lines, finally, by the tension of its constructional relief, and not by its ornament; the aesthetic value of painting, interior and exterior, by relationship in position and dimension of colour, finally, by the painterly conception or architecture (ceiling, wall, floor), and not in the painting of trees, cows, windmills; the aesthetic value of sculpture, as an object of use, interior and exterior, as chair, vase, stove, lamp-post, and not as ornament.

Seen in this light, the contemporary concept of art as a whole and that of architecture, in particular, is seen not to be keeping pace with socio-aesthetic development in general and to be in need of radical reform.

Theo van Doesburg

Painting by Giorgio de Chirico and a Chair by Rietveld

Difference and correspondence.
Difference in intention, in expression, in means.
Correspondence in metaphysical feeling and mathematical indication of spaces.
In both: spaces bounded by spaces.
Penetration of space.
Mystique of space.

In Chirico's painting, intentional — we nevertheless condemn every art with malice aforethought — in Rietveld's chair, unintentional, inevitable, clear, real:

A SLENDER SPATIAL ANIMAL

In Chirico's *Solutidine* (see Chirico Album No. 12): in the foreground mathematical man — controlling spaces and controlled by spaces. A spatial dimension symbolized by each plane, corner or point about, within or beside it.

SPATIAL ANATOMY

and, in contrast to mathematical man caught in the spatial web:
a sober open space with a factory and a rectangular pipe beside it.

Rietveld's chair: unintentional, but unpitying transformation of open space with, as contrast:

NECESSITY

SITTING

CHAIR

material limitation in contrast to rich, unconcealed and permanent plasticism of open spaces.

CHAIR

dumb eloquence as of a machine.

[*Vol. III, No. 5, p. 46*]

De Stijl 1921

Hans Richter

Principles of the Art of Motion

Explanatory note. The drawings reproduced show the principal stages of processes which are conceived to be in motion. The complete works will be realized on film. The process itself: creative evolutions and revolutions in the realm of the purely artistic (abstract forms); roughly analogous to the sounds of music in our ears. As in music the action (in a totally theoretical sense) is presented by pure material, and because all the material comparisons and associations have fallen away, it finds tensions and resolutions in the material, in an elemental, magical sense.

I *Genealogy (super-historical)*

(a) Cézanne, Derain and Picasso attempted, by scientific, intuitive methods, an analysis of natural objects, which resulted in the objective isolation of certain elementary relationships in form (and in the use of them in a single rhythm throughout the whole picture).

(b) While these artists experimented with the natural object and related their findings to it, the advances did not proceed from the object itself but from the pure relationships of the forms to each other ... This gives rise to the possibility not only of regarding painting as an art of planes, but of projecting it in time also.

(c) Cézanne, Derain and Picasso did not, however, arrive at the concept of real motion as the impetus of the visual arts. This was because, in spite of the principle of polar construction on which all their work is based, Derain and Cézanne emphasize verisimilitude and thus (although this emphasis is synthetic) tie themselves down to something which prohibits a clear recognition of the relationships of the forms (which would lead to motion). For his part Picasso dissolves the natural object in the light of the pure formal relationships and thereby achieves new freedoms, but not of such consequence and rhythmic unity (synthesis) as Cézanne and Derain.

(d) For reasons of this kind these painters were unable to recognize the problem of time. Only through the synthetic resolution of formal relation-

ships which are based, not on nature, but on a polar, rhythmic principle of vision (where rhythm includes all its sub-divisions); only so did Viking Eggeling recognize the possibility of extending rhythmic actions in time and thus discover a new art form.

II *Continuo*

The 'language' (language of form) 'spoken' here is based on an 'alphabet' which arises from an elementary principle of observation: polarity.

Polarity as a general principle = compositional method of every expression of form. Proportion, rhythm, number, intensity, position, sound, tempo, etc. Empirically it is the contrasting relationship of counterparts, large and small; spiritually, the analogy relationship of things which differ from each other in other spheres. Creative exchange and logical similarity and dissimilarity in the concept of the work in question.

The great will and the visible goal of these works is not confined in them.

The aesthetic principles of the alphabet point the way to the total work of art because these principles, which the artist uses synthetically, undogmatically, apply not only to painting but equally to music, speech, dance, architecture, drama. The concept of a culture as the totality of all creative forces growing from a common root to an endless, multifarious form (not addition, but synthesis).

III *Definition of art*

(a) Transcendental definition: Art = human urge to create. As such, the individual's means of giving himself a significance in the transcendental world. (Super-individual = striving towards the transcendental.) Art serves the realization of a higher unity: the idea of man in humanity: the bringing to perfection of the individual in a higher form of organization. The 'whole', humanity = synthesis of the individual (constructive principle).

The will to reach this goal is an ethical requirement. Ethics are based on the belief that we are capable of a more perfect existence, and postulate that we behave in accordance with this belief: a total ethic (as opposed to a religious or philosophical ethic) requires that we act 'toward totality'.

The creative relationship between the individual and the unity which contains him is synthetic; a logical relationship, creative, non-mathematical in kind. Singularity of the multifarious, meaningful relationship of the contrasts in analogies (polar synthesis).

145

If human creativity (insofar as it is capable of synthesis) obtains significance from the idea of a total 'existence' then 'synthesis' is the distinguishing mark of transcendental purpose.

The result of recognizing this = the fostering of this creativity which leads to the unity of all creative expressions of mankind — culture.

(b) Practical definition: utmost economy of means. Only a true discipline of the elements and the most elemental application of them, allows for further construction on that foundation. One thing must be stressed again and again: art is not the subjective explosion of one individual, but an organic language of humanity with the most serious meaning, and must therefore, in its basic elements, be so free of error and so lapidary that it can really be used as such, as the language of mankind. It is a mistake to believe that the significance of art lies in individual achievement; rather, art itself imposes upon the individual the general obligation to devote that part of his work which is subject to the will to the construction and enrichment of this very thought. The imposition of this scientific problem is not so much a restriction of the intuition (from which, ultimately, artistic activity springs) as its most basic material. Inspiration is indeed the first essential of a work of art, but the power to control the components is the necessary condition of completing one.

(c) Critical relationship. As the language of the psyche = (art) has a more penetrating effect on people because it is less hedged about with conditions than the world of concepts, to which the misuse of the word has made us almost completely deaf, in the same way, a realistic — not a sentimental — kind of investigation and sifting of all the fundamentals of the language of art is of decisive importance for critical judgment.

Appendix. There can be no doubt that the cinema, as the new sphere of operation for creative artists, will quickly be in great demand for the production of works of art. It is therefore all the more important to point out that a simple string of forms one after another is meaningless in itself, and that it can only be given meaning by art (as defined above). It is absolutely essential for this new art to be composed of clear, unambiguous elements. Without them it might well develop as a game — even a highly seductive game — but never as a language.

[*Vol. IV, No. 7, pp. 109–112*]

A new world plasticism has now begun.

The capitalists are deceivers, but the socialists are equally deceivers. The former want to possess, so also do the latter. The former want to swallow up much money, many people and much rump steak, but the latter wish to swallow up the former. Which is worse? Will they be successful? *We are completely unconcerned.*

We know only this one thing: only the bearers of the (new) spirit are upright, they want only to *give*. Disinterestedly. They are emerging from among all people, in every land. They are free of deceitful phrases: they do not address each other as 'brother', 'master' or 'Comrade'. A spiritual language is again being spoken and in this language they understand one another.

The bearers of the new spirit of the age do not form a sect, church or school.

In the old world spiritual concentration (Christ) and material concentration (capitalism) were the possession, the axis around which the whole nation developed. *Now the spirit has been dispersed.* In spite of that, the bearers of the spirit are joined together. Internally.

There is no longer any help for Europe. Concentration and possession, spiritual and material individualism were the foundations of the old Europe. It imprisoned itself in them. It can no longer escape from them. It is going to ruin. We look on calmly. Even if we were able to do so, we should not wish to help. We do not wish to prolong this old prostitute's life.

Already a new Europe has begun in us. The ludicrous socialist -1-2-3 Internationals were only external; they consisted only of words. The international of the spirit is *internal*, unexpressed. It does not consist of words, but of creative deeds and internal force. Spiritual force. With this, a new world order is being formed.

We do not call to the nations 'Unite' or 'Join with us'. *We do not proclaim anything to the nations. We know that those who join us belong from the beginning to the new spirit. With them alone does the spiritual body of the new world permit itself to be formed. Work!*

[*Vol. IV, No. 8, pp. 124–125*]

De Stijl 1922

Theo van Doesburg

The Will to Style: The reconstruction of life, art and technology

(Text of a lecture given at Jena, Weimar and Berlin)

The problem of art occupies a prominent position beside the problem of the economic reconstruction of Europe. I do not propose to go into the question of how far the two problems are interrelated; the only thing that we can be sure of is that the solving of the economic problem, like that of the artistic problem, is beyond the abilities of any one individual, and this fact is an advantage. Because it means that the pre-eminence of the individual, the Renaissance view of life, has come to an end.

In politics, as in art, only collective solutions can have decisive significance.

If we only use our eyes to look at the total picture of life today we may come to the conclusion that it is a picture of chaos, and we cannot be surprised if those who feel ill at ease in this apparent chaos attempt to escape from the world or lose themselves in theoretical abstractions. But we must be quite clear that flight from reality is as great a mistake as reliance on pure materialism. We will not find any solutions in escape to the Middle Ages, nor in the re-erection of Olympus which is recommended by some art-historians. For proper understanding of the challenge of our age we must comprehend the structure of life, not just with our eyes but rather with our inner senses. Once we have wrested the synthesis of life from the depths of our being and recognized it as the substance of culture and art, it will not be hard for us, with a ready supply of documentary evidence from the past, to approach the solution of the problem. We are not the first to struggle for a solution of the problem of art: it has been the struggle of many generations. The proof of that can be found in all the significant works of art in our heritage. However different these expressions of artistic endeavour may seem to our optic sense, our inner senses recognize every human creation to be only the upper

148

surface of a battle waged in our very being. Not waged in art, science, philosophy and religion alone, but in our daily life where it takes the form of the struggle for spiritual and material existence.

What is the nature of this struggle?

Every work of art, of the past or of the present, provides an answer.

This conflict, which has its foundations in the structure of life, is a conflict between two polar forces. You may call them Nature and Spirit, or the Feminine and Masculine principles, Negative and Positive, Static and Dynamic, Horizontal and Vertical — they are the invariable elements in which the contradictions of our existence are rooted and which can be seen in variability. To bring about an end to the conflict, a reconciliation of the extremes, an agreement between the polarities — that is the stuff of life, the basic object of art. This reconciliation, which appears in art as harmony or vital repose, contains in itself the criterion for the essential significance of every work of art; not indeed for a work of art as an individual expression, but for art as the collective expression of a race, for a style. Every civilization has had to contend with these fundamental truths. The characteristic physiognomy of every period in art history shows how far people succeeded in creating an expression, a style, a balance between the extremes I have listed. In one civilization the natural element, spontaneity, will dominate, in another the spiritual element, contemplation. Only rarely is this duality brought under control and a balance achieved.

To explain this more clearly I have made a simple diagram, in which I have laid out synthetically the various civilizations from the Egyptians to the present day.

As I explained in detail in my lecture *Classique, Baroque, Moderne*, instead of the theory of rise, expansion and decline, I prefer the concept of a continuous evolution. This continuous evolution is one of the spirit in life and art, but in space and time it takes the form of rise, expansion and decline.

This leads to the conclusion that every new growth contains the seeds of decline, but every decline offers the possibility of a new rise.

Never, anywhere, is there an ending.

The process is unceasing.

The whole system of evolution depends on increasing spiritual depth, which causes a revaluation of all values.

In this short exposition I have summarized the fundamentals of my theory of art. Now I come to my diagram, which is shown here.

natural

Spiritual

The two horizontal lines represent the polarities of nature, at the top, and spirit, at the bottom, at their furthest extremes. The gradual reconciliation of these two forces is shown by the triangle, which contains the types of cultural development. The letters, from right to left, signify as follows: E = Egyptians, G = Greeks, R = Romans, M = Middle Ages, R = Renaissance, B = Baroque, B = Biedermeier, IR = Idealism and Reform, NG = Neoplasticism (*Neue Gestaltung*), the epoch which is beginning now. The hatched central line represents the golden mean, the absolute identity of the dual forces of nature and spirit. (Continuous evolution.)

The zig-zag line within the triangle represents the actual position *vis-à-vis* the polarities occupied by the artistic and cultural life of each epoch in turn.

The Egyptians achieved the identity of them, the golden mean in the manifestations of their culture, in their art. The same is true of the Greeks.

With the Romans we can see a sharp divergence towards the natural, while in the following era, the Middle Ages, the exact opposite happens, a trend towards the spiritual.

The Renaissance approaches the natural once more and the Baroque age moves even further in the same direction. The art of the post-Romantic period shows a far better balance; in the period of Idealism there is again a move towards the spiritual — and now, in the age of reconstruction, of Neoplasticism, we have arrived on the path of identity between nature of spirit. (Cessation of polarity.) We have only to look deep into the essence of philosophies and religions, which differ from each other only in their forms, to discover these concepts of polarity as the meaning of life.

150

They are the symbolic representation of a truth, which it is our task to make real, and perhaps no other age has given so precise an expression to the conflict between nature and spirit as our own. This has nothing to do with what we understand by nature and spirit in a philosophical context. It is enough if, in the reality of our own existence, we recognize two principles, each complementing the other, as the substance of all our actions.

In the art of the past these principles were veiled, as in nature, where they are concealed in various outer forms. Not only the artist, but also the philosopher and scientist were concerned to discover the essence of the being behind these forms, and to cast it in a new shape. This explains why the simple imitation of outer forms has nothing to do with art. Every artist — of the past or not — tries by his expressive medium to establish the balance between two extremes, going beyond nature or outer form. Every great art, whether the art of an individual or a collective art, a style, expresses this balance as harmony or repose (example: Egyptian sculpture).

But this repose of harmony cannot be won without a struggle. This struggle, which is revealed by creative activity, proves that the spiritual power recognizes nature as its own other part, as its contrast. Thus the relationship of the artist to the world within and around him is a relationship of contrast.

I thought it necessary to begin my lecture with this short metaphysical introduction in order to explain the true relationship of the artist to nature. The great difference between the artists of the past and the artists of the present is that the latter are fully aware of this relationship. They exist in the world as conscious creators, while the old artists, who honoured the unconscious, were forced to rely on an intuitive, animal spontaneity. Feeling lends the strongest impetus to their work, taking the form of a tragic figure (example: Sasetto [Sienese school] *John the Baptist*). Tragedy is the most powerful expression of the cause of struggle, that is, of the will to overcome nature. The tragic in art is the psychological expression of imperfect man, torn by his belief that the great contrasts which he thought of primitively as the here and the hereafter, as heaven and earth, as good and evil, could never be brought into complete harmony.

If imperfect man expressed the one weighty, earth-bound extreme in the tragic, he attempted to express the other buoyant, celestial extreme by the freedom of the angelic (example Fra Angelico: *Rising Angel*). He

could express the reconciliation between the extremes only by a symbol, for example, by the Ascension of Christ (example: Grünewald, *The Ascension*). This explains the persistence of the Christian tragedy as a subject of art until well into the Renaissance, in spite of the doubts cast on a predominantly spiritual and symbolic view of life by the clinical freshness of science and philosophy. We must be clear that in all these works of art of the past the synthesis of life is shown by an image, never as a plastic form.

An image is an indirect symbol, represented by an analogy.

Plastic form is a direct expression, arising out of the characteristics of the artistic medium (example: Mondrian, *Composition 1921*). The difference between expressing the substance of life by indirect, secondary means and by direct, primary means, between an image and a plastic form, gives us a clear picture of the precise difference between old and new. We can regard everything that falls between these two means of artistic expression, like Romanticism, Impressionism, Cubism, Futurism, Expressionism, Purism, etc. as Experimentalism (examples from Romanticism to Purism: Daumier, Monet, Picasso, Severini, Kandinsky and Marc, Ozenfant). These forms of expression, which show very clearly the struggle for a new balance, a new harmony in the polar elements of life, were experimental because their dominant feature was the spontaneity of nature, though in an abstract form. For this reason it was quite impossible for them to produce a general, architectonic, organically constructive, artistic statement. Although these experimental forms expressed above all the need to get rid of traditional imagery, they were not able to forge a universal collectivist form of expression, not able to create a style. The chief proof of this is the lack of any fundamental creative principles in the works of art. They are necessarily lacking because the impetus for these works came from the sensations of individuals. Moreover, the common subject even of these experimental art movements was still the tragic, although expressed in abstract, lyrical forms.

The basic motive force of these experimental artistic modes of expression is an imperfect concept of the dualism of life between feeling and intellect. Neither feeling nor intellect singly can give us the solution to the problem of art. The great value of the experimental movements is that they discovered the power of pure means of expression: colour in painting, mass in sculpture, space in architecture, pure sounds in music, and so on. By doing this they did away with the dichotomy of form and

Werner Graeff. *Motorcycle construction*

content. In order to get a clear insight into the problem of art it is necessary for us to study the works of art of the past for evidence of how the substance of life is translated in the artistic composition. This substance is expressed by an image or is veiled, illusory.

Generally the composition divides the picture into three: a central part, or compositional axis, and right and left halves (example: Grünewald, *The Crucifixion*). This practice of dividing the picture into three is most prevalent and conscious during the Renaissance (example: Raphael, *Three Graces*). The axis or centre of the composition links the two halves together, giving rise to a certain symmetry. As a result the overwhelming impression made by the work is static. This is the beginning of the architectonic outlook which dominates all art today. Life itself, however, is not only static but dynamic, not just constructive but destructive; it contains both extremes. Baroque art, with its dynamic power, is a reaction against the static (example: Michelangelo, *God Creating the Earth*). Let us leave the nations where the plastic elements dominate and turn to those nations where the painterly elements are most prominent. If we look at Rembrandt, for example, we find polarity—the contrasts between light and darkness (example: Rembrandt, *The Jewish Bride*). In the example I have chosen here

153

the synthesis of life is even more strongly expressed by visual presentation. And in relation to my thesis, this painting by Rembrandt takes on the significance of a supra-national creative urge. Even at this stage in the development of painting the secondary elements of the picture (that is, the subject-matter) have become the primary formal elements; in other words, the objects depicted are subordinated to the artistic composition. In Impressionism the principle found in Rembrandt's work has become a system (example: Manet, *Le Déjeuner sur l'herbe*). The subject-matter becomes even less important; in place of Rembrandt's contrasts of light, Manet gives us colour contrasts. The emphasis on contrasts became more and more pronounced, as you can see most clearly in this painting by Manet, in which the whole composition is characterized by the effect of the constant alternation of light and dark colours. The creative urge of later periods in art history which breaks down national boundaries, proves to my mind the existence of a universal artistic need for plastic form, which is present in earlier periods, but less asserted. With Van Gogh the struggle for immediacy of expression becomes very fierce (example: Van Gogh, *L'Arlésienne*). With brutal certainty he is forcing his own experience of contrast on to the canvas. Using an enclosed, rigid, formal structure, he is attempting to overcome the duality, to effect a balance between the static and the dynamic, and to transmit the spirit in the material. But it was impossible to overcome this duality (the opposing concepts which tore the imperfect man of the past) without first destroying the illusion of nature, without bursting open enclosed forms, without overcoming form altogether. From now on, closed form was recognized as an obstacle to the new search for style. In the work of artists since Van Gogh, for instance in the work of Van der Leck and Picasso (examples: (a) *Beggar* and (b) *Harlequin*), form is deliberately altered and subordinated to the surface composition. With this development the surface of the picture, which up till now had always been treated in a negative way, obtains its real significance.

As a result of the scientific and technical widening of vision a new and important problem has arisen in painting and sculpture beside the problem of space, and that is the problem of time. In earlier periods in art history the problem of space was dealt with by arranging forms next to each other in perspective; similarly an advance towards the solution of the problem of time was made by placing figures one after another. Exact expression, a true balance between the impetus of space and time, was

made possible only by mechanization of the surface of the picture. The process of mechanizing the picture surface was prepared for by several different artists, such as Rousseau and Van der Leck (examples: (a) *Bridge* and (b) *Column of Artillery*).

The surface of a picture is predominantly horizontal; on it the artist's sense of time is expressed by emphasizing a sequence, by repeating a particular *motif*.

Of course, in emphasizing time by rhythmic repetition the emphasis of three-dimensional perspective is lost. Nonetheless, time here is still represented naturally, not artistically, that is, created rhythmically by purely painterly means. I have used these different examples only to show you that these problems, the problems of plane and colour, of space, time and mechanization, were already present in pre-architectonic art. In my opinion what we understand by new art is not something startling and novel, but the result of that creative urge which has been felt by every artist. In the art of the past all the creative elements were obscured by natural representation. The most recent generations of artists have discovered them anew and are using them, ignoring everything which stands in the way of a monumental synthesis.

In the new plastic art the expressive impulses become more profound, abstract, and are allied to architecture. The struggle for an elemental style with elemental means which I have briefly described, takes a path parallel to that of the progressive development of technology. From the most primitive tools of the Stone Age (example: primitive drill) there has developed the electrical machine, perfect in its form and in its function (example: latest model of drill). In the same way the primitive drawings of the Stone Age have developed into the elemental works of art of our own age.

Where these two lines of development (the technical and the artistic) meet in our age the application of the machine to the new style is a matter of course. The machine is the purest example of balance between the static and the dynamic, between intellect and instinct. If culture in the broadest sense really means independence of nature, it is no wonder that the machine takes pride of place in the concept of cultural style. The machine is the supreme example of intellectual discipline. Materialism, as a philosophy of life and art, considered hand craftsmanship to be the purest expression of the soul.

The new spiritual philosophy of art not only saw at once its limit-

less potentialities for artistic expression. For a style which is no longer concerned with the production of individual pictures, ornaments or private houses, but makes a collective assault on whole districts of cities, sky-scraper blocks and airports, with due consideration of the economic circum-stances — for such a style there can be no question of employing hand craftsmanship. The machine is all-important here: hand craftsmanship is appropriate to an individualistic view of life which has been overtaken by progress. Hand craftsmanship, in the age of materialist philosophy, debased man to a machine; the machine, used properly in the service of cultural construction, is the only means of bringing about the converse: social liberation. This is by no means to say that mechanical production is the only requirement for creative perfection. A prerequisite for the correct use of machines is not quantity alone but, above all, quality. To serve artistic ends the use of machines must be governed by the artistic conscious-ness.

The needs of our age, both ideal and practical, demand constructive certainty. Only the machine can provide this constructive certainty. The new potentialities of the machine have given rise to an aesthetic theory appropriate to our age, which I have had occasion to call the 'mechanical aesthetic'. Those who believe that the spirit will only overcome nature in some sphere beyond the boundaries of reality will perhaps never admit that the general form of our life today provides the necessary condition for a style of life and art in which the religious truths which transcend the indivi-dual can be realized. The style which we are approaching will be, above all, a style of liberation and vital repose. This style, far removed from romantic vagueness, from decorative idiosyncrasy and animal spontaneity, will be a style of heroic monumentality (example: American grain silo). I should like to call this style, in contrast to all the styles of the past, the style of the perfect man, that is, the style in which the great opposites are reconciled. All the things which were known as magic, the spirit, love, etc., will be made real by it. The marvels which so delighted primitive man can be realized by electric current, by mechanized control of air and water, by technological conquest of space and time. The more influence new developments have upon our life and our art, the more marked are the contrasts of old and new. These violent contrasts simply would not exist if the new had completely replaced the old. But as the old concept of art continues to exist in every age — even today — the characteristics of both concepts of life emerge.

156

Let me give you some examples of the characteristics of the new style in apposition to those of the old.

Certainty instead of uncertainty.
Openness instead of enclosure.
Clarity instead of vagueness.
Religious energy instead of faith and religious authority.
Truth instead of beauty.
Simplicity instead of complexity.
Relationship instead of form.
Synthesis instead of analysis.
Logical construction instead of lyrical constellation.
Mechanization instead of manual work.
Plastic form instead of imitation and decorative ornamentation,
Collectivism instead of individualism, etc.

The urge to establish the new style is seen in numerous phenomena. Not only in painting, sculpture and architecture, in literature, jazz and the cinema, but most significantly of all in purely utilitarian production.

All those various artefacts which serve a particular purpose do not start out with any artistic intentions. And yet they move us by their beauty. Iron bridges, for instance, create an ornamental effect by the rhythm with which their various parts are conjoined. This is brought about not only by painstakingly exact calculation but by an instinctive awareness of harmonious relationships: (example: an iron bridge). No ornamentation, nothing superfluous, nothing artistic in the sense of little decorative touches added as an afterthought. Only the truthfulness of the thing itself. Its truth, its function, its construction before anything else. No weakness deriving from individualistic theorizing.

In all these objects (whether iron bridges, railway engines, cars, telescopes, farmhouses, aeroplane hangers, chimneys, skyscrapers, or children's toys) we can see the urgings of the new style. They show exactly the same endeavour as the new creations in the realm of art to express the truth of the object in clarity and purity of form. So it is not surprising that the beauty of machinery is the very core of inspiration for the newest generation of artists.

Art is a game and games have their rules. Just as earlier generations of artists played with nature, so modern artists, for example the Dadaists, are playing with the machine (example: Man Ray, *Danger*).

159

You will know just how the mechanical control of the forces of nature and the conquest of space and time affect our daily lives if you have ever used the telegraph, the telephone, an express train, a car, an aeroplane, and so on.

Gradually the old dream of primitive man, to become master of his world, is being realized. By perfecting his control over the cosmic forces, primitive, mythbound man is becoming cosmic man.

The most recent inventions, for instance the portable telephone in a hat invented by the American Frank Chamber, show us to some extent how far the potentialities in the realm of control of cosmic forces can go. It is remarkable that the main concern of the younger generation in Europe and even in America is to solve the problem in art and technology. The direction taken by painting, by Cubism in particular, will run through all the arts like a scarlet thread in the course of this century. As this direction is essentially constructive and architectonic it would not be surprising if the conjunction of the different visual arts were to produce the solution. We can only expect to find the solution in monumental synthesis. A development of this kind has already been under way for many years in architecture.

A number of architects (Viollet-le-Duc, Peter Behrens, Berlage, Van de Velde) have purified architectural conventions and freed them of the leaning towards superfluous decoration.

Architectonic plasticism will evolve from the functional needs which determine the division of the space. The interior ought to determine the shape of the exterior. In this way architecture has found its own expressive medium again. I will show you some examples to illustrate the contrast between decorative and monumental architecture. In this first picture (the Zwinger in Dresden) the clutter of decorative sculpture destroys the architectonic plasticism. The next picture (house by Van 't Hoff) shows a clear plasticism created by purely architectural means. With this building all the external features are the result of internal features. Every spatial unit within the house can be perceived from the outside. No pointed gables. No merging with the landscape, and yet it gives ideal form to a vital repose which transcends nature.

This next example (Münster Town Hall) shows a façade where all the architectural emphasis is concentrated on the gable. I call this two-dimensional architecture. The gable is, for the most part, an empty front, not a necessary result of the inner structure.

This two-dimensional architecture of façades is all very well for painters; an architect's task is to master three-dimensional space by a proper proportional division of the total space. The four sides must be comprehended within one monumental shape. The *Allegonda*, by Kamerlingh Onnes and Oud, gives an idea of the architectonic principles of our age. Architecture today faces difficult problems. Obviously the planning of a whole urban area presents quite different problems from a single building. But even large-scale planning permits a satisfactory solution in keeping with the plastic style of our age. The stylistic principles of Pauw and Hardeveld's housing complex in Rotterdam are the same as those of the aeroplane on the direct Prague-Paris service.

The next picture (hotel in Woerden by J. Wils) shows a solution to the problem of building on two sides of a square, where the emphasis on projection and depth creates a fine plastic effect. The chimney in the middle serves as an axis to the whole design without resulting in symmetry. The repeated interruption of cubic masses gives a rhythm to the space which can also be seen in the next group, of office buildings. Here the shapes of the rooms are determined by their function, and in turn determine the external construction of the building. If we turn now from outer architectonic appearances to interiors, we see in this picture how a common monumental intention which unites architect and painter can produce a formal clarity in the room (Wils and Huszár: Bersenbrugge Atelier, The Hague). In contrast to baroque decoration the painting strengthens the architecture instead of destroying it. I am sorry that I can only show these interiors in black and white. The effect of the colours in their spatial relationships and the unity of furniture, curtains and carpets have been set off against each other so harmoniously that the result is not just artistic but ethical. Only a truly artistic use of colours in space can bring about this harmony. In modern architecture the problem of colour and space is the most important, indeed it is the most difficult problem of our age. In my opinion the solution will be found only in a monumental synthesis. A reconciliation between impulses of space and time can be effected only in chromo-plasticism, that is, in treating three-dimensional space as a painter's composition. As early as 1916 modern Dutch architecture began to tackle this task. And monumental painters have rediscovered their true purpose in this: to introduce painting into architecture. The next two pictures (one shows a bedroom, the other a small consulting room) give you an example of chromo-plasticism; simplicity, clarity and vital

repose are the most important rules for the creation of monumental synthesis. The same concepts are expressed by this Rietveld armchair, whose simple construction gives harmonious shape to the function of sitting. The same stage of development now being approached by technology, architecture and painting was reached long ago by sculpture. Three examples will explain. The first picture is an example of anti-artistic sentimentality, dominated not by artistic considerations but by physical externals. Photographic plastic detail (Professor Seger, *Dance*). Instead of original form the imitation of nature. A pretence of rhythm without any spatial relationship.

Secondly, naturalistic sculpture, emphasizing the duality of matter and form, accentuating rhythm by physical poise and counterpoise, but again without a reconciliation between form and space (Rodin, *L'Idole*).

Thirdly, the union of open space and the enclosed form given to trans-cendental repose (example: Archipenko). Great similarity to the perfect shapes produced by and for modern industry (example: porcelain retort).

Efforts are also being made to perfect this modern art of movement in film. Here too the new artistic form is being created from the combining of the impetus of time and space (example: V. Eggeling and Hans Richter).

At the top and bottom you can see three separate instants of two *motifs* in an abstract filmic composition. Film techniques of light and movement give the *motifs* their artistic form by simultaneously juxtaposing them in space and time.

Using film techniques in the painting of pure form gives the art a new ability: the artistic solution of the dichotomy of static and dynamic, of spatial and temporal elements, a fitting solution to the artistic needs of our time.

What I have shown here to be the beginnings of Neoplasticism in art and technology has nothing to do with expressionistic anarchy. In the face of aggressive impulses, the new style requires a synthesis which transcends individuality, a harmonious union of all the arts. If the arts of the past and the present are as perfect as they can be, it can be claimed that the future monumental art will unite all that is best and most signifi-cant in our practical and ideal achievements in a great harmony.

The demand for this monumental synthesis, using purely artistic means, was first made by the group of Dutch artists known as the De Stijl group, and the examples of architecture, sculpture and painting which I have shown you were all produced in Holland by this group.

This merging of art and life signifies nothing less than the spiritual reconstruction of Europe.

The striving for pure monumental creation is revealed in music too, and I will show the next pictures with the support of pure musical compositions. (Musical examples: Jacob van Domselaer. Neoplastic examples: Mondrian, Van Doesburg, Vantongerloo, Rietveld, Van 't Hoff.)

The musical compositions of Jacob van Domselaer are based on the same principles: musical, harmonic creation using the relationships of pure sounds to soundlessness.

<div align="right">

[Vol. V, No. 2, pp. 23–32; No. 3, pp. 33–41]

</div>

Piet Mondrian

The Realization of Neoplasticism in the Distant Future
and in Architecture Today

Architecture, conceived as our total [non-natural] environment

'Architecture' is progressively becoming *'construction'*; 'handicraft' is dissolving into *'industrial design'*; 'Sculpture' has become mainly 'decoration' or objects of *luxury and utility*; 'Theatre' is displaced by the *cinema* and *music-hall*; 'music' by *dance music* and the *phonograph*; 'painting' by *film, photography, reproductions* and so on. 'Literature' by its very nature is already largely *'practical'*, as in science, journalism, etc., and becomes increasingly so with time: as 'poetry' it is increasingly ridiculous. In spite of all, the arts continue and seek renewal. But their way to renewal is their *destruction*. To evolve is to *break with tradition*. 'Art' (in the traditional sense) is progressively dissolving — as it already has in painting (in Neoplasticism). Simultaneously, *outward life* is becoming fuller and many-sided thanks to *rapid transportation, sports, mechanical production and reproduction, etc.* One feels the limitation of spending a 'life' in creating art, while *the whole world is going on around us*. More and more, *life* commands our attention — *but it remains predominantly materialistic*.

Art is becoming more and more 'vulgarized'. The 'work of art' is seen as a *material value* — which drops lower and lower unless 'boosted'

by the trade. Society increasingly opposes the life of *intellect and feeling* — or employs them in its service. *Thus society opposes art too.* Its predominantly physical outlook sees only decadence in the evolution of life and of art: today, feeling is now society's flower, intellect its power, art its *ideal* expression. Our surroundings and our life show poverty in their incompleteness and stark *utilitarianism.* Thus art becomes an *escape. Beauty and harmony* are sought in art because they are lacking in our life and our environment. Consequently, beauty or harmony become the 'ideal', something *unattainable,* set apart as 'art', separated from life and environment. Thus the 'ego' was freed *for fantasy and self-reflection, for the self-satisfaction of self-reproduction*: creating beauty in *its own image. Actual* life and *true* beauty were lost from attention. All this was inevitable and *necessary,* for in this way *art and life became disengaged.* Time is *evolution,* even though the 'ego' also sees evolution as an *unattainable* 'ideal'.

Today the masses deplore the decay of art, while they nevertheless oppress it. *The physical predominates or seeks to dominate their whole being: thus they oppose inevitable evolution* — even while it is nevertheless accomplished.

In spite of all, both art and reality around us show this precisely as *the coming of a new life* — man's ultimate *liberation.* For although art is created by the flowering of our predominantly physical being ('feeling'), basically it is the *pure plastic expression of harmony.* A product of *life's tragedy* — due to the domination of the physical (the natural) *in us and around us* — art expresses the still imperfect state of our innermost 'being'. The latter (as 'intuition',) tries to close the eternally unbridgeable *gap* that separates it from the material-as-nature: it seeks to change disharmony to harmony. Art's *freedom* 'allows' harmony to be *realized,* despite the fact that the physically dominated being cannot *directly* express or attain pure harmony. The evolution of art in fact consists in achieving the *pure* expression of harmony: outwardly, art appeared as an expression that (in time) *reduced* individual feeling. Thus art is both *expression* and the (involuntary) *means of material evolution: of attaining equilibrium between nature and the non-natural* — between *what is in us and what is around us.* Art will remain both expression and means of expression until (relative) equilibrium is *reached.* Then its task will be fulfilled and harmony will be *realized* in our outward surroundings and in our outward life. The domination of the tragic in life will be ended.

Then the 'artist' will be absorbed by the *'fully human being'.* The 'non-artist' will be like him, equally imbued with beauty. Predisposition will

draw one to the aesthetic, another to the scientific, or to another activity — but the 'speciality' will be an equivalent part of the whole. Architecture, sculpture, painting and decorative art will then merge into *architecture-as-our-environment*. The less 'material' arts will be realized in 'life'. Music as 'art' will come to an end. The beauty of the sounds around us — purified, ordered, brought to the new harmony — will be satisfying. Literature will have no further reason to exist as 'art'. It will become *simply use-and-beauty* (without lyrical trappings). Dance, drama, etc., as art, will disappear along with the dominating 'expression' of tragedy and harmony — the movement of life itself will become harmonious.

In this image of the future, life will not become static. On the contrary: beauty can never lose by its deepening. But it will be a different beauty from the one we know, difficult to conceive, impossible to describe. Even Neoplastic 'art' (which remains to some degree individual) still expresses this — its own realization — imperfectly. For it cannot directly express the fullness and freedom of life in the future. *The Neoplastic conception will go far beyond art in its future realization.*

Just as the contours of the human figure cannot be straightened except by clothing, there are some things that do not permit the most extreme intensification, and to force them would lead to rigidity. In contemporary architecture, for instance, a dinner-service does not require a specifically prismatic form: a tautened round form will suffice. These details will be automatically absorbed by the strength and completeness of reality as a whole. In any case, such utensils need be kept in sight only when they are in 'use'. *Simplicity* will make everything more convenient. This will come automatically through the quest for efficiency in machinery, in transportation, etc. Man will then become *free*: labour makes him a *slave*. He will also be more free, both inwardly and outwardly, because of his environment. Perfection of the outward in opposition to simplification of the inward creates harmony (harmony in the sense of *perfect action*, not in the old sense of pastoral repose). (On the new harmony, see my *Neoplasticism*, 1920.)

Will the backwardness of the masses make *perfect life* impossible even in the remote future? This is of no importance to *evolution*, which continues regardless, and with it alone must we reckon.

Throughout the centuries art was the *surrogate* reconciling man with his outward life. 'Represented' beauty sustained man's belief in 'real' beauty: beauty could be *experienced perceptibly*, although in a limited and narrow

way. Whereas 'faith' demands a super-human abstraction in order to experience harmony in life, and science can only produce harmony intellectually, art enables us to experience harmony *with our whole being*. It can so infuse us with beauty that we become *one* with it. We then realize beauty in *everything*: *the external environment can be brought to equivalent relationship with man*.

The material world around us is gradually becoming *transformed* to this end. This 'transformation' is necessary, for both art and surrounding reality show that in order to achieve *actual* harmony it is not enough for our humanity alone to become mature. (Harmony is then merely an *idea*. Precisely by his 'maturing' the individual outgrows natural harmony: he must create a *new* harmony.) Reality and art show that it is also necessary to *reduce* the outward around us and, so far as possible, to *perfect* it around us, so as to harmonize with man's full humanity (reduced outwardness and intensified inwardness). Thus there arises a *new concept of beauty, a new aesthetic*.

In the reality of our environment, we see the *predominantly* natural gradually disappearing through necessity. The capricious forms of rural nature become tautened in the *metropolis*. In machinery, in the means of transportation, etc. we see natural materials become more harmonious with man's gradually evolving maturity. Precisely by concentrating on the material, external life is moving toward freedom from material oppression. The pressure of the material destroys the sentimentality of the ego. Thus it helps to purify the ego through which art is expressed. Only *after* this, can equivalent relationship, equilibrium — thus *pure* harmony — arise.

Art also evolved from the natural to the abstract; from the predominant expression of 'sentiment' to the *pure* plastic expression of harmony. Being 'art', it could actually anticipate the reality of our environment. Painting, the freest art, advanced in the most purely 'plastic' way. Literature and music, architecture and sculpture became active almost simultaneously. In various ways Futurism, Cubism and Dadaism purified and reduced individual emotion, 'sentiment', the domination of the ego. Futurism gave the initial impulse (see F. T. Marinetti, *Les mots en liberté Futuristes*). Consequently *art as ego expression* was progressively destroyed. Dadaism still aims to 'destroy art'. Cubism *reduced natural appearance in plastic* expression, and thus laid the ground for Neoplasticism's *pure plastic*. Materialistic vision was deepened and *the plastic of form annihilated*.

What was achieved in art must for the present be limited to art. Our

external environment cannot yet be realized as the pure plastic expression of harmony. Art advances where religion once did. Religion's basic content was to *transform the natural*; in practice, however, religion always sought to harmonize man *with nature*, that is, with *untransformed* nature. Likewise, in general, Theosophy and Anthroposophy—which, although they already knew the *basic symbol of equivalence*—were never able to give *vitality to equivalent relationship, to real fully-human harmony*.

Art, on the other hand, sought this *in practice*. It increasingly *interiorized* natural externality in its plastic until, in Neoplasticism, nature *actually* no longer dominates. Its expression of equivalence prepares the way for full-humanity and for the end of 'art'.

Art is already in partial disintegration—but its end *now* would be premature. Since its *reconstruction-as-life* is not yet possible, a new art is still necessary; but *the new cannot be built out of old material*. Thus even the most advanced of the Futurists and Cubists retreat more or less to the old, or at least are not free of the old. The great truths they proclaimed are not realized in their art. *It is as if they were afraid of their own consequences.* The new seems to remain immature even among those who initiated it. Nevertheless, *the great beginning has been made.* From this beginning pure consequences were manifested. From the new movement *Neoplasticism* arose: *an entirely new art—a new plastic*. As purified art, it shows clearly the *universally valid laws* on which the new reality is to be built. For the 'old' to vanish, and the 'new' to appear, a universally valid concept must be established. It must be rooted in feeling and in intellect. That is why, some years ago, Theo van Doesburg brought 'De Stijl' into being: not to 'impose a style', but to discover and disseminate in collaboration what in the future will be *universally valid*.

Once realized in painting, the Neoplastic concept was manifested in sculpture (Vantongerloo's prismatic compositions). Several architects moved homogeneously with 'the new plastic', and tried uniformly to apply its theory in their practice. Several were truly convinced of the *necessity* for a new architecture, 'an architecture consistent with everything our time has to offer in spiritual, social and technical progress' (lecture by J. J. P. Oud, Feb. 1921). It speaks well for Neoplasticism that advanced minds outside the movement strive in the same direction—without, however, achieving its 'consequence'. *The consequence of Neoplasticism is frightening.* They doubt that it is possible to realize the Neoplastic idea as architecture today: they 'create' without *conviction*.

The contemporary architect lives within 'building practice' — *outside art*. Insofar as he responds to Neoplasticism he tries to incorporate it directly in his building. But if he fails to see that he must first create his building 'as a work of art', it is because he does not fully feel or appreciate the content of Neoplasticism. Neoplasticism can only be realized as 'environment' through the 'work of art'.

In our time, each work of art has to stand on its own. Certainly Neoplasticism's complete realization will have to be in a multiplicity of buildings, as the *city*. But to reject Neoplasticism because it cannot be realized today is unjustified. Today, even Neoplastic painting has to stand on its own — but this does not make it individual, because of its determined 'plastic' character.

The practice of architecture today is generally not *free* — as Neoplasticism demands. Today freedom is found only through individuals or groups who wield material power. One is therefore limited to *the individual building* — which opposes itself to its environment — to nature, to traditional or heterogeneous building. It is nevertheless a 'plastic expression', *a world in itself* and thus can realize the Neoplastic idea. The Neoplasticist must *abstract* the environment, for he recognizes that there can only be harmony through *equivalence*; for him, harmony between nature and the man-made is *fantasy — unreal, impure*.

But even as a 'work of art', Neoplastic architecture can only be realized under certain *conditions*. Beside *freedom*, it demands *preparation* of a kind unfeasible in customary building practice. If the founders of Neoplasticism in painting made great sacrifices before they succeeded in fully expressing the 'new' plastic, its achievement in the ordinary architecture of today must be *close to impossible*.

Execution in which every detail must be *invented and worked out* is too costly or impossible under present circumstances. *Absolute freedom for continuous experimentation* is necessary if art is to be achieved. How can this come about within the complex limitations of conventional building in our society? First there must be the *will* and the *power* to realize the Neoplastic idea. A school to meet all research requirements should be founded. (*Note*, 1925: I was unaware, when I wrote this essay, that the Staatliches Bauhaus at Weimar, transferred to Dessau in 1925, was already working in this direction.) A specially designed *technical laboratory* is needed. This is far from impossible; they now exist, but they are academic — superfluous because they merely *reproduce* what already exists. Today the architect is

compelled to create a 'work of art' more or less hastily and constrictedly, that is, he can only evolve it on paper.

How can he meet every new problem *a priori*? A plaster model is no real study for an interior design; and there is neither time nor money for a large scale model in metal or wood. Time will provide what we should be able to do today. Long and diversified research will finally create the completely Neoplastic work of art in architecture.

'Building' and 'decoration' as practised today are compromises between 'function' on the one hand and the 'aesthetic idea' or 'plastic' on the other. This is due solely to circumstances: for the reasons mentioned, the two will have to be combined.

Use and beauty *purify each other* in architecture. That is why architecture through the ages, despite its many limitations, has been the prime vehicle of 'style'. Of necessity — being tied to materials, technology, function and purpose — it was poor soil for expressing 'sentiment'. That is why it retained a greater objectivity (known as 'monumentality'). On the other hand, precisely for this reason it could not evolve as rapidly as the freer arts.

Function or purpose modifies architectural beauty. Thus the difference between the beauty of a factory and that of a house. It can even limit beauty: some utilitarian things — such as factory installations and machinery, or wheels — may require a round form, although the 'straight' expresses the profoundest beauty. Roundness in such cases usually takes the form of the pure circle, which is far from nature's capriciousness. The *architectural design* can nevertheless control everything, but a certain 'relativity' always remains.

The deeply rooted belief that architecture operates with three-dimensional 'plastic' is why Neoplasticism's 'planear' expression is thought to be inapplicable to architecture. That architecture must be *form-expression* is a traditionalistic view. *It is the (perspective) vision of the past*; Neoplasticism does away with that (see 'Neoplasticism', 1920). The new vision — even before Neoplasticism — does not proceed from one fixed point of view: it takes its viewpoint *everywhere* and is *nowhere limited. It is not bound by space or time* (in agreement with the theory of relativity). In practice it takes its viewpoint before the plane (the most extreme possibility of plastic intensification). Thus it sees architecture as a *multiplicity of planes*: again the *plane*. This multiplicity is composed abstractly into *plane plastic*. At the same time practice demands a still relative visual-aesthetic solution through composition, etc. — because of the relativity of our physical movement.

To be a *plastic of the plane* in this way, Neoplastic architecture requires *colour*, without which the plane cannot be a vital reality for us. Colour is also necessary in order to reduce the naturalistic aspect of materials: the pure, flat, determinate (i.e., sharply defined, not fused) *primary or basic* colours of Neoplasticism, and their opposition, *non-colour* (white, black, and grey). The colour is supported by the architecture or annihilates it, as required. Colour extends *over the entire architecture*, equipment, furniture, etc. Thus the one annihilates the other in the whole. But we thus also come into conflict with the *traditional conception* of 'structural purity'. The idea is still current that structure must be 'emphasized'. Recent technology, however, has already dealt this notion a blow. What was defensible in brick construction, for example, is no longer so for concrete. If the plastic concept demands that structure be neutralized plastically, then the way must be found to satisfy the demands both of structure and of plastic. Neoplastic architecture requires not only an 'artist', but a *genuine Neoplasticist*. All problems must be solved in a *genuinely Neoplastic way*. Neoplastic beauty is *other* than morphoplastic beauty, just as Neoplastic harmony is *other*, and is not harmony for conventional feeling.

Also in our outward surroundings, another beauty is being manifested quite apart from Neoplasticism. 'Fashion' in dress, for instance, shows the abolition of structure and the transformations of natural form: *an annihilation of nature* which does not impair beauty, but *transforms* it. *Today structural and aesthetic purity are merged in a new way*. We also see it in art. Naturalistic expression required that anatomy (structure) be expressed; there is no place for this in the new art. Neoplastic architecture will take advantage of the latest technical inventions without impairing the plastic conception. Art and technology are inseparable, and the further technique develops, the purer and more perfect Neoplastic art becomes. Technology is already working hand in hand with the Neoplastic idea. For where brick construction needed curved vaulting to enclose space, reinforced concrete gave rise to the flat roof. Steel construction itself also offers many possibilities. Is its expense the objection to Neoplasticism in architecture? The cost would be much lower if research were performed by the special institute we mentioned. And how much could Neoplastic architecture save on ornament and stone carving, etc. Yet expense is a main reason why this new architecture will for some time to come remain limited to the 'work of art'. Nevertheless, many aspects of the *Neoplastic conception can already be realized in current construction*.

Ornament is already much reduced in advanced modern architecture, and it is no surprise that Neoplasticism *excludes it altogether*. In such architecture, beauty is no longer an 'accessory' but *is in the architecture itself*. 'Ornament' has been *deepened*. So too, sculpture has been absorbed in furniture and equipment, etc. Utilitarian objects become beautiful through their basic form, that is *in themselves*. Yet they are nothing in themselves: they become *part* of the architecture through their form and colour.

In an interior, empty space becomes 'determined' by the so-called 'furniture', which in turn is related to the spatial articulation of the room, for the two are *created simultaneously*. The position of a cabinet is as important as its form and colour, all of which are in turn as important as the design of the space. Architect, sculptor and painter find their *essential identity* in *collaboration* or are all united *in a single person*.

The Neoplastic conception of utilitarian objects, etc., merging into the whole and neutralizing one another, is in complete conflict with certain modern tendencies which set furnishings apart as 'decorative art'. Their aim is to make art 'social', to bring it 'into life'. In fact, it is nothing other than the making of 'paintings' or 'sculptures' — but in an impure way, for 'art' demands freedom. Such tendencies can never 'renew' our environment. The attention it receives is dispersed on details. Efforts of this kind are equally *detrimental* to pure painting when they adapt pure plastic elements. For they employ painting decoratively where it should be *purely plastic*. Neoplasticism *seemingly* lends itself to decoration (through its planearity); actually the 'decorative' has no place in the Neoplastic conception.

If architecture and sculpture have been evaluated from the point of view of painting, this is possible because in architecture they are a unity. Neoplastic aesthetic originated in painting but once formulated, the *concept is valid for all the arts*.

[*Vol. 5, No. 3, pp. 41–47; No. 5, pp. 65–71*

Account rendered by the De Stijl group, Holland, before the Union of International Progressive Artists

I I speak here for the De Stijl group in Holland which owes its being to the need to draw the consequences of modern art, i.e., to solve general problems in practice.

II Our purpose is construction, that is, the organization of the medium as a unity (creating form, plasticism).

III This unity only becomes possible by the suppression of subjective idiosyncrasy in the expressive medium.

IV We reject all subjective choice of forms and are making preparations for the use of an objective, universal creative medium.

V Those who are not afraid of the consequences of this new concept of art we call progressive artists.

VI The progressive artists of Holland have taken an international view from the very beginning. Even during the war (see the introduction to *De Stijl*, Vol. 1, 1917).

VII This international outlook was imposed by the very way our work developed, which was out of the practice of our art. The development of the most progressive artists of other countries also imposed the very same necessities.

VIII Being certain that the same problems (in science, technology, architecture, sculpture, painting, music, etc.) were developing in every country, in 1918 we drew up our first manifesto.

IX The manifesto runs as follows:

Manifesto I of De Stijl, 1918

1 There is an old and a new consciousness of the age. The old one is directed towards the individual. The new one is directed towards the universal. The conflict of the individual and the universal is reflected in the World War as well as in art today.

2 The war is destroying the old world with all that it contains: the pre-eminence of the individual in every field.

3 The new art has revealed the substance of the new consciousness of the age: an equal balance between the universal and the individual.

4 The new consciousness is ready to be realized in everything, including the everyday things of life.

5 Traditions, dogmas and the pre-eminence of the individual (the natural) stand in the way of this realization.

6 Therefore the founders of Neoplasticism call on all those who believe in the reform of art and culture to destroy those things which prevent further development, just as in the new plastic art, by removing the restriction of natural forms, they have eliminated what stands in the

way of the expression of pure art, the extreme consequence of every concept of art.

7 Throughout the world one and the same consciousness has driven present-day artists to take part, on a spiritual level, in the world war against the pre-eminence of individualism and idiosyncrasy. Therefore they sympathize with all who are waging a spiritual or material battle for the creation of international unity in life, art and culture.

8 The journal *De Stijl*, founded to serve this purpose, intends to assist the placing of the new concept of life in a clear light. Anyone who wants to can help by:

9 (i) sending their full name, address and profession to the editors, in token of agreement;

(ii) contributing material of the widest variety (critical, philosophical, architectural, scientific, literary, musical, etc., as well as reproductions) to *De Stijl*, which appears monthly;

(iii) translating and propagating the views published in *De Stijl*

Signed:

Theo van Doesburg, painter	Antony Kok, poet
Rob. van 't Hoff, architect	Piet Mondrian, painter
Vilmos Huszár, painter	G. Vantongerloo, sculptor
	Jan Wils, architect

X This manifesto expressed the common point of view of the collaborators—painters, architects, sculptors and poets — and aroused the concurrence of progressive artists in every country (see *De Stijl*, Vol. 2, 1918, p. 94, and Vol. 3, 1919, pp. 1–4). This was proof of the practicability and of the need for an international organization. I have come here to collaborate in a practical manner with this organization.

Düsseldorf, 30 May 1922

Signed: Theo van Doesburg.

DECLARATION

of the international faction of constructivists[1] at the first international Congress of Progressive Artists,

We came to Düsseldorf with the firm intention of forming an International. But the following differences have become apparent:

[1]Constructivist is used here only to point the contrast with all 'impulsivists' (De Stijl).

Union

1 The invitation to found the Union gave as the basis of the organization 'the warm, living inter-relationship of international spirits'.

II Complete lack of clarity as to the true purpose of the Union: whether it is to be a trade union representing economic interests, or whether it is to construct an economic organization in order to carry out specific cultural interests.

III No definition of 'Progressive Artist'. The proposal to put questions of this kind on the agenda was turned down on the grounds that the attitude each individual holds towards the problems of art is an entirely personal matter.

IV It appears from the Union's manifesto that it envisages a series of undertakings whose main purpose will be to establish an international circuit for art exhibitions. In other words, the Union intends to pursue a *policy of mercantile colonization.*

Ourselves

I Good will is not a programme and therefore cannot serve as the foundation for an organization, especially if the good will collapses at the very moment when it is supposed to become a reality in the face of opposition within the congress.

II To us it is quite clear that first of all a specific attitude must be taken to the problems of art, and that economic questions can play a part only within that framework.

III We define the progressive artist as one who denies and opposes the pre-eminence of the subjective in art and founds his work not on a personal lyricism but on the Neoplastic principle of a systematic organization of the medium as a means of expression comprehensible to all.

IV We reject the art exhibitions of today as shops, where goods, stacked together without any purpose, are bought and sold. Today we stand between a society which does not need us and one which does not exist; therefore we can only contemplate exhibitions which demonstrate what we hope to realize (sketches, plans, models) or what we have realized.

174

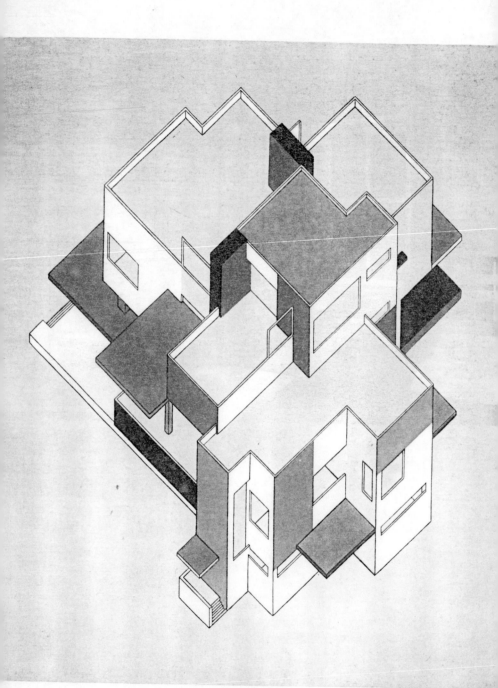

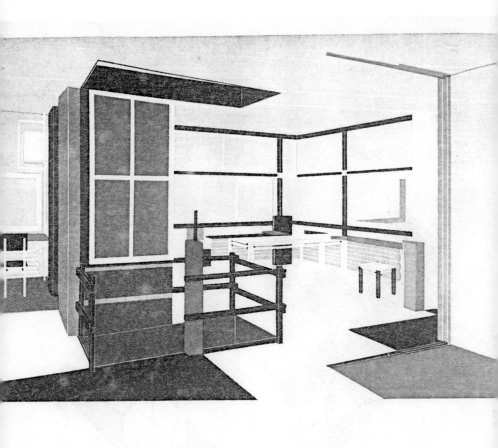

For the reasons given it should be clear that an International of progressive artists can be formed only on the following basis:

(a)　Art is as much a method of organizing ordinary life as science and technology.

(b)　We assert that art today is ceasing to be a dream which sets itself up in opposition to the reality of the world, ceasing to be a means of uncovering cosmic secrets. Art is a general and real expression of the creative energy, which organizes human progress; that is, art is a tool of the general process of labour.

(c)　We must fight to make this assertion good, and we must be organized for the fight. This is the only way to liberate our collective energy. In this way our principles and our economic needs become as one.

The transactions of the Congress have proved that the pre-eminence of individualistic attitudes prevent the construction of an International of progressive solidarity from the elements of this Congress.

Düsseldorf, 30 May 1922

<div align="right">

Signed: Theo van Doesburg
El Lissitzky
Hans Richter

</div>

<div align="right">

[Vol. V, No. 4, pp. 59–64]

</div>

Theo van Doesburg

Against Imitative Artists

Life reveals itself to be of nature and of the spirit.

Art is concerned with life.

The true subject of art (in general) is unity.

The unity of nature and spirit is reality.

The art of previous centuries (of the Assyrians, Egyptians, Greeks and of the Renaissance) was characterized by the predominance of nature.

Artists took visible nature as their starting point. In the best periods they tried to penetrate more deeply into nature.

Proceeding from visible nature, they created a whole culture of *exterior form*. The other part of reality, that is to say, *interior nature* (non-visible — referred to as spirit) was symbolized by human transfiguration (angel, devil, god, dragon, siren, etc.,) or by accessories: in the folds of a costume, in a flower, an animal (a dove, a lizard, etc.), an object. But the aesthetic subject was chiefly unity.

Art proceeding from unity could not reflect anything in itself but unity or harmony.

The artist copied nature increasingly (irrespective of his subject) by intuition, spontaneously or by scientific methods, more constructively.

The era during which visible nature was the starting point extended into the nineteenth century and may be regarded as the age of infantile and imitative art.

The artist's aim was to create a harmony in the manner of nature and of science.

The art of the nineteenth century which had its seat in France and chose as its motto 'nature seen through temperament' is the transitional stage of subjective art. Now 'modern' art is trying to create a culture of *interior form*.

The artist's starting point was the (speculative) content of nature, *i.e.*, the spirit. Visible nature was an intermediary element. The artist works from within to without instead of from without to within.

The new art is more exact than ancient art because it is less naturalistic.

During previous centuries natural form was only a crutch with which art moved towards the creation of aesthetic harmony.

In the twentieth century the artist needs to destroy this crutch. He wishes to proceed unaided. The artist wishes to create an artistic harmony, *i.e.*, by his own means of expression. He creates *immediately* by the balanced relationships of opposites towards a plastic unity.

Accordingly, this age which has now begun should be called: the age of a new plasticism.

If it proceeds only along this path, art may become independent.

If it proceeds only along this path, art may achieve its aim: to create a determinate expression of unity by true artistic means (colour, in respect of painting; volume, in respect of sculpture; and space, in respect of architecture). The work of art will become a real and independent object.

If, to quote Michelet, the Renaissance was the revelation of the world and of man, the century of Neoplasticism is the revelation of the unity of *nature and spirit*.

The art of the future generation will be the collective expression by the organization and the discipline of the plastic means towards a real unity.

[*Vol. V, No. 7, pp. 95–96*]

De Stijl 1917–1922 and its movement in:
Painting – Architecture – Sculpture – Monumental Art
Music – Literature – Anti-Philosophy
Mechanism – Objects – Dance

De Stijl arose from a general need to defend and explain a new mode of plasticism opposed to all formal art.

Formal art: all art which gives expression in geometrical forms and forms derived from nature; in short, in closed form.

New plasticism: the art which replaces form by the characteristic means of expression of every kind of art and so abolishes all duality.

The new plasticism opposes modern art in all its variations, but recognizes that it is the purest and perhaps the only logical outcome of this art – in particular – of Cubism.

Only through this outcome was it possible to establish universal values as a general basis for all the arts. The power of the new plasticism resides in this 'possibility of extension'.

Although various artists in different countries have worked consciously and unconsciously at the new means of plastic expression, the painter Piet Mondrian was the first to arrive, in about the year 1913, at the realism of the new plasticism as painting, through the consistent following through of Cubism. This act, which earned the appreciation of the youngest generation of Dutch artists,[1] aroused in the most consistent artists confidence in the possibility of a new mode of plasticism. Both through the work and the formulation they became fully conscious of the positive value and the potentialities for development of the new plasticism.

Thus *De Stijl*, which greets in Mondrian the father of the new plasticism, became the collective confession of an a-national and a-individualistic (and in its furthest reaching consequences – collective) force of expression.

[1] See, *inter alia*, the article by Theo van Doesburg about modern art (on the occasion of an exhibition of the 'Moderne Kunstkring' (Modern Art Circle) in the Amsterdam Municipal Museum ('Eenheid', 18 October 1915).

[*Vol. V, No. 12, pp. 177–178*]

De Stijl 1923–1925

Theo van Doesburg

From the New Aesthetic to its Material Realization

Building is not the same thing as creation.

Nor is the gradual relinquishing of the superfluous and of the usual decorations in colour and form the same as creative building: it is undecorated building. Creative building is something more.

Nor is the piling of living-hutches on top of each other, or the stringing of constructional units one after the other the same as creative building. That kind of building is a process of mechanical repetition, like the process of photography, or the use of historical architectural styles.

The (apparent) economizing in the organization of space for communal living (normalization) is a hindrance to creative building.

Nor is creative building, in the Neoplastic sense, a simple matter of straightening out curves and flattening diagonals, of laying bare the skeleton of the building's joints and girders. This kind of building is anatomical, like naturalistic painting.

All these things are prerequisites for further progress towards creative building.

Constructivist building is not necessarily the creation of plastic form.

One could perhaps say that to think of building as piling things on top of each other is a 'visual' conception.

This is on the same level as the primitive, principally southern, idea that the principles of form relate only to three-dimensional sculpture. For modern man, building and creation can be identical with form, expression (even formless expression, e.g., using colour alone), synthesis and organization.

Obviously, creation needs a medium. In the modern sense (as opposed to the 'exclusively constructive' sense) creation is organization of the medium to form an unmistakable, real unity.

I call space and materials the media.

Anything which disrupts this unity reduces architecture once more to the subordinate level which it has occupied till now.

Only in our time has the leading art form, painting, shown the way which architecture must take in order that it may, like creative painting and sculpture, with mechanical means and disciplines, realize in material form what is already present in the other arts in imaginary (aesthetic) form.

Nobody should be put off by the fact that the art which took the lead at the beginning of the twentieth century, painting, created *a posteriori* an ideal aesthetic. Our new consciousness of life demands the destruction of duality,[1] feels the need for unity, for an indivisible, universal reality and has the will to realize what has been indicated by the ideal aesthetic of the 'free arts' in material terms, in architecture.

Not only in Holland but also in Russia (after 1917) this new movement 'from the aesthetic to its material realization' proceeded from the consequential development of painting (in Holland Neoplasticism, in Russia Suprematism and *Proun*).

Now at last architects are gaining confidence in the use of their expressive medium.

The dualists' firm but one-sided belief in an architectonic balance of spirit and matter is medieval in origin and made it quite impossible to organize materials soberly and clearsightedly, to form an unmistakable, real unity. Only when a predominantly religious view of life had been replaced by a more scientific view (during the Renaissance) were materials and material contrasts recognized as expressive media.

In the Middle Ages matter was used symbolically, in the Renaissance it was used, most of the time, sensuously, as decoration. Thanks to advances in physics, our age has seen not only the shattering of the belief in matter as a solid body, but also, in art, the acceptance of matter as, in essence, energy.

It is fundamentally important for the creative architect to recognize the differences in energy between different materials, so that he can use these differences to realize what painters have indicated in the basic material of creative art: Colour.[2]

In the lectures about colour which I gave in Germany, I made the first attempt to define colour (from the point of view of the visual arts) as 'matter' and matter as different intensities of energy. In my expositions of

[1]Duality means the generally accepted concept of an imaginary, spiritual world in sharp contrast to a concrete, material world.
[2]In my forthcoming book *Neue Gestaltungslehre* ('Theory of Neoplasticism'; in four parts, Colour, Form, Space, Creation) this idea is expounded in full.

the basic materials of creation, my rejection of colour in the visual arts, as the result of light passing through a prism (even though arranged more or less metrically) or as a medium of literary symbolism, aroused hardly any opposition. And yet, starting from the postulate that colour is the fundamental material of the visual arts, I was laying down important principles for the development of architecture.

The creative painter has to organize contrasting, dissonant or complementary energies in two or three spatial dimensions to produce an unambiguous harmony, and the creative architect has to do the same with his material. Not decoratively, to produce an effect which makes an easy appeal to the senses, but creatively, exploiting the contrasts of energy inherent in the materials. In creative painting, yellow and blue, for example, express two contrasting energies; in architecture this is done by two contrasting materials, e.g.:

Wood — compression.

Concrete — tension.

On the other hand dissonant materials are, for example:

Concrete — rigid tension.

Iron — elastic tension (a pulling quality).

Only those works in which the creative forethought of the builder has allowed the force of energy a maximum of expression are created works.

An iron bridge is good, *i.e.*, it has been created, when the various materials are so organized and unified that a maximum of energetic force is obtained.

A building is good, *i.e.*, created, when the various materials (including light) are so organized and unified that a maximum of energetic force is obtained.

It is not possible in a short article to list all the extraordinary potentialities of expression opened up by this. Starting with the most extreme of contrasts — vacuum and mass, the open transparency of glass and the closed opacity of stone — the constructor will be able to assess the relationships, not only of site, position and proportions, but also of the contrasting, dissonant and complementary energies, and organize them in unity.

In this way the ideal aesthetic of one art is realized in the materials of another, and ideal and mechanical aesthetics, theoretical, artistic creation and utilitarian construction, are united in a perfect balance. This balance is 'style'.

Creative form will thus be made available to all. The organization of materials and, when necessary, the creation of new materials will be a task for everybody. If the architect produces a challenging design (without an aesthetic precedent) the engineer must find the material in which to execute it. Architecture will never by an expression of the creative consciousness of the age if architects timidly, passively, content themselves with existing materials. If a project demands a particular material, the creative engineer must either invent that material or adapt the material available. Only those who are now learning their way in the world of materials as a result of the ideal aesthetic, will discover by mechanical and technical means the materials (including colour) which will make the new creative style in architecture possible by their contrasting, dissonant or complementary energies.

If we look at the way materials are used in present-day building we cannot but see that nearly all this so-called architecture is stifling the material under layers of sentimentality. It is exactly the same in so-called painting, where, again, layers of sentimentality murder the energetic force of the basic material (colour). This criminal misuse of the material as something dead (wood, stone, colour, glass, iron) has its origin in the grotesque, distorted glorification of the dualistic concept of a spiritual never-never and a material here-and-now.

When material is used to give reality to aesthetics an attitude will be created which will do away with the separation of the ideal from the real.

The re-creation of life as a unified whole draws nearer the new culture.

Weimar 1922 *[Vol. VI, No. 1, pp. 10–14]*

<div style="text-align:right;">

Piet Mondrian

Is Painting Secondary to Architecture?

</div>

As a consequence of today's growing concentration on practical life, painting is regarded by many as 'play', as 'fantasy'. In contrast to architecture, which is regarded as having practical and 'social' importance, painting remains an 'amenity of life'. This is a quite common view; the *Larousse* dictionary lists under 'amenity' (*agrément*): 'arts of amenity: music, painting, dancing, riding, fencing'. This definition overlooks the plastic element in

art which logically follows from the cloaking of the purely plastic. Thus it is a reaction to the misuse of art.

The obscuring of the purely plastic by form or by capricious rhythm turns 'art' into 'play'. The beauty thus created is 'play', 'lyrical' (*i.e.*, it sings or describes). Lyricism is a vestige of the childhood of mankind, of an age more familiar with the lyre than with electricity. If one wishes to preserve lyricism in painting, one turns it into a pleasant game both for those who wish or choose the 'practical', as well as for those who require 'purely plastic' art. The former 'wish' for play and fantasy alone with the starkly practical; the latter are not moved by capricious play in art. Has not the time come for those who want play and fantasy in art to find them in the cinema, etc., if they do not see it or find it in life itself? Is it not time for art to become purely *art*?

In our time, architecture, although not regarded as play, is also treated as mere amenity but in a different way. Architecture is seen as the practical, and painting as the ideal expression of man's subjectivity — rather than as expression of plastic emotion. Plastic emotion thus appears secondary rather than primary — as it does throughout the old art: all morphoplastic subordinates the purely plastic.

The purely plastic is not the imitation of life but is its opposite. It is the immutable and the absolute as opposed to the changing and the capricious. The absolute is expressed in the straight. Painting and architecture in the new aesthetic, are consequent executions of the composition of the straight in self-annihilating opposition: a multiple duality of the constant rectangular relationship. A new aesthetic and a new art are prerequisites for the realization of universal beauty.

Architecture was purified by utilitarian building, with its new requirements, technology and materials. Necessity, therefore, is already leading to a purer expression of equilibrium and to a purer beauty. But without new aesthetic insight, this remains accidental, uncertain; or it is weakened by impure concepts, by concentration upon non-essentials.

The new aesthetic for architecture is that of the new painting. A purer architecture is now in a position to achieve the same consequences that painting, purified through Futurism and Cubism, realized in Neoplasticism. Thanks to the unity of the new aesthetic, architecture and painting can merge into a single art and can resolve into each other.

[*Vol. VI, No. 5, pp. 62–64*]

Theo van Doesburg

Towards a Plastic Architecture

1 *Form.* The basis for a sound development of architecture (and of art in general) is to overcome every idea of form, in the sense of preconceived type.

Instead of taking as a model earlier types of style and, in so doing, imitating earlier styles, it is necessary to pose the problem of architecture completely afresh.

2 The new architecture is elementary, that is, it is developed from the elements of building, in the widest sense. These elements, such as function, mass, plane, time, space, light, colour, material, etc., are at the same time elements of plasticism.

3 The new architecture is economical, *i.e.*, it organizes its elementary means as efficiently and economically as possible, without wasting means or material.

4 The new architecture is functional, *i.e.*, it is developed from the accurate assessment of practical requirements that it lays down in a clear ground plan.

5 The new architecture is formless and yet determinate, *i.e.*, it does not recognize any preconceived formal frame-work; any mould in which are cast the functional spaces arising from practical dwelling requirements.

In contrast with all previous styles, the new architectural method does not recognize any self-contained type, any basic form.

The subdivision of the functional spaces is strictly determined by rectangular planes, which possess no individual forms in themselves, since, although they are limited (the one plane by the other), they can be imagined extended into infinity, thereby forming a system of coordinates, the different points of which would correspond to an equal number of points in universal, open space.

From this it follows that the planes possess a direct tensile relationship with open (exterior) space.

6 The new architecture has freed the concept of monumentality from notions of large and small (since the word 'monumental' has been misused it has been replaced by the word 'plastic'). The new architecture has demonstrated that everything stems from relationship, the relationship of opposites.

185

7 The new architecture does not recognize a single passive moment. It has conquered the opening (in the wall). The window possesses an active significance as openness in opposition to the closed character of the wall plane. Nowhere does there appear simply a hole or a void, everything is strictly determined by its contrast. (Compare the various counter-constructions in which the elements comprising architecture — plane, line and mass — have been placed loosely in a three-dimensional relationship.)

8 *The plan.* The new architecture has disrupted the wall and, in so doing, destroyed the division between inside and outside.

Walls are no longer load-bearing; they have been reduced to points of support. As a result, a new open plan has been created, differing completely from the Classical plan in that internal and external space are interpenetrating.

•9 The new architecture is open. The whole consists of a single space, which is subdivided according to functional requirements. This subdivision is effected by means of separating planes (interior) or sheltering planes (exterior).

The former, which separate the various functional spaces from one another, may be mobile, *i.e.*, the separating planes (former internal walls) may be replaced by moveable screens or slabs (under which category the doors may also be included). In a later stage of its development the plan will have to disappear completely. The spatial composition projected in two dimensions, set down in a plan, will be replaced by an accurate constructional calculation, a calculation that will have to reduce the bearing power to the simplest, but most resistant, points of support. Euclidean mathematics will not be of any service to us in this task, which will be easily achieved, however, with the aid of non-Euclidean calculations in four dimensions.

10 *Space and time.* The new architecture takes account not only of space, but also of time as an accent of architecture. The unity of time and space gives the appearance of architecture a new and completely plastic aspect (four-dimensional temporal and spatial plastic aspects).

11 The new architecture is anti-cubic, *i.e.,* it does not strive to contain the different functional space cells in a single closed cube, but it throws the functional space (as well as canopy planes, balcony volumes, etc.) out from the centre of the cube, so that height, width and depth plus time become a completely new plastic expression in open spaces.

In this way architecture (in so far as this is constructionally possible —

task for the engineers!) acquires a more or less floating aspect which, so to speak, runs counter to the natural force of gravity.

12 *Symmetry and repetition.* The new architecture has destroyed both monotonous repetition and the rigid similarity of two halves, the mirror image, symmetry. It does not recognize repetition in time, the street wall or standardization. A group of buildings is as much a whole as is a detached house. The same laws apply to the building group and to the town as to the detached house. Against symmetry the new architecture sets the balanced relationship of unequal parts, *i.e.,* of parts which, because of their different functional character, differ in position, dimension, proportion and location.

The equal importance of these parts derives from the equilibrium of inequality and not from equality. The new architecture has also made 'front' and 'back', 'right' and possibly also 'above' and 'below' equal in value.

13 In contrast to the frontality sanctified by a rigid static concept of life, the new architecture offers a plastic wealth of multi-faceted temporal and spatial effects.

14 *Colour.* The new architecture has destroyed painting as a separate, imaginary expression of harmony, whether secondary through representation or primary through colour planes.

Colour planes form an organic part of the new architecture as an element of the direct expression of its time and space relationships. Without colour these relationships are no living reality; they are not visible.

The equilibrium of architectural relationships first becomes visible reality through colour. The modern painter's task is to organize this into a harmonious whole (not in a plane, not in two dimensions, but in the new field: four-dimensional time-space). In a further stage of development, colour is to be replaced by denaturalized material with its own colour (task of the chemists); but only when demanded by practical requirements.

15 The new architecture is anti-decorative. Colour (and the colour-shy must try to realize this!) is not decorative or ornamental, but an organic element of architectural expression.

16 *Architecture as a synthesis of the new plasticism.* In the new architecture, building is understood as a part, the sum of all the arts, in their most elementary manifestation, as their essence. It offers the possibility of thinking in four dimensions, *i.e.,* the plastic architect, under which heading I also include the painter, has to construct in the new field, time-space.

Since the new architecture does not permit any imagination (in the form of free painting or sculpture), the intention is to create from the outset a harmonic whole with all essential means, so that each architectural element plays a part in creating, on a practical and logical basis, a maximum of plastic expression without, at the same time, doing damage to the practical requirements.

Paris 1924 [*Vol. VI, No. 6/7, pp. 78–83*]

Piet Mondrian

No Axiom but the Plastic

Our time sees the impossibility of holding universally valid principles. It sees the untenability of a fixed view of the perceptible, of an unshakable conception. It accepts no human opinion as serious or true. It sees everything *'relatively'*. This view grew out of art, philosophy, science (the theory of relativity, etc.), and out of practical life itself. We are beginning to break with tradition. We no longer want to build on doctrines, or even on logic. Nevertheless, by understanding the relativity of everything, we gain an intuitive sense of the absolute. Moreover, the relative, the mutable, creates in us a desire for the absolute, the immutable. The human ego desires the immutable. Because this is unattainable, we return to the relative and try to perpetuate *it*: since that is impossible, we again seek the immutable and even ignore the mutable. So it has been throughout the centuries.

The *desire for extremes* caused the tragic in life, in art, expressed as the lyrical. Until the present, culture was based on the relative and on a traditional representation of the absolute, which became axiomatic; this representation of the absolute was 'form', just as the relative is 'form,' and constantly changes. In art, both were always cloaked in form: *the relative always dominated*. Therefore art was always more or less *descriptive* (lyrical), even when symbolic. In the symbolic, the purely plastic becomes impure because the symbolic manifests itself not as art but as truth — therefore impure, untrue, because then the element of form 'becomes 'a form' (in the cross, for example).

Today we see a resistance to such 'representation', to this *disguising* of

the absolute as well as to the naturalistic capriciousness of the relative. The masses, however, believe that only the relative can be knowable because it is directly perceptible. But although they deny it, they feel unconsciously, intuitively, the need to emphasize the absolute, the need to abstract the natural. They are also compelled to do this because of external pressures — the new necessity.

Our products show this, as well as the general search for clarity and purity in everything. The relative in our environment, at first predominantly natural, is now assuming an increasingly mathematical appearance. *Thus the absolute is beginning to express itself more purely* all around us. There is increasing homogeneity between man, who is now outgrowing his formerly dominating naturalness, and his environment. Within this relativity, *a new relativity is slowly growing in which the absolute is also expressed*.

This greater equilibrium already plastically expresses the character of the future. Thus the search for extremes is abolished: equivalence between relative and absolute becomes possible. But far more purely than in our environment, equilibrated relationship between the relative and the absolute has been achieved in art, the field of intuition.

The freest art, painting, could be the most consequent. Gradually but rapidly, natural appearance was abstracted in the plastic: form as well as colour. In Cubism, form was broken up and tensed. Neoplasticism broke with form altogether by abstracting it and reducing it to the *pure elements of form*. The closed curved line, which did not express plastic relationship, was replaced by the straight line in the duality of the constant perpendicular position, which is the purest plastic expression of relationship. From this it constructed its *universal plastic means, the rectangular colour-plane*. Through the duality of position of the straight, it expresses equilibrium (equivalence) of relative and absolute. It opposes the colour plane to the non-colour plane (white, grey, black), so that through this duality, the opposites can annihilate one another in the multiplicity of the composition. The perpendicular position expresses the constant, the rhythm of the composition expresses the relative.

Thus painting shows *plastically* that the manifestation of both relative and absolute can be plastically expressed through *the straight*. Thus, equivalence as well as opposition and variety. This is possible only through *the straight*. The straight cannot be made more abstract: it is the most extreme possibility of the purely plastic.

Thus in Neoplasticism, *a principle* has been plastically expressed: immutability, constancy. Colour and line and composition have fixed laws.

This principle of *equilibrated relationship of relative and absolute*, seen *purely plastically*, can become a general principle of life. It states that for the fully-human man pure equilibrium can only be achieved through the most deeply *interiorized naturalness within us and around us*, and by *intuition becoming conscious* within us. Thus, through the equivalence of the dissimilar.

Paris 1923 [*Vol VI, No. 6/7, pp. 83–85*]

Theo van Doesburg – C. van Eesteren

Towards a Collective Construction

We must realize that life and art are no longer separate domains. That is why the 'idea' of 'art' as an illusion separate from real life must disappear. The word 'Art' no longer means anything to us. In its place we demand the construction of our environment in accordance with creative laws based upon a fixed principle. These laws, following those of economics, mathematics, technique, sanitation, etc., are leading to a new plastic unity. In order to define the relationships of these reciprocal laws, it is necessary to understand and establish them. Until the present time the field of human creation and its constructional laws has never been examined scientifically.

They cannot be imagined. They exist. They can be observed only during the course of collective activity and through experiment.

The basis of these experiments is the simple knowledge of the universal primary elements of expression so that the means may be found of organizing them to create a new harmony. The basis of this harmony is the knowledge of contrast, of the complex of contrasts, dissonance, etc., etc., which makes visible everything that surrounds us. The multiplicity of contrasts gives enormous tensions, which create, by reciprocal abolition, equilibrium and repose.

This equilibrium of tensions forms the essence of the new constructive unity. Now we demand the practical application or demonstration of this constructive unity.

Our age is the enemy of all subjective speculation in art, science, technique, etc. The new spirit which governs almost the whole of modern life is opposed to animal spontaneity (lyricism), to domination by nature, to artistic *coiffure* and *cuisine*.

In order to construct something new we require a method, *i.e.,* an objective system. If we discover the same characteristics in different things we have found an objective scale. One of the fundamental and permanent laws that the modern constructor makes visible, for example (by the means appropriate to the particular art), is the relationship of their characteristics and not the relationship of things in themselves.

The speculative method, that childhood malady, has prevented the healthy development of construction in accordance with universal and objective laws. Personal taste, including admiration for the machine (mechanism in art), is of no importance for the realization of this unity of art and life. Mechanism in art is an illusion like all other illusions. (Naturalism, Futurism, Cubism, Purism, etc.), and even more serious than any metaphysical speculation.

Development, on the other hand, is made possible by the predominant employment of elementary methods of construction, in the suppression of all metaphysical illusions. The future will eventually arrive at the expression of a new dimension in three-dimensional reality.

Neither in dynamism, nor in statics, neither in functionalism, nor in art, neither in composition, nor in construction, but in the penetration of all the elements of a new creation of reality on a universal basis. Since the formation of the 'De Stijl' movement in Holland (1916) painters, architects, sculptors, etc., have arrived during the course of their practical work at the definition and application of laws which lead to a new unity of life. It is through the new conception born of mutual cooperation that these distinctions between the practitioners of the various arts will cease to exist.

Today, we may speak only of the builders of the new life.

The exhibition of the 'De Stijl' group in the *salles de l'Effort moderne* (Léonce Rosenberg) in Paris had as its aim the demonstration of the possibility of collective creation on this universal basis.

Paris 1923 [*Vol. VI, No. 6/7, pp. 89–91*]

I During the course of our collective efforts we have studied architecture as a plastic unity of all the arts (excluding technique and industry) and we have found that the result would give a new style.

II We have studied the laws of space and their infinite variations (*i.e.,* spatial contrasts, spatial dissonances, spatial complements etc.), and we have found that all these variations of space can be controlled as a balanced unity.

III We have studied the laws of colour in space and time and have found that the balanced relationships of these elements ultimately give a new and positive plastic art.

IV We have studied the relationship between space and time and have found that the plastic expression of these two elements through colour gives a new dimension.

V We have studied the mutual relationships of dimension, proportion, space, time and materials and have found the definitive method of combining them as a unity.

VI By the disruption of enclosure (walls) we have abolished the duality between interior and exterior.

VII We have given colour its true place in architecture and we declare that painting has no *raison d'être* apart from architectural construction (*i.e.,* from the picture).

VIII The age of destruction is totally finished. A new age is beginning:

THE GREAT AGE OF CONSTRUCTION

Paris 1923

[*Vol. VI, No. 6/7, pp. 91–92*]

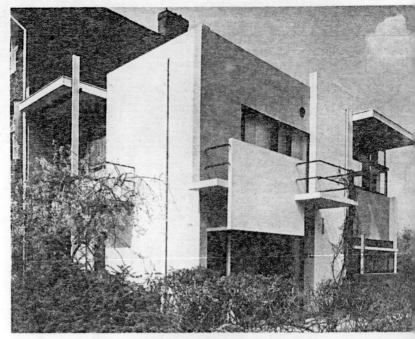

45 Gerrit Thomas Rietveld. *Schröder residence, Utrecht.* 1924

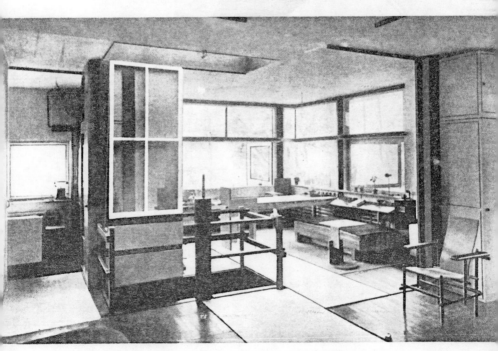

46 Gerrit Thomas Rietveld. *Schröder residence, first-floor interior, Utrecht.* 1924

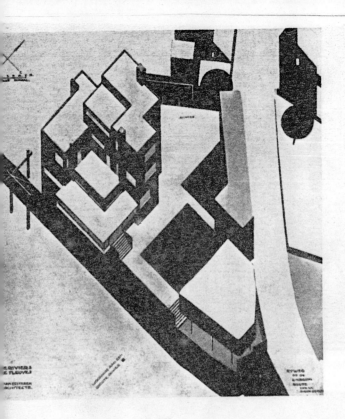

7–8 Cornelis van Eesteren. *Project for a riverside house.* 1923

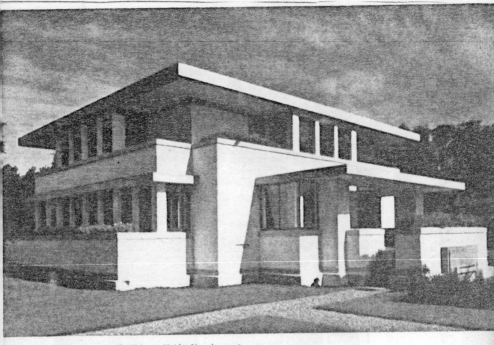

49 Robert van't Hoff. *Huis ter Heide, Utrecht.* 1916

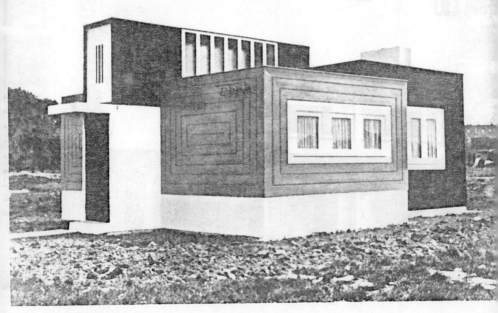

50 J. J. P. Oud. *Site office.* 1923

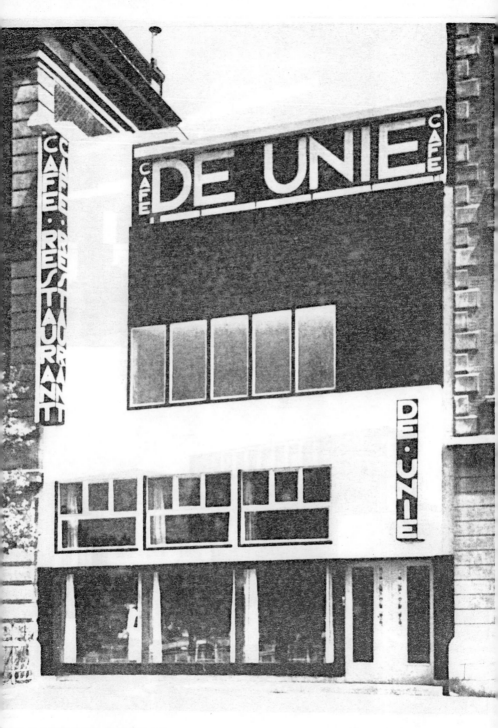

J. P. Oud. *Café de Unie, Rotterdam*. 1925

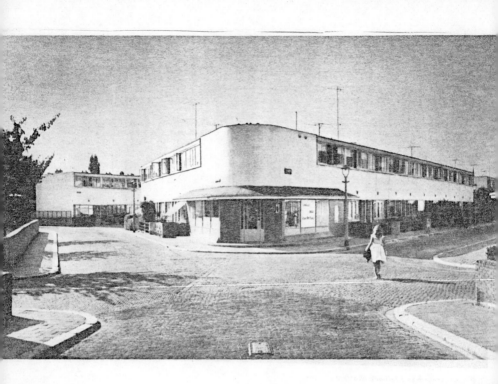

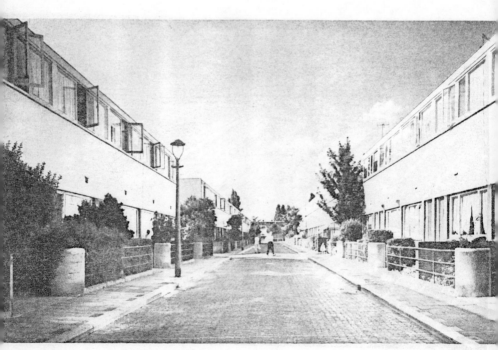

52–3 J. J. P. Oud. *Kiefhoek estate, Rotterdam.* 1925–30

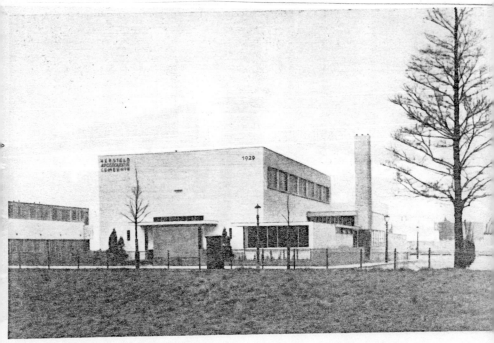

. J. P. Oud. *Church in Kiefhoek, Rotterdam.* 1928

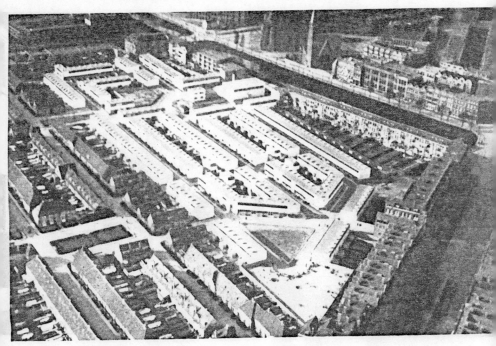

J. J. P. Oud. *Kiefhoek estate, Rotterdam.* 1925-30

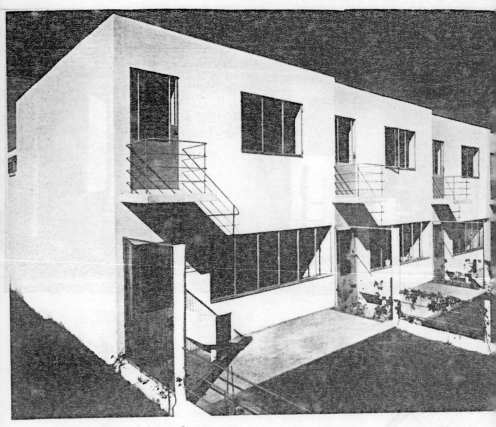

56 J. J. P. Oud. *Weissenhof estate, Stuttgart.* 1927

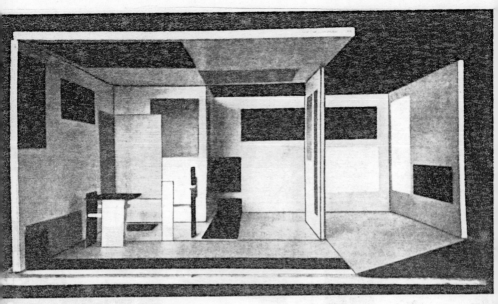

Vilmos Huszár. *Project for interior*

César Domela. *Neoplasticist composition No. 10.* 1930

De Stijl 1926–1928

Theo van Doesburg

Painting: From Composition to Counter-Composition

Memorandum 1926. In 1912, under the title 'Attempt at a New Art Criticism', I published my first essays on the new art. I tried to measure my own development as objectively as possible against the general development of art and came to recognize the universal as the new content of art and the straight line as the new means of expression of the future. These two elements were found, in my opinion, to lead to a new style.

I ended this period with an abstract composition that was an abstraction of natural form (*Girl with Buttercups*). In 1916, after my release from military service, I founded, not without enthusiasm, *De Stijl*. If the war had not prevented it, I would have started *De Stijl* in 1914, for I resumed in 1916 where I had left off in 1914, although my work and views may have been purified and sharpened in the meantime. In an article 'From Nature to Composition' (which appeared in 1918 in *De Hollandsche Revue*), I summarized my views in a series of illustrations — abstractions of a subject — and showed how I had evolved from naturalistic to pictorial composition.

With this result (a composition made up of dissonants) I ended this period.

When I wrote down the title for this article, it seemed to me desirable to record the above notes since this article might serve as a sequel to 'From Nature to Composition'.

In 1924, with the white-black-grey composition illustrated in this issue, I ended what I now regard as the period of Classical abstract composition.

I The concept 'counter-composition' was not deliberately invented, but *arose*. And not accidentally or arbitrarily. It indicates a stage of working and plastic thought (or vision) which can be explained after the event.

In so far as painting itself is a form of thought, of plastic thought or vision, it might be said that any explanation is superfluous. And rightly so,

201

but an explanation after the event (which, therefore, precludes theorizing), can meet this objection. The time is past in which the painter, architect or composer did not think in the course of production or did not live during the process of thinking.

On the one hand, the concept of 'counter-composition' is opposed to Classical — albeit abstract — composition and to the Classical plastic concept.

On the other hand, it is opposed to the fundamental universally prevailing structural elements of nature and architecture.

Of course, the latter were important for development . . . but man has only recently discovered himself and his own age. It is our age which has produced the need for contrast. The latter was realized not only in the external manifestation of colour and matter plasticism, but also and chiefly in the tempo of life and in the technique of the daily mechanical functions of life, such as standing, circulation, driving, lying, sitting — in fact, in everything that comprises the content of architecture.

The vertical walls of our dwelling, the horizontal planes of floor and ceiling, and the intermediate vertical and horizontal planes, table, chair, cupboard, bed, etc., are sufficient proof of this. These movements, in so far as they were connected with industry, have now been taken over by machines.

In short: we execute our physical movements in the horizontal-vertical direction.

Through the continual repetition of these natural movements they have become more or less mechanical. Instinct has been mechanized. Our spirit plays no part in it. Our spirit, in so far as it has not become fossilized in our physical life, opposes this natural 'mechanism' and assumes a completely new dimension.

In everything that surrounds us the fundamental polarity of the natural horizontal and vertical structure reveals itself. In our homes and in the city, more elementary perhaps than in the forest and the landscape, but everywhere, this natural duality, more or less tautened.

Our predecessors expressed it in all their productions as much as we do, although figuratively in 'Standbein and Spielbein' or, symbolically, in the cross. All Classical constructions (load and support) were built upon it.

Horizontal-vertical (H.V.) is the fundamental content of physical, real and optical nature. The Classical principle of art was to bring these two into plastic unity through equilibrium, but this principle proved inadequate to express the modern spirit, which is characterized by the need for the

sharpest contrast of nature, physical structure and of every symbolic romanticization of the latter.

Since our physical life function is carried out in H.V., it is obvious that, for so long as this function has not yet been taken over by machines, the best architecture is that which is completely based on H.V.

II Although there exist no objective and absolute laws, *independent* of an ever-deepening and changing way of thought (which, if they did exist, would lead to dogmatic rigidity) — no fundamental, objective truths, no universal truth — the specific gravity of our spirit has nevertheless become calculable.

If optical vision had not changed into a more-than-sensuous, a super-sensuous vision, our age would never have produced the courage to see spirit in matter. No essential difference would exist between a painting by Picasso (from his 'abstract' period) and a painting by Paulus Potter, or between a recent Brancusi sculpture (for the blind) and a glass egg from a bazaar.

Nature has not changed independently of us, but we have constantly made different use of her.

If this were not so, natural forces would not have been transformed — thanks to the human spirit — into mechanical and imponderable forces. The same is true of the individual, organic life function. We are convinced that it is a sign of 'higher civilization' when these organic functions are transformed into mechanical functions, and we already more or less despise those who function organically in complete naturalness. This contempt is directed chiefly towards the complete identification with organic nature. What we miss in 'natural' man is: opposition, contrast, resistance, struggle — in a word, spirit.

Without wishing, as in medieval Stoicism, to undervalue nature, we see that the human spirit is of a completely different structure and that, in the general aspect of the technique of life (formerly called 'drama'), nature serves only as contrast, as opposition (and not as counterpart) to the spirit.

A flight in an aeroplane may suffice to convince you how great is the difference in method between nature and the human spirit, when you compare together city and countryside. Everywhere that the human spirit has intervened, as in the city, a completely different order prevails, based upon completely different laws and expressing itself in completely different form, colour, line and tension.

Just like the relationship of the city to the countryside, just as contrasting, just as hostile, is the relationship of the structure of the human spirit to that of nature.

The spirit is the natural enemy of nature (however paradoxical that may sound), without this necessarily implying a duality.

The distance which lies between the soughing of the wind, the murmuring of the water and the electrical instruments of the Negro jazz band, is filled by the human spirit.

III What I understand by spirit is very different from what our forefathers understood by it, or from what modern witches, fortune-tellers and theosophists still understand by it.

Because of the way in which expressions pass into tradition, the word 'spirit' (as the superior principle in man) has lost its meaning and, consequently, also its force of expression. It is, therefore, difficult to describe what is immediately revealed in plasticism. If the tension between the extremes of our consciousness is neutralized, such as, for example, the tension between nature and spirit by a relative plastic equilibrium, there nevertheless arises, because of the urge towards evolution, the need to take up a new position in relation to this equilibrium. If this were not so, the spirit would become fossilized in the equilibrium that had been attained and (to quote Roland Holst for once) this would then be the 'dead point'. Irrespective of what is understood by this equilibrium — a new culture, a new construction, a new religion, or a new attitude towards life — if this equilibrium were the only concern, there would be contained and achieved in it everything that the human spirit was capable of producing. As a new culture, this equilibrium would allow no further evolution. If this equilibrium were a new construction or plasticism, it could neither be improved nor developed. The equilibrium achieved would, in this instance, be absolute instead of relative, stable instead of labile; it would be eternal and unchangeable.

Such a thing is, of course, impossible and yet, however nonsensical it may sound, it is the basis of all traditions and all dogmas which, because of the firm belief in the immutability of their principles, became formal and ultimately died.

The urge towards evolution and its accompanying disruption of the equilibrium already achieved (revolution), the most glorious and ineradicable quality of the human spirit, order things differently, however.

Just as the longing to enrich our concept of space by means of mathematics continually enriches our power of imagination (intuition or consciousness) with a new dimension by assuming a new direction in relation to the direction already known, so also does the urge towards enrichment of our concept of plasticism make our consciousness accessible to a new polarity, but on a completely different and higher plane than the earlier, Classical polarity between nature and spirit.

If we are able to see the principle of balanced relationship that preceded this new polarity as the perfect *résumé* of the Classical principle of art, we shall be able to understand that this new polarity is formed by the unity of nature and spirit, with, as its counter-pole, the new superior life principle.

With the diagrammatic illustration of the ever-shifting equilibrium given below, it will be easier to follow the line of evolution to which we have been referring above.

IV The foregoing remarks are not intended to be more than rather imprecise indications of what is immediately expressed plastically by the diagonal (in relation to natural and architectural structure). The new painting can still have significance as a means of spiritual expression only in so far as it opposes natural organic structure to architectural structure instead of being homogeneous with it. Now this homogeneity was expressed by the exclusively H.V.-determined painting in the H.V.-determined structure of architecture. The former emphasized the latter. The extension of colour plane and line was in the same direction as the natural and tied architectural structure. In contrast painting (counter-composition) this extension of line and colour plane runs counter to the natural and architectural structure, *i.e.*, contrasts with the latter.

These two extreme possibilities offer a great number of secondary possibilities. Plastic intuition governed by scientific understanding — that is what modern man requires.

In the following article I shall discuss how far technique and method change at this new level of work. In this first article, too, it is necessary to give up all illusion (*e.g.*, the suppression of illusion or romanticism in the form of value, tone, etc.), and to dare to employ pure material as the most determinate and superior means of expression.

Note
With the explanations given below I have tried to describe more closely

the meanings that I attach to various frequently repeated expressions. I feel that by this means much misunderstanding can be avoided.

Spirit: The thinking principle in man, which distinguishes him from the beast. The superior quality of substance, which is borne by the soul.
Instinct: The first impulse arising from the purely animal need of self-preservation, to protect oneself and reflect on a natural opposition.
Intuition: Immediate insight in respect of values, truths and things, without thought having first been given to them.
Intellectual: What is grasped by the spirit, instead of exclusively by the intuition.
Intelligence: The actual operation of the spirit, which governs and unites all the other functions of the emotions.

[*Vol. VII, No. 73/74, pp. 17–27*]

Theo van Doesburg

Painting and Sculpture

About Counter-composition and Counter-sculpture. Elementarism (Fragment of a Manifesto)

Terminology. According to Marinetti, the term counter-composition might better be replaced by *peinture anti-statique* (anti-static painting). This concept, however, can also be applied to architecture. Through new materials and the application of new constructional methods (stressed structure, etc.), architecture may also assume an anti-static character, optically at least. What is real in painting is only apparent in architecture. No matter how it is combined, matter is always subject to gravity. It makes no essential difference whether architecture employs load and support, tension and compression construction, or no construction at all (consider the potentialities of light-weight frames of cast concrete, and the modern hardening systems which are preparing the way for chemical architecture).

Our age lies under the constellation of contrast and has a consequent need to determine the correct relationship of man to the universe. In the bending, pressing, wringing, welding and flattening of material, in mechanical methods of production, he overcomes the natural character of material. Through modern technique material is transformed,

denaturalized. The forms which thereby arise lack the rustic character of antique forms. Upon this denaturalization or, better, *transnaturalization,* the style of our age is largely based.

The expression *néo-plasticisme* (new plasticism) gives rise to the unintended misunderstanding that what is being referred to is a new plasticity, in the sense of corporeality, of three-dimensional relief. *'Beeldend'* (plastic), in the sense which has been attached to it since I first used the expression in my essays, 'The New Movement in Painting' (in the Journal *De Beweging,* 1916), as a contrast to 'picturesque' and representational, and which expression was later used in *De Stijl* to denote the immediate, elementary expression of aesthetic relationship, is not covered by the Latin concept 'plastic'. Consequently, I have replaced this term by the more comprehensive, more universal, expression: *elementarism.*

Elementarism, moreover, is real instead of abstract. The expression 'abstract' has also given rise to much misunderstanding. The reason for this will become clear from the standpoint I shall develop in this article.

In relation to visual forms of expression such as painting and sculpture, the concept of abstract is highly relative. Abstraction belongs to one of those spiritual operations in which (in contrast to the spontaneity of the emotions) certain (aesthetic) values were isolated from real things. Nevertheless, when these values became visual and were applied as a pure constructional means, they became real. Thus the abstract was associated with the real, thereby demonstrating the relative nature of the concept.

The expression 'abstract-real' (Mondrian) was, therefore, a happy invention. But, for a new orientation, we can rest content with *real.*

The age of abstraction is past.

Is not an elementary painting, *i.e.,* a determinate, self-contained, organic combination of flat colours, more concrete than the same combination concealed by the illusion of a natural organic form? Indeed, this momentarily static, frozen manifestation, isolated within the four sides of the plane, is more abstract than the organism of an 'abstract' painting composed of real colours. In fact, only that which goes on within the isolation of our thoughts is really abstract. An opened newspaper is the physical embodiment of an enormous abstraction, whose importance is determined by the man who bends over it to absorb, in the abstract, cinematographically and at great speed, the diversity of current events. The newspaper is real only as a pattern of black and white. For the printer the newspaper has a reality quite different from its reality for the reader.

Abstract and real are relative, if not changeable concepts.

It is certain, however, that the increasing need for visual reality has led to the enormous expansion of cinema and illustrated journalism (consider the flood of magazines), photography, etc. This need for visual reality forms an integral part of the style of our age. The poster is a modern means of communication, no less real than the train. We already possess a visual conquest of time and space in the film and we are no longer far from a chemical and radio-mechanical abolition of our remaining dependence upon nature.

IV It is absolutely necessary for a new orientation that we recognize this increasing need for reality in its development from an isolated abstract-religious culture that is no longer suited to our nerves.

The separation of church and state, art and church, architecture and the art jungle of politics and economics, are important stages in this development.

Both in the development of art and in that of architecture, this need for reality has also made itself felt for many decades.

For architecture, the separation of pure construction and pure art brought a strong possibility of realization. On the one hand, architecture had to free its characteristic elements from the art jungle of the past, and in so doing become 'abstract', independent. On the other hand, painting wrested itself free from architecture, the anecdotal illusion and the Classical concept of composition. Orthogonal[1] composition, in which extreme tension, horizontal-vertical, was neutralized, retained — as a relic of Classical composition — a certain homogeneity with the static nature (load and support) of architecture.

Counter- (or anti-static) composition has freed itself completely from this homogeneity. Its contrasting relationship with architecture is to be compared (but at another level) with the contrasting relationship between white, flat architecture and grey, curved nature.

Elementarism was the first truly to free painting from all convention.

A rapid review of the historical development of composition from purest Classicism will help to convince us of this.

i Classical symmetrical composition
Equal division and placing on both sides of the picture plane, the sides being divided by a fixed centre into two equal halves (example: *The Three*

Graces). The painters who lived before the Christian era often departed from the method of symmetrical composition, but, in the Christian era, when the 'figurative' centre, Isis, Apollo, etc., was replaced by Mary, Christ, etc., the symmetrical 'central' method of composition acquired a formal methodical importance, which lasted until the beginning of the twentieth century.

ii Cubist, concentrical composition

Symmetrical composition has, during the course of the ages, 'pressed' itself increasingly towards the centre, towards the axis of the picture plane, to such an extent even that the composition has taken on a completely spindle-like structure, leaving the outer parts of the canvas unoccupied; Christ, Mary, Cross, etc., have been replaced by Guitar, Bottle, Newspaper, etc.

iii Neoplastic, peripheral composition

Very important, fundamental renewal of the methods of composition. Gradual abolition of the centre and all passive emptiness. Composition develops in opposite direction: instead of towards the centre, towards the outermost edge of the canvas, and even appears to continue beyond it. In this latter tendency lay also the possibility of compositional development in three dimensions.

iv Elementary (anti-static) counter-composition

Adds to orthogonal, peripheral composition a new diagonal dimension. Thereby dissolving in a real manner horizontal-vertical tension. Introduction of sloping planes, dissonant planes in opposition to gravity and static architectural structure.

In counter-composition, equilibrium in the plane plays a less important role. Each plane forms part of the peripheral space and the construction is to be conceived as a phenomenon of tension rather than of plane relationships.

Greater variety of new plastic possibilities. For example, in addition to orthogonal, also diagonal, combined and simultaneous constructions. Introduction of colour as independent energy.

V *Elementarism* has recognized Time as a modern element of plasticism. In so doing, it has given new creative possibilities to film, sculpture and

theatre. In consequence, synoptical[2] effects also acquired a fundamental importance. Elementarism is an exclusively universal method of plasticism and production. It is opposed to all compromise as well as to all dogmatic one-sidedness. It is to be conceived as the most vital means of expression of the modern spirit. It is the product both of Neoplasticism and of a new orientation in the modern scientific and technical spheres.

Elementarism comprises every expression in the most essential, elementary manner. It requires everything to be determinate and confines itself to the pure elementary state of each thing separately.

Nature as nature, culture as culture, art as art and architecture as a serviceable, practical method of construction. All earlier systems have claimed to be able to neutralize the hostility between organic nature and human intelligence, whether by means of an interval or through a balanced relationship.

Elementarism rejects these systems and finds in spiritual and social chaos the confirmation of its basic principle relating to the total structural differentiation of nature-society and human spirit-individual. It lends support to every destructive force that contributes to the true liberation of the human spirit and to raising it to a higher level.

As a result of a new orientation relative to the earlier attempts at renewal in life and art (including Futurism, Cubism, Expressionism, Dadaism, Neoplasticism, etc.), Elementarism has assimilated all truly modern elements (often ignored through one-sidedness).

Elementarism is to be regarded, therefore, as the synthesis of the new plastic consciousness of the age. The 'isms' of the last decades have mostly perished, either because of their one-sided, dogmatic limitations, or because of compromise or chauvinistic tendencies. They no longer have any force or value for renewal.

Elementarism finds its equivalent in Relativism, in the latest researches into matter and in the phenomenological propositions relating to the unlimited, yet latent, power of human intelligence. Opposed to all religious dogmatism, the Elementarist sees in life only a *transformation perpetuelle* and, in the creative subject, a contrasting phenomenon.

VI *The matter of counter-composition.* The increasing need for reality, expressing itself in the gradual suppression of all illusionist aids and transitions, brings the independence of matter increasingly to the fore.
This is also the case in relation to colour.

Elementarism rejects the modulation of colour, that had its origins in illusionism.

Each colour possesses, as pigment, as matter, an independent energy, an elementary force. This applies both to the three most positive colours, yellow, blue and red, and to the negative equivalents: white, black and grey. Neither Cubism nor Neoplasticism were able to manage without colour 'value'.

Nevertheless, it should be recognized that an attempt was made in Cubism (Picasso), in Futurism (Carra) and in Merz (Schwitters), through the use of other materials (such as newspaper, coloured materials, sheet steel, tin, glass, etc.), to establish colour value determinately or, more precisely, to bring it to material independence. The post-Cubist means of expression ignored this, albeit instinctive, tendency. In Neoplasticism it was only the tendencies towards relationship and abstraction that were consistently pursued. Besides making use of other materials, Cubism had, while retaining colour values obtained through modulation, also made use of letters, numerals and areas of uniform stipple.

Elementarism rejects these equivalents, but recognizes their great value. It opposes the positive colours with the negative colours white, black and grey, and adds, if these are not adequate, elementary *variants* of colour or line (see, for example, the compartments in my *Counter-Composition XV* 1925, *De Stijl* 73/74). The very elementary earth colours and ochres may also serve as 'variants'.

In my now completed *Beeldende Kleurenleer* (plastic colour theory), I have discussed, in the simplest manner, colour as energy, and also as dissonance, contrast and variant.

VII *Counter-sculpture.* In sculpture as an independent plastic expression it is difficult to construct elementarily, at least in the sense of painting, poetry, etc. Orthogonal sculpture, for example, may, on the one hand, already be purer and more consistent than Cubist or Orphistic sculpture, but on the other hand, it gives a greater emphasis to the natural force of gravity than did its predecessors (and in this perhaps resides its tragedy). In the light of this, the need for dynamism becomes explicable, whether by means of moving figures or through more elementary volumes, *i.e.*, from the desire to create contrast on the axis at right angles to the static one.

Elementarism prepares for the possibility of an elementary counter-sculpture and the first thing to be done is to destroy, out of contempt for

the Euclidean view of the world (from a fixed point), this axis. This is not difficult as sculpture, but the sculpture itself has too much of the *Schmuck-teller* (ornamental dish) about it and, so, of Russian influence.[3]

On the figurative side, there are already very important documents available (*cf.* several good sculptures by Archipenko, *Dance*, reproduced in *De Stijl*, Year 1, and *Gondolier*; also many works by Boccioni, Brancusi, Laurens), yet there is almost nothing on the elementarist side that might serve as an example of counter-sculpture. Optical illusion plays a perilous role in this problem and appears unavoidable.

Rome, July 1926 *[Vol. VII, No. 75/76, pp. 35–42]*

Notes
[1] *Orthogonal*: Vertical
[2] *Synoptical*: Simultaneous visual summation of the different parts belonging to a whole.
[3] A Russian sculptor by the name of Tatlin called his sculptures of bent sheet steel *Counter-relief*. These, however, had nothing to do with counter-sculpture, since Tatlin, as a romanticist, understood neither the modern problem of sculpture nor that of architecture. This is proved sufficiently by the spiral, baroque monument which, in addition to its illogical combination of parts and spaces, is symbolic! Russian muddle-headedness and snobbish bravado to impress the flappers!

I. K. Bonset

about the sense of literature

in writing it is a question of whether the sentence is 'full', charged. hence the (dutch) term: *volzin.*

the sentence may be charged in many ways. conceptually, *i.e.*, with various kinds of ideas; poetically, if the sentence is full of creative discovery; and purely literary when, through the rearrangement of words and phrases, a new reality acquires a special form, whether conceptually or a-logically. the conceptually charged sentence is obviously meaningless to poetry. the nonsensical sentence, on the other hand, may well be meaning-

ful to modern poetry. writing, as creation with and from the word material, is pure poetry. the new verse rests upon creative invention, which is not possible without absolute destruction of syntax and the idea (and of everything relating to ordinary reason). this destruction of syntax and idea is accompanied by the abolition of time and space.

the new poetry has truly been completely liberated from these logical classifying elements of human consciousness. it knows neither a next-to-each-other nor an after-each-other. its dimensions are in the spaceless and the timeless, this applies however, only to the new poetry. it is *a priori* super-dimensional, super-real and counter-morphic.

certainly there were among the *tachtigers* (poets of the 1880s) small movements in this direction, but, at the same time in france, there were, proportionally speaking, enormous amounts of real poetry in circulation (ghil, mallarmé, de sade, de lautréamont, etc.,). the *tachtigers*, however, lacked confidence in the word-as-matter, as independent means of expression, which led, in consequence, to a rapid degeneration into bourgeois romantic or tendentious laying on of words, which had ultimately to end in a morass of words (quérido).

[Vol. VII, No. 77, p. 78]

Theo van Doesburg

Painting and Sculpture

Elementarism (Fragment of a Manifesto)

Elementarism was born, partly as a reaction against an all too dogmatic and often short-sighted application of Neoplasticism, partly as a consequence of Neoplasticism and, finally and chiefly, as a strict correction of Neoplasticist ideas.

I Elementarism rejects the demand for an absolutely static state which would lead to rigidity and cripple creative potential.
Rather than denying the existence of time and space, Elementarism recognizes these factors as the most elementary of a new plasticism. Just as Elementarism tries to bring the two factors, statics and dynamics (rest and movement), into a balanced relationship, so equally does it strive to

combine these two elementary factors, time and space, into a new dimension. While the expressive possibilities of Neoplasticism are limited to two dimensions (the plane), Elementarism realizes the possibility of plasticism in four dimensions, in the field of time-space.

Elementarism opposes to the orthogonal method of plasticism, that is homogeneous with natural construction, a heterogeneous contrasting, labile method of expression by means of sloping planes relative to the static, perpendicular axis of gravity.

If Neoplasticism, through the banishment of the central method of composition, had already opened up new paths, Elementarism renews our optical impressions completely, it does not permit the work of art a left and a right half, and it destroys radically the Classical, optical frontality of the painting.

If all our physical movements are already based upon Horizontal and Vertical, it is only an emphasis of our *physical* nature, of the natural structure and functions of organisms if the work of art *strengthens* — although in an 'artistic manner' — this natural duality in our consciousness.

If Neoplasticism has already (and rightly) rejected symmetry, associated with our natural organic structure, it also lay in its line of development to reject orthogonalism, associated with our natural organic structure, *as the only possible means of expression*. This is what Elementarism does, when, through the suppression of a rigid static state, it arouses in us a new spiritual movement, accompanied by a new optics.

Elementarism is, therefore, the purest, and, at the same time, the most direct means of expression of the human spirit, which recognizes neither left nor right, neither symmetry, nor statics, nor the exclusively Horizontal-Vertical but is always in revolt, in opposition, to nature.

II The construction method of Elementarism is based upon the abolition of positive and negative by the *diagonal* and, in respect of colour, by the *dissonant*. Balanced relationship is not the final result. Elementarism rejects the *modulation* of colours against each other and of each colour against the whole (the Classical concept of composition!) Elementarism acknowledges colour as matter and as independent energy.

III Elementarism rejects all artificial colour value and opposes to it counter-value, *i.e.*, variant against invariant, dissonant against contrast, and, finally, combinations of line and materials.

Elementarism opposes to the balanced relationship composition of Neo-plasticism: non-balanced counter-composition as a phenomenon of a time-space tension of colour, line or plane, always in opposition to the natural and architectural structure.

Elementarism completely excludes architecture as art.

From years of experiment and research it has been found that art and architecture are completely different and incompatible factors.

Elementarism is consciously striving for the end of arts and crafts and is hostile to any decorative application of the new principles. Elementarist principles, realized in architecture, produce an elementary architecture that is free of aesthetic intention.

IV Elementarism is directed not only to art, architecture and objects of utility, but also to living man and society. It wishes to renew the life concept, individually and collectively. It wishes to strengthen and arouse the spirit of opposition and revolt in the new generation, and counts upon making possible, collectively, with a great band of young people, a real, inner renewal of our mentality. This agitation, which is psychological rather than political, demands a heroic spontaneity. As a psychological, agitational movement, Elementarism is called Profundism.

The art renewals of the last twenty years have not been able to prevent individuals and society from being exclusively concerned with material interests. The material, natural well-being of individual or society has functioned and still functions as a measure of value. Completely different means from art are needed to raise man from his ignominious state (into which he was brought by religion) to a new, optimistic life concept. Elementarism provides the means and sympathizes with all movements (including those which propose other artistic principles) that make sacrifices for the renewal, liberation and enlargement of our life concept.

The increasing need for experience of reality is not to be confused with an increase of the materialistic concept of life.

The experience of reality is not to be regarded as the result of the old and almost conquered duality of spirit and matter.

In essence, spirit and matter are concepts of qualities that are to be equated with those of positive and negative, or of fast and slow, active and passive. In the experience of reality, used in my sense of the term, these two qualities have been neutralized and assumed to be a unity. Whether this experience of reality is 'abstract' is, from the Elementarist point of view,

a technical question and really to be regarded as secondary. It plays, at least in Elementarism, a secondary role. For the Elementarist, who sees the origin of polyrelativity in universal movement (not to be confused with displacement), spirit and matter, reality and super-reality, abstract and concrete are nothing more than formulae, under which category we have included the development of consciousness of the thought process *up to the present time.*

This thought process or this development of consciousness is the only reliable revelation of this polydimensional movement. Objective and subjective belong equally to this class of concept, of which Elementarism has washed its hands.

Elementarism begins where philosophy and religion have said their last word. These two have become fossilized in forms and formulae and have ceased to exist as spontaneous, living revelations of consciousness. Each consciousness presupposes an intellectual influence instead of an emotional one. The Elementarist denies emphatically any objective influence, he is aware that everything became, becomes and will become reality through the subject, who recognizes it. Emotion (art), work and intellect were the three organs of consciousness. The artist's life consciousness led through emotion, that of the proletariat through work and that of the intellectual world through the analyzing intellect.

The great struggle which began with Elementarism is concerned with the following: to destroy completely the illusionist view of the world in all its forms (religion, stupor of nature and art, etc.,) and yet, at the same time, construct an elementary world of exact and splendid reality. It has the task of destroying, piece by piece, ornamental sculpture that conceals our world image, relics of religion and all other formal traditions.

The Elementarist is a spiritual rebel, an agitator, who wantonly disturbs at the expense of his own peace, the peace of the regularity and repetitiveness of bourgeois life. He does not break with form on a piece of canvas eighteen inches square, but does break with it irrevocably on the enormous plane of human tragedy.

He knows that man is a tragic animal who is able only through tradition to live as a preserved relic and through constant repetition of each day in one and the same way. He knows that this condition, this grace, is based upon some illusion or other, which is called now religion, now duty or honour. If this illusory relationship is abolished, there is abolished at the same

time the life possibility of the bourgeosie and of what sets itself above that. The Elementarist knows that these different forms of existence are only temporary, relative and transitory and have greater interest as generative than as cultural phenomena. A new cultural phenomenon was, for example, the discovery that the concepts spirit, body, soul, did not express any real life factors, and that these indications of consciousness can no longer have any real elementary, value.

Elementarism preaches the total destruction of traditional absolution in any form (the nonsense about a rigid opposition as between man and woman, man and god, good and evil, etc.) The Elementarist sees life as a vast expanse in which these life factors are constantly alternating with one another. The positive differences are only imaginary, and yet have become completely neutralized and uniform as reality. The Elementarist opposes to this uniformity the absolute concept of a universal movement. It even includes his personal ego. Thus neither does it give plastic expression to a fixed point, while consciousness as a product or goal of life occupies an elementary position (fulfilment of consciousness).

Paris, December 1925–April 1927 [*Vol. VII, No. 78, pp. 82–87*]

De Stijl 1927 (Jubilee Number)

Theo van Doesburg

General Introduction

It is now ten years since, in pursuit of an idea which my friend Antony Kok
and I first worked out at the time of the general mobilization of 1914, I
founded a journal which had the exclusive aim of publicizing and defending
a new form of plasticism in which we believed with total conviction.

To this journal I gave the name *De Stijl*. For me this title summarized
everything I hoped for in the international evolution of art in the immediate

218

DE STIJL

F.g. Still. 1924-1927.

De Stijl 1927 (Jubilee Number)

Theo van Doesburg

General Introduction

It is now... years since I applied to appeal with an appeal on form, and with a more... part of the time he was working on fighting
decided to meet with... had the explicit term of publicity... and defending
a new form of... present-minded... is in our experimental format.
To this... Leave the... For... this (old surrounded...
everything. I hoped for an international confrontation about the image...

future. The title was the inspiration of a moment; but the line which I followed was the product of other, and more carefully considered, factors.

I cannot speak of these factors, which promoted and governed the process of growth of the De Stijl idea and the De Stijl movement, without allowing this article to take an autobiographical turn. To remain absolutely objective is only partly possible in this case [*sic*]. My enthusiasm for the new kind of plasticism, which had in my view been rendered inevitable by the new tendencies in art, led me to neglect my own interests, and to suffer at the hands of others who were only half-convinced or even entirely unconvinced. Although they lived by my enthusiasm, their aim was to maximize their own artistic modernity and social success. They are very welcome to both; but they have no call to be surprised if my initial objectivity is now replaced by a deliberate subjectivity. In regard to De Stijl, and everything connected with it, a reversion to subjectivity on my part is inevitable for two important reasons:

1. Since the De Stijl idea so intimately concerns the development of my own innermost consciousness, anything that is said about its growth and development must involuntarily take on the character of a confession. Only that which issues from the personality itself can (I am convinced) be of general importance.

2. The analysis of the inner and outer motive forces, which in the last resort determine the value of any action, must lead to a certain amount of spiritual self-surgery and self-castigation.

An element of quite legitimate ambition is a mainspring of our activity. In connection with De Stijl (as idea, movement and journal), this ambition existed rather as a survival than as a new phenomenon. In my case it was fed by my defensive reaction against the outside world rather than by a struggle with myself. Taken all in all, the only thing that counts is the proportional strength of the motive force of the idea, which on the one hand determines the degree of responsibility which one has towards it, and on the other hand overrides the petty slanders and suspicions which gather to oppose any noble idea.

If the De Stijl idea had remained tied to a closed, dogmatic and completely static experience (as with Mondrian), it would not only have barred the way to any possible further development but it would also have become arid and introverted; it would have lost so much vitality that it would come to be regarded as the barren offspring of human error. The De Stijl idea, as I understand it, is creative power in perpetual motion; it has an unlimited

relevance. But if it is regarded as a limited and dogmatic system of thought and creativity, the De Stijl idea is without any relevance, present or future.

To interpret it in a paradoxical way: the De Stijl idea as the idea of a new style, as an addition to the multitude of existing evolutionary possibilities, is meaningless and anachronistic. The De Stijl idea as the dissolution of all styles within one elementary plasticism is significant, spiritually alive, and in advance of its time.

The former attitude is rooted in pessimistic self-imposed limitations, in conservatism, in inner poverty and in narrowness of outlook; the latter is based on optimism, gradual progress towards perfection, acceptance of life, spiritual omnipotence, revolt.

Within these two antithetical attitudes the ten-year evolution of the De Stijl idea is contained.

There can be no advance towards perfection, cultural or personal, without the destruction (first) of the self and (second) of one's existing attitudes towards life.

The De Stijl discipline, as it was maintained over the years, exerted its unifying influence in every respect and in every direction, and thus made possible the further evolution of a real form of creative figuration (plasticism) using unambiguous means.

The requirement that the means used should in themselves be pure was stated by De Stijl for probably the first time; the result was that, in the new phase of pure creative figuration (plasticism) which began in 1924, the development of pure means of expression was no longer a goal but a point of departure. The fact that so few people found it possible to come close to the essence of the De Stijl idea is largely due to the inaccessibility of the language (Dutch) in which the work of the De Stijl movement was expressed. My own activities, as well as Mondrian's pamphlet *Le Néo-plasticisme* and my book *Classique – baroque – moderne*, made some difference to the situation, but in general the far-reaching influence of the movement, which was beyond anyone's control, was a product of the works of art themselves.

I know very well that the idea underlying De Stijl (both movement and publication) is no one's private property; as with a revolution, the right intellectual atmosphere must be there before any movement can be a success. However, the sentence which I spoke in 1912 – 'Disengage form from nature, and what is left is style' – contains in embryo all the elements

which five years later took shape as De Stijl. The need for a more abstract, more immediate manner of expression was felt by others as well; and they, not being hampered by years of military service, as I was, were able to put their idea into practice sooner than I. This fortunate circumstance is one of the factors which set De Stijl, as a movement, on its feet. The experience of these first concrete products of the idea strengthened my own conviction that a unity of style was in the making. In 1913–14 I had sought to find this style in an abstract, purified form of Expressionism (rather along the lines of today's Surrealism); but it is these first products of the new style, created by others, that confirm the correctness of the assertion which I made in 1912 in an article in the journal *Eenheid*: 'When the criterion was beauty, the undulating line came to the fore; but when the criterion was truth, the line simplified itself; this new criterion will lead it to end in a straight line.' In the use of the straight line I saw the consciousness of a new culture. 'The Straight Line' was the title I wanted to use before I hit upon '*De Stijl*'.

From the De Stijl idea, there gradually developed the De Stijl movement. This movement spread rapidly, year by year. Initially it was sustained only by a small, cliquish, diffident group which eventually partly dispersed and was strengthened by an infusion of new blood; now, De Stijl as a set of *demands* stands firmly in the international spotlight. No one can any longer deny that the whole evolution of modern art, especially in Northern Europe and most obviously in architecture, is De Stijl-orientated, i.e. directly or indirectly based on the work of De Stijl. As a result of the De Stijl movement other parallel movements came into being (in Germany, Belgium, Austria, Czechoslovakia, Japan, England, America, Russia, etc.). This would not have been possible if the work of De Stijl had been limited to painting.

It is only because De Stijl as a group consistently presented the image of an idea which belonged to its time — a collective idea — that the movement bore fruit. Although the internationalization of the De Stijl idea was entirely due to the editorial policy of the journal *De Stijl*, it was obviously only as a group phenomenon that De Stijl could give expression to a general collective aspiration towards style.

It is demonstrably true that this so-called group contained, from the outset, major inequalities, both of talent and of speed of evolution, which made conflicts inevitable. Nevertheless, in spite of all the mental incompatibilities which were concealed under the common motto 'De Stijl', the

opportunity existed, in the context of a general reaction against the tensions of the war, accompanied by a craving for spiritual nourishment, to fulfil a mission which will prove to have been unique in the history of art and of civilization. Whereas all movements in art used to be confined to their country of origin, the De Stijl movement spread in a short time all over Europe. This was true even in a literary sense—a remarkable fact in view of the language barrier.

Never had an idea been the object of such vigorous propaganda, in so receptive a period. This receptivity was not confined to Europe alone.

One is automatically reminded of the case of Futurism; but Marinetti's propaganda was on an altogether smaller scale, and his objectives were chauvinistic, and consequently influential only in a southerly and neutral cultural zone. He also had unlimited funds. De Stijl had nothing but dedication and hard work.

It is necessary that the living word should demolish, once and for all, the ossified clichés which are the products of jealousy, prejudice and calumny.

As I write these words in the cool air of the Vosges, and look back over what happened ten years ago in Leiden, it seems to me that I was very naïve to fail to realize that my ideal—the development of a maximum of creative power through collective effort—was an impossibility; faith in 'the straight line' was restricted to a few. *De Stijl*, as a publication, made my error only too plain. Van der Leck was jealous of the amount of space that Mondrian took for his theoretical statements, and demanded more space for his own work and ideas. The architect Oud, a very hesitant recruit to the group, held public office as a city architect and condemned the publication in *De Stijl* of what he claimed were Dadaistic articles; he cautiously refrained from signing any of the manifestos, which plainly set out the views of the De Stijl (not those of Dadaism!). He did, however, later contribute to certain second-rate publications which appeared under the title *Overzicht* or *I-10*, and which contained articles which had been printed in *De Stijl* or even rejected by it.

For the sake of contrast, the simultaneous publication of good and inferior ideas is often as inevitable as the coexistence of superior and mediocre human beings; but what was called 'independence' often led to backsliding—as was the case with Huszár's stylized naturalistic poster art, Vantongerloo's cups and plates, which were inferior to those in the shops, and Oud's continuation of the architecture of Van de Velde. For want of a

guideline the orientation was lost; a high value was placed on works which were based only on imitation and theft. Not to speak of the fact that men who had formerly been deadly political foes, the pseudo-anarchists and the communists, who, along with all wearers of beard and sandals, were excluded from De Stijl, now came to be regarded as comrades-in-arms in the cause of a new world of the spirit.

Dutch stubbornness, complacency and prejudice, together with the fatal dread of a leap in the dark (no, not sober, just stodgy and vulgar) helped to ensure that this collective intellectual movement would be a short-lived thing. Although no one made any sacrifices (except, of course, Mondrian, Rietveld, Röhl and many of the younger contributors), and although only a few understood what it was all about, everyone wanted to be a leader of De Stijl. Everyone, even though he could do nothing except repeat what had been better said elsewhere, wanted to give propaganda lectures (propaganda for himself?), even to set up a dictatorship. But not one of these miniature dictators contributed one spark of new inspiration, one new idea; what they did do, admittedly, was to swell the ranks of De Stijl as a collective reality.

De Stijl as a product of logical evolution draws its strength from a growing understanding of the principle of Elementarism. As the original basic tenets of De Stijl are now generally known and largely put into practice, the further extension and exploration of the De Stijl idea now has a totally new dimension.

On a higher plane, as a movement whose role is 'world-renewal', it is unimportant whether each individual act of expression is justifiable in Elementarist terms. The work itself, the product of an intellectual revolution, must first exist; only then can a purifying and eliminatory process of criticism and verification be of any use.

In my manifesto 'Elementarism' (parts of which have appeared in De Stijl), I have already sketched out the line of future evolution. De Stijl as a publication must forever remain the pioneer of an intellectual revolt, and must be based upon a maximum of creative power, at once purifying and aggressive, tolerant and exclusive, constructive and destructive.

De Stijl as an idea has been spreading further and further afield; today it has reached Japan, tomorrow it could reach North and South America. Futurism is dead. Expressionism is dead. Cubism is dead. Dadaism is dead. Dead, dead, dead, all the isms which arose from the beginning of the twentieth century onwards, and which were still arising at the time when

223

De Stijl began. But the phenomenon which we now see emerging under the name of Neoplasticism took shape, step by step, on the basis of the De Stijl idea. The logical coherence of this idea resides in the all-embracing nature of Elementarism.

A chair remains a chair, a table remains a table, a house remains a house:

PRINCIPAL COLLABORATORS IN DE STIJL

From 1917 to 1927

Founder: Theo van Doesburg

The names with* are of those who collaborated directly in the founding of De Stijl.

1	1917 — 18	A. Kok *	J. J. P. Oud *	B. v. d. Leck	P. Mondrian*	V. Huszár*	Jan Wils
2	1918 — 19	A. Kok	J. J. P. Oud	G. Rietveld	P. Mondrian	V. Huszár	Jan Wils
3	1919 — 20	A. Kok	J. J. P. Oud	G. Rietveld	P. Mondrian	V. Huszár	I. K. Bon
4	1921	Aldo Camini	H. Richter	G. Rietveld	P. Mondrian		I. K. Bon
5	1922	Aldo Camini	H. Richter	G. Rietveld	P. Mondrian	V. Huszár	I. K. Bon
6	1923 — 25	Aldo Camini	H. Richter	G. Rietveld	P. Mondrian	C. v. Eesteren	I. K. Bon
7	1925 — 27	Hugo Ball †	Hans Arp	G. Rietveld-Schräder	P. Mondrian (until 1925)	C. v. Eesteren	I. K. Bon

And still it continues

224

an object and that is that is all. What is made, an advertisement, like a
formula, will never be art. A line of poetry, a painting, a sculpture, are
products of a creative process freed from that too; that too, there are
. .
. .

an object of use, and that is all. What is more, an advertisement, like a frying-pan, will never be art. A line of poetry, a painting, a sculpture, are products of a creative process freed from ulterior motives; as such, they are products of a spiritualized intellectual culture, and signposts to a new and de-naturalized reality.

[*Jubilee number pp. 2–9*]

ob. v. 't Hoff	G. Vantongerloo	Gino Severini	Doesburg			
ob. v. 't Hoff	G. Vantongerloo	Gino Severini	Doesburg			
	G. Vantongerloo		Doesburg			
			Doesburg			
El Lissitzky	G. Vantongerloo		Doesburg			
G. Antheil	Kiesler	W. Graeff	Doesburg			
G. Antheil	Kiesler	W. Graeff	Doesburg	César Domela	Vordemberge Gildewart	C. Brancusi

Piet Mondrian

The Plastic Means

1 The plastic means must be the plane or the rectangular prism in primary colour (red, blue, yellow) and non-colour (white, black, grey). In architecture, empty space acts as non-colour, and volume acts as colour.

2 The equivalence of the plastic means is necessary. Although differing in dimension and colour, they must nevertheless have the same value. Equilibrium generally requires a large area of non-colour and a smaller area of colour or volume.

3 The duality of opposition in the plastic means is equally required in the composition.

4 Constant equilibrium is achieved through the relationship of position and is expressed by the straight line (the limit of the plastic means) in its principal opposition.

5 Equilibrium neutralizes and annihilates the plastic means and is achieved through the relationships of proportion in which they are placed and which creates the living rhythm.

Here are five Neoplastic laws which determine the pure plastic means and their use.

1927 [*Jubilee number, 1927, pp. 37–38*]

Cornelis van Eesteren

Ten years of 'Stijl'. Art, Technique and Town Planning

Man is slowly becoming aware that he is the victim of an uncomprehended and uncontrolled development of technique. Understanding of the nature of technique is not proportional to technical ability. The chaotic condition of our environment (the modern cultural landscape) and our settlements (towns) and the inefficient lay-out of our homes are the tangible results of this lack of understanding.

Artists have discovered intuitively this lack of balance, understanding and ability.

Reactions to this discovery were Cubism, Dadaism and functional architecture.

They provided the means of rediscovering and bringing our environment, reality and matter back under control.

Many painters turned to architecture, advertising, etc., for this purpose. The poets saw a new material in the word: they sought the universal. The particular, isolation within the self, no longer satisfied them. An urge towards collectivity arose. The painter studied the colour and form of things, the architect studied dwellings, the town planner towns, etc.

They all tried to realize in material — wood, stone, colour, steel, concrete and glass — their collective insights, to reveal the passive facts and results.

The artists could see that our age is formless, *i.e.,* that our age has found no synthesis of thought and work. But they could sense the beginnings of a synthesis in the products of technique, which have all arisen from the same mode of thought, from technology. The engineer and the modern artist, although unknown to each other, already had much in common.

Artists began to approach matter differently. In their compositions of material they began to denaturalize the subject-matter (Cubists, Dadaists).

The engineer did the same in his constructions. Iron, a material that was formerly forged and kneaded into more or less playful forms, became a new material for him. He invented steel, experimented with it for spans, and began, after he had made the necessary safety calculations, to construct with it. He designed constructions in which forces of tension and compression cancelled each other out — he constructed an equilibrium of tensions. In place of the medieval smith with his sense of play came the engineer with intuition controlled and guided by the intellect. The engineer

227

also denaturalized material. Intelligence constructs. Material is the means of achieving the end with a minimum of material and a maximum of result. The development of technique gave man a hitherto unknown degree of freedom in relation to material. He does not know how to use this freedom. This is seen best and most clearly in our towns or our most densely built-up industrial areas. All our modern great cities or industrial landscapes are chaotic. Instead of technique increasing individual happiness, it is threatening to choke it.

A few architects have seen this. They began to consider how this chaos could be conquered. Thus they did not begin by considering the form of the city, but first tried to discover the origins of this chaos. Just as the position of a room in a house is not accidental, so must the position and arrangement of the various urban neighbourhoods, parks, sports grounds, factories, dwellings, etc., be studied and given consideration.

For this reason the modern town planner is concerned with the town and with the increasingly built-up countryside as phenomena and expressions of modern life, to which he must give form and full recognition.

He knows that the old must give way to them. He possesses something positive, which he is convinced is better than the old, that must disappear when it is worn out.

By taking up this standpoint he comes into constant conflict with the 'Preservationists', who would prefer to let their fellow men live in tumble-down buildings (in traditional costume) because such picturesque scenes still give them sensations of beauty. (The Preservationists themselves travel to such places by car.)

Where there is good reason, the modern town planner makes such cultural relics into museum pieces or turns a part of the town into an open-air museum. But he does so consistently (see my plan for Unter den Linden in Berlin, where the old part is turned into an open-air museum).

The town planner (urbanist) knows that every age and every society had the cities they deserved. Our age is no exception. As a constructive element of society, it is his task to point to the possibilities that modern technique offers to our cities, so that they can renew themselves and again satisfy the demands we make upon them. It is the urbanist's task to examine and plan the reorganization of our towns and a rational use, arrangement and occupation of the soil.

The Hague 1927 [*Jubilee number, 1927, pp. 93–96*]

incomparable mechanization

i studied and got a firm hold on this subject during my stay in paris in the winter of '25–'26.

we are experiencing the final dismissal and departure of certain art forms.

a sharp distinction must be made between truly modern art and·'latter-day art'. it sometimes happens that a subject of apparently timeless significance is given a contemporary form and treated from a contemporary point of view. but this only amounts to putting a fresh coat of paint on the matter to make it a lovelier funeral.

the fact that the role of mechanization in art is continually being given labels which are designed to reduce its importance to that of just one factor, related to its social and economic achievement and potentiality, such as: convenient, mechanical, a bit cheaper, equally enjoyable, reproducible, substitute, transferable, etc., betrays just how dangerous and false are the interpretations and estimations that have been made of the mission and purpose of mechanization.

among all the fuss and the defence of the problem of mechanization, i always declare that the most important, the most significant factor has been avoided and disregarded: the elimination of chance (which now, at last, makes possible the liberation of matter).

'individual' temperament and the delightful vagaries of the personality cult (both of them factors which affect creation and yet have nothing to do with art) are eliminated herewith, once and for all.

freed of the totally misconceived and totally unnecessary ballast, the incisive, consequential, forward-looking and confident progress towards the development of absolute creation has succeeded in reaching the basic essentials in the way of components and materials (sound, colour, light, surface, time, space, movement, interval). similarly, thanks to mechanization, pure, absolute creation is now, at last, enabled to reach the most concise, the surest, the most precise interpretation.

mechanical creation will only be positive and fascinating where it can be achieved with only those particular means, in other words, where it cannot be translated or explained in the terms of a different *genre*. 'only', not 'also' or 'and', creatively possible in this particular presentation.

the subject of mechanization, which has become so 'contemporary' and urgent, is given too much importance in certain cases (as a result of misunderstanding). for example, even in the field of 'visual art': it seems to me that, since it has been established that the particular origin of colours and all the other creative materials makes no difference, the value of mechanization is often overestimated and people expect something world-shaking in this respect.

far more likely is the danger of forgetting the purpose in admiration of the means. or of becoming purely ornamental.

i repeat:

there is no such thing as mechanization 'in' art. mechanization as a means of artistic expression — sound, colour, light, etc. — is really new. the following development in the relationships between *genres* is worth watching: the purposes and preserves of the particular art forms which we have acknowledged till now are changing and are being exchanged! e.g., the stimuli and laws of composition of painting have turned up in the territory of choreography, where we see them revealed for the first time in the art of our day in their most attractive strength and most powerful tension.

everywhere in the next few years we shall see the *genres* and subjects of a century's standing completely dissolve and disappear. (the century of weary men and latterday art.)

mechanization will produce totally new laws and stimuli in absolute creation, which will certainly exercise a strong influence by their intensity and conception. creative man has a need, a right and a duty to use these and all new creative materials, to investigate tham and to develop them.

mechanization does not entail superiority to the hands, the body or the person, does not compete with them, and is 'incomparable' in both senses of the word.

the subject of mechanization is new! comprehension and criticism of its place in creative art require an entire, independent culture, which is as yet the prerogative of only a few people.

<p align="right">[Jubilee number, 1927, pp. 106–108]</p>

Aubette Number

DE STIJL

NB

NUMÉRO
CONSACRÉ
A L'

AUBETTE

N°
87
88
89

STRASBOURG

Theo van Doesburg

Notes on L'Aubette at Strasbourg

The architect François Blondel, who was born in Paris in 1717, was given the task by the government in 1764 of creating new roads in Strasbourg to contain the traffic that had been increasing as a result of tourism, and of constructing on the main square a building that would serve as an example for the style of that period. On 15 July 1764 Blondel arrived in Strasbourg with his assistants, the surveyor Lothe and the engineer Boutter. The enormous building, which filled almost the whole of the northern side of the Place Kléber, was completed in 1767. Blondel was called the 'straightener' and, in fact, he had reduced to a more or less straight façade the building that encroached too much upon the square. The whole of the building was used for military purposes (officers' quarters, guard room, armoury, etc.). The name 'aubette', originally 'obet', derives from 'aube' (dawn), because orders were issued from here at dawn.

In 1840 the Kléber monument was inaugurated. In 1845 the most fashionable café, the Cafe 'Cade', was opened in the aubette and in 1867 one of the rooms, now a cinema ballroom, was transformed into a concert hall. For a long time the city's School of Music was established here. In 1869 the aubette became the property of the City of Strasbourg. A number of rooms were arranged as an art gallery. They contained works by Schongauer, Memling, Perugino, Correggio, Ribera, da Vinci, etc. In 1870 the whole gallery was destroyed by fire. Before the war, in 1911, the city proposed a radical remodelling, not only of the aubette, but of the whole square. Forty-six architects were invited to collaborate, but the plans, which are in the municipal archives, were never carried out. The aubette remains a building of mediocre appearance.

In 1922 Messrs Paul and André Horn and Ernest Heitz took a ninety-year lease of the right-hand wing of the aubette, but the city made a condition that no modification should be made to the façade, which is regarded as a 'historical monument'.

One of the lessees, Mr Paul Horn, himself an architect, had the foundations restored and inserted a number of small rooms, to his own designs. All that remained of the old aubette were the façade, roof and columns. Consequently, the aubette no longer has its definitive form. At first, no one knew what to do with this colossus and the plans, which were made

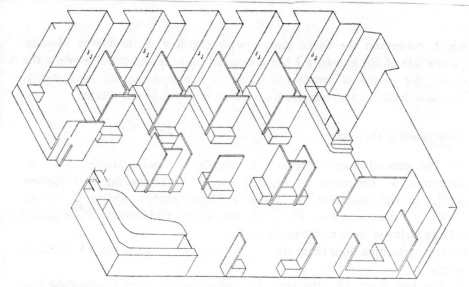

Theo van Doesburg. *Design for an inner room of the 'Aubette'*

during the first four years by several architects and interior decorators, were not carried out. The aubette traversed on paper all the variations of style from Empire to Biedermeier.

In September 1926 I entered for the first time into direct contact with the aubette through Mr Arp as intermediary. The Messrs Horn invited me to Strasbourg and I found there the possibility of executing on a large scale my ideas in the field of the construction of interiors and of transforming one of the finest rooms into the modern idiom. Mr Paul Horn, in whom I found an advocate of my ideas, persuaded me to set up an office on the Place Kléber. I first had to make new plans which would, in the nature of things, correspond with the uses of the different rooms. These plans were agreed by Messrs Horn and Heitz without any fundamental changes.

These preliminary plans, in which the function of the whole building was established, bore the stamp of a large-scale establishment of the kind to be found in large cities. I imagined a kind of 'house of passage', in which the use of the various rooms would not be too strictly defined. On the first floor I wanted to link the large hall with the cinema-ballroom by means of a foyer bar. In this way the public would be able to follow the film in the cinema-ballroom without having to remain in the room itself. This fluidity, as I imagined it, was already given by the arcade on the ground floor

233

which connected the Place Kléber with the Rue de la Haute Montée. To the left of the entrance I had a location plan erected which enables the visitor, by means of words and signs, to orientate himself more easily. The same location plan has also been put up in the different rooms.

Arrangement of the Rooms

On the ground floor there are: 1 arcade, 2 café-brasserie, 3 café-restaurant, 4 tea room, 5 Aubette Bar, 6 stairs leading to telephone booths in the basement, 7 ladies' and gentlemen's toilets, 8 cloak-rooms, 9 American Bar, 10 cellar for dancing and cabaret.
A large staircase leads to the upper floors.
On the mezzanine floor there are: 11 toilets, 12 cloakrooms, 13 billiard rooms.
On the first floor: 14 the large hall, which is also used for dancing and cabaret, 15 large banqueting hall, which is connected by a foyer to 16 small banqueting room. The kitchen and refrigerator are located in the mezzanine, while the kitchen offices are at the back, towards the Cour de l'Aubette, where there is also a service lift.

The other floors are used for offices and staff quarters, as well as for pantries, etc.

Materials

My original intention was to use exclusively durable materials, but because of expense I was obliged to restrict myself and use instead *illusionist materials*, such as colour, as a means of expression. The following are the materials which were used for fitting up the building:

Concrete, iron, glass, aluminium, electro-plating, nickel, hard rubber (for door handles, handrails, etc.), terrazzo, rabitz, linoleum, parquet, lincrusta, ripolin, frosted glass, leaded windows, rubber, leather, enamel, etc.

The use of wood has been avoided as far as possible and concrete has been used in its stead for walls and fixtures such as the bar tables. All the doors have been made from large squares of glass, framed in iron. The windows separating the passage from the tea room and the café rise uninterrupted to the ceiling, giving the maximum light and view to the interior. The lighting demanded a special study. It is inspired by the particular use of each

room. I tried to achieve a regular, full lighting which, nevertheless, would not dazzle the eyes and would avoid shadows. Centralized lighting has been abolished completely. Direct lighting has been installed in the small and large banqueting halls, in the tea room and in the passage; indirect lighting in the café-brasserie, the restaurant and the cinema-ballroom. The direct lighting in the large banqueting hall is in the form of large enamel sheets into which light bulbs have been fitted (16 bulbs in a square 4 ft × 4 ft). The same dimension of 4 ft × 4 ft is used for the ventilators. In the cinema-ballroom, the lighting takes the form of reflectors attached to nickel tubes. I originally wanted to light the rooms with neon, but I had to abandon the idea, because this kind of lighting does not yet give satisfactory results for white light. In the café-restaurant and the brasserie, I also used lighting on aluminium sheets, which, when placed on walls next to the mirrors, gives very lively effects. The tables, chairs, sofas and other accessories are mass-produced. In these pieces of furniture, as in the cupboards, etc., there has been no attempt at artistic effects.

Painting

The painting of the ceiling and walls in the large banqueting room on the first floor and in the cinema-ballroom has been carried out in relief. There were two reasons for this: firstly, because in this way I achieved a better defined surface and avoided clashing of the colours; secondly, because the fusion of the two colours was absolutely impossible.

Large banqueting hall: the surfaces are separated by bands 12 in. wide and $1\frac{1}{4}$ in. deep. Light and colour were of primary importance here in relation to function. They have given a form to the 'fixed furniture' of the room and are incorporated into it. For the subdivisions I took as a starting point a 4-ft module, this being the height of the radiators and of the grey 'neutral' zone of the balustrade. The smallest colour surface here measures 4 ft × 4 ft, while the largest ones always represent a multiple of 4 ft × 4 ft plus the width of the band (12 inches). (Example: 4 ft × 8 ft + 1 ft or 4 ft + 1 ft × 4 ft + 1 ft, etc.) For a height of 4 ft up from the floor, I employed a neutral zone, which I also repeated in a vertical direction, making it possible to instal clocks, batteries of electric switches, etc., without harming the impression of the whole. The lighting sheets as well as the ventilator grilles have been made to form an organic part of the composition. (The colour composition is based upon dissonances.)

Cinema-ballroom

It was very difficult to animate this room by the use of colours. I did not have any unbroken surface at my disposal. The front wall was interrupted by the screen and the emergency exit, the rear wall by the entrance door, by the door of the small banqueting hall and by the openings for the cinematic projectors, as well as by the reflector. The left-hand wall was broken up by the windows extending almost to the ceiling, and the right-hand wall by the door to the kitchen offices. Now, since the architectural elements were based upon orthogonal relationships, this room had to accommodate itself to a diagonal arrangement of colours, to a counter-composition which, by its nature, was to resist all the tension of the architecture. Consequently, the gallery, which crosses the composition obliquely from the right-hand side, was an advantage rather than a disadvantage to the whole effect. It accentuates the rhythm of the painting.

The surfaces are raised $1\frac{1}{2}$ in. above the plaster and separated from one another by bands $1\frac{1}{2}$ in. deep and 14 in. wide. If I were asked what I had in mind when I constructed this room, I should be able to reply: to oppose to the material room in three dimensions a super-material and pictorial, diagonal space.

The painting of the café and the restaurant on the ground floor has been as far as possible directly harmonized with the fittings, the materials and the light. Colour as pigment will always remain an illusionist substitute for obtaining an effect which is really produced only by the practical and aesthetic qualities of materials.

Signs

In my opinion, it would be out of place to choose an existing script for the signs. Neither the signs nor the illuminated advertising can be treated in the same way as typography. I had also imagined for the signs (including advertisements and neon lights) a severe rectangular script, which could be employed according to the uses of the rooms.

In the rooms designed by Madame Taeuber Arp and Hans Arp (except the cellar-ballroom), painting and the straight line have equally been applied. Moreover, the form of lighting in the tea room, small banqueting hall, staircase, etc., is comparable with that in the large banqueting hall. Corresponding to the prevailing colour of the tea room, which is grey, is

the neutral surface of the cinema-ballroom. By retaining such factors as lighting, prevailing tone, etc., in adjoining rooms, unity has not been compromised, in spite of the great differences between the rooms. The ornamental panels in the tea room were originally to have been carried out in mosaic. These surfaces have been arranged with much taste in accordance with the decorative principle. There is also much taste in the distribution of colours in the Aubette Bar behind the tea room.

For the floor of the passage, Hans Arp has been inspired by the direction of movement along these floors. The surfaces have been carried out in white, blue and black slabs disposed horizontally, while the painting of the staircase has a vertical accent. Arp wanted to emphasize vertical movement in this way. The two directions eventually culminate in the great glazed window.

Since those of us who collaborated here were people of different orientations, we made it a principle that each one was free to work according to his own ideas. Thus in the cellar-ballroom painted by Arp, for example, the inspiration was that of an unbridled imagination. The same was true for the lighting of the preceding room (American Bar), where the round column surviving from an earlier architecture served as a *leitmotiv*. The walls and, in particular, the long partition at the front were designed, in their turn, according to a 'premorphist' conception.

[*Vol. VIII, Aubette number, pp. 2–13*]

De Stijl: Final Number

Theo van Doesburg

elementarism

what is the supreme state for the painter? to feel himself as colour, to be colour. without that, the work is colourless, even though it is a medley of colours. to be colour, to be white, red, yellow, blue, black, that is to be a painter. it is not sufficient for today's and tomorrow's painter to think in colour, he must be colour and eat colour and make a painting in himself . . . as form, a single element is sufficient, the square, for example. line is divisive and binding at the same time, it gives the work direction and force. composition is not the highest thing. it is the transition to a universal form of plastic expression. the only ones capable of really great work are those who do not hesitate to distrust their visual impressions and are able to destroy. perfect work is first created when we also surrender our 'personality'. the universal lies behind our personality, impulse has never produced a work of lasting value and importance. the approach to universal form is based upon the calculation of measure, direction and number. the same approach lay at the basis of the pyramid. as far as the compositional stage, personality still has some validity, beyond composition personality becomes ridiculous and a hindrance. preference for colour is like preference for a particular dish — it equates art with the kitchen. to feel oneself as colour means carrying the whole spectrum within one, not as a treasure, but as a cross. the spontaneous method does not produce great art, since it is based upon a fleeting inspiration. only what has been long worked over, well-considered and matured is of value. by working quickly and hastily one is able to retain only transient impressions, but the work does not compel one to depth or contemplation. the cool surface is of greater importance than the nervous method of working or the warm palette. spiritual fulfilment finds completion in grey, yellow or green, rather than in red or brown. i have no objection to the use of ochres provided they are really understood as material. one must always paint in opposition to nature and its 'temperament'. to surrender, to let oneself go in the work is weakness,

feeble-mindedness. if you are full of red, choose green or blue, if you are full of yellow, choose grey or black. in this constant opposition lies the secret of true visual creation and of all great art. visual creation presupposes an *a priori* oppositional relationship between ourselves and our material, between ourselves and nature and our environment, otherwise visual creation is pointless. one must know how to make oneself small so that the work may be great.

white, always a lot of white and black, because only in this way does colour obtain its full significance. a painting might consist of only one colour if it could evoke in us all other colours by means of measure, direction and position.

the best handwork is that which betrays nothing of handwork. this perfection is dependent upon our environment: an absolute purity, a constant light, a clear atmosphere, etc., are the qualities of our environment which became qualities of the work. your studio must be like a glass bell-jar or hollow crystal. you yourself must be white. the palette must be of glass. your brush sharp, square and hard, always free from dust and as pure as a surgical instrument. there is certainly more to learn from medical laboratories than from artists' studios: the latter are cages smelling of sick monkeys.

your studio must have the cold atmosphere of the mountains at an altitude of ten thousand feet, the eternal snows must lie there. cold kills the microbes.

paris, 13 july 1930 [*Final number, pp. 15–16*]

List of Illustrations

Colour Plates

I Piet Mondrian. *Composition No. 3 with colour planes.* 1917. Oil on canvas. 48 × 61 cm. Gemeentemuseum, The Hague.

II Piet Mondrian. *Composition: Grey structure with colour planes.* 1918. Oil on canvas. 40 × 60.5 cm. Prof. Max Bill collection, Zurich.

III Piet Mondrian. *Composition.* 1921. Oil on canvas. 49.5 × 41.5 cm. Kunstmuseum, Basle (Emanuel Hoffmann Foundation).

IV Piet Mondrian. *Composition with red, yellow and blue.* 1927. Oil on canvas. 61 × 40 cm. Stedelijk Museum, Amsterdam.

V Theo van Doesburg. *Pure painting.* 1920. Oil on convas. 135.8 × 86.5 cm. Musee National d'Art Moderne, Paris.

VI Bart van der Leck. *Still-Life with wine bottle.* 1922. Oil on canvas. 40 × 32 cm. Kröller-Müller Rijksmuseum, Otterlo.

VII Theo van Doesburg—Cornelis van Eesteren. *Architectural project.* 1923. Watercolour.

VIII Gerrit Thomas Rietveld. *Colour project for the Schröder residence, Utrecht.* 1923–4. Watercolour.

Monochrome Illustrations

1 Piet Mondrian. 1929.

2 Theo van Doesburg. 1923.

3 Theo van Doesburg in his studio. 1923.

4 Jacobus Johannes Pieter Oud. *c.* 1925.

5 Bart van der Leck. *c.* 1925.

6 Cornelis van Eesteren. 1923.

7 Gerrit Thomas Rietveld. *c.* 1925.

8 Piet Mondrian. *Still-life with ginger jar II.* 1912. Oil on convas. 91 × 5 × 120 cm. Gemeentemuseum, The Hague (S. B. Slijper collection).

9 Piet Mondrian. *Trees in blossom.* 1912. Oil on canvas. 65 × 75 cm. G. J. Nieuwenhuizen Segaar, The Hague.

10 Piet Mondrian. *Pier and ocean.* 1914. Charcoal and Indian ink. 53.5 × 66 cm. Harry Holtzman collection, New York.

11 Piet Mondrian. *Pier and ocean.* 1915. Oil on canvas. 85 × 108 cm. Kröller-Müller Rijksmuseum, Otterlo.

12 Piet Mondrian. *Composition with pure colour planes on white ground.* 1917. Gouache on cardboard. 34 × 47 cm. Mrs and Mr B. H. Friedmann collection, New York.

243

13 Piet Mondrian. *Composition in blue, B.* 1917. Oil on canvas. 61 × 48 cm. Kröller-Müller Rijksmuseum, Otterlo.

14 Piet Mondrian. *Composition: Bright colour planes with grey lines.* 1919. Oil on canvas. Diagonal 84 cm. Kröller-Müller Rijksmuseum, Otterlo.

15 Piet Mondrian. *Composition: Checkerboard, bright colours.* 1919. Oil on canvas. 86 × 106 cm. Gemeentemuseum, The Hague (donated by S. B. Slijper, Blaricum).

16 Piet Mondrian. *Composition.* 1922. Oil on canvas. Rothschild collection, Kitchawan, New York.

17 Piet Mondrian. *Composition with red, yellow and blue.* 1930. Oil on canvas. 48 × 48 cm. Alfred Roth collection, Zurich.

18 Bart van der Leck. *The storm.* 1916. Oil on canvas. 118 × 159 cm. Kröller-Müller Rijksmuseum, Otterlo.

19 Bart van der Leck. *Geometrical composition I.* 1917. 95 × 102 cm. Kröller-Müller Rijksmuseum, Otterlo.

20 Bart van der Leck. *Horseman.* 1918. Oil on canvas. 94 × 40 cm. Kröller-Müller Rijksmuseum, Otterlo.

21 Theo van Doesburg. *Russian dance.* 1918. Oil on canvas. 136 × 62 cm. Museum of Modern Art, New York.

22 Theo van Doesburg. *Card-players.* 1916-17. Tempera. 117 × 147 cm. Nelly van Doesburg collection, Paris-Meudon.

23 Theo van Doesburg. *Abstract version of 'Card-players' (Composition 9).* 1917. Oil on canvas. 116 × 106 cm. Gemeentemuseum, The Hague.

24 Theo van Doesburg. *Composition II.* 1918. Oil on canvas. 56.5 × 101.5 cm. Solomon R. Guggenheim Museum, New York.

25 Theo van Doesburg. *Contra-composition of dissonances XVI.* 1925. Oil on canvas. 100 × 180 cm. Gemeentemuseum, The Hague.

26 Theo van Doesburg. *Composition XX.* 1921. Oil on canvas. 98 × 68 cm. Meriden Museum, Connecticut.

27 Theo van Doesburg. *Arithmetical composition.* 1929. Oil on canvas. 50 × 50 cm. Museum of Modern Art, New York.

28 El Lissitzky. *Proun GBA No. 4. c.* 1923. Oil on canvas. 77 × 82 cm. Gemeentemuseum, The Hague.

29 Friedrick Vordemberge-Gildewart. *Composition No. 31.* 1927. 100 × 130 cm. Gemeentemuseum, The Hague.

30 Georges Vantongerloo. *Construction in the sphere.* 1917. Blue-painted wood. Height 17 cm. Nelly van Doesburg collection. Paris-Meudon.

31 Georges Vantongerloo. *Composition.* 1924. Concrete. Height 25 cm. Peggy Guggenheim collection, Venice.

32 Theo van Doesburg. *Restaurant Aubette, Strasbourg.* 1928.

33 Theo van Doesburg. *Interior.* 1919. With furniture by Gerrit Thomas Rietveld.

34-5 Theo van Doesburg. *House with studio, Meudon.* 1930.

36 Theo van Doesburg—Cornelis van Eesteren. *Design for a hall in a university.* 1923.

37-8 Theo van Doesburg—Cornelis van Eesteren—Gerrit Thomas Rietveld. *Project for private house.* 1923-4.

39-40 Theo van Doesburg—Cornelis van Eesteren. *Project for private house.* 1923.

41 Gerrit Thomas Rietveld. *Red and blue armchair.* 1918. Stedelijk Museum, Amsterdam.

42 Gerrit Thomas Rietveld. *Chair.* 1923. Stedelijk Museum, Amsterdam.

43 Gerrit Thomas Rietveld. *Sideboard.* 1919. Stedelijk Museum, Amsterdam.

44 Gerrit Thomas Rietveld, *Consulting room for Dr Hartog, Maarssen.* 1920. Destroyed.

45 Gerrit Thomas Rietveld. *Schröder residence, Utrecht.* 1924.

46 Gerrit Thomas Rietveld. *Schröder residence, first-floor interior, Utrecht.* 1924.

47-8 Cornelis van Eesteren. *Project for a riverside house.* 1923.

49 Robert van't Hoff. *Huis ter Heide, Utrecht.* 1916.

50 J. J. P. Oud. *Site office.* 1923.

51 J. J. P. Oud. *Café de Unie, Rotterdam.* 1925.

52-3 J. J. P. Oud. *Kiefhoek estate, Rotterdam.* 1925-30.

54 J. J. P. Oud. *Church in Kiefhoek, Rotterdam.* 1928.

55 J. J. P. Oud. *Kiefhoek estate, Rotterdam.* 1925-30.

56 J. J. P. Oud. *Weissenhof estate, Stuttgart.* 1927.

57 Vilmos Huszár. *Project for interior.*

58 César Domela. *Neo-plasticist composition No. 10.* 1930. Wood, copper and plexi. Diagonal 110 cm. Gemeentemuseum, The Hague.

ACKNOWLEDGMENTS FOR PHOTOGRAPHS

Gemeentemuseum, Amsterdam 3, 7, 34, 42, 43; Jan Versnel, Amsterdam 45; Gemeentemuseum, The Hague 25, 28, 29, 58; Van Ojen, The Hague 56; Verlag DuMont Schauberg Photo archives, Cologne 1, 2, 5, 8, 9, 10, 12, 14, 15, 16, 17, 22, 23; Solomon R. Guggenheim Museum, New York 24; Museum of Modern Art (Soichi Sunami), New York 21; Rijksmuseum Kröller-Müller, Otterlo 18, 20; Gemeentewerken, Rotterdam 52, 53.

The following originals were supplied by the editor: 4, 6, 11, 13, 19, 26, 27, 30, 31, 32, 33, 35, 36, 37, 38, 39, 40, 41, 44, 46, 47, 48, 49, 50, 51, 54, 55, 57.

Biographies

ANTHEIL, George

Born 1900, in the United States; composer, pupil of Ernst Bloch. One of the forerunners of modern movement in music; reverted later on to neo-classicism. Works in Hollywood, composer of music for Paramount Pictures.

ARP, Jean

Born in Strasbourg, 1887, sculptor, painter and poet.
1907 Studies at Weimar.
1907–8 Académie Julian, Paris.
1912 Contact with Kandinsky and the *Blaue Reiter*.
1914 In Paris, meets Apollinaire and his friends.
1916 One of the founders of Dada in Zurich.
1919 In Cologne, with Max Ernst.
1921 Marries Sophie Taeuber.
1922 Lives in Paris, takes an active part in surrealist movement.
1926 Lives in Meudon.
1930 Concentrates on sculpture.
1931 One of the founders of Abstraction-Création.
1940 Flees to Grasse, southern France.
1942–5 Lives in Switzerland.
1945 Return to Meudon.
1966 Dies in Basel.

BALL, Hugo

Born 1866, in Germany; writer and poet, one of the pioneers of expressionism.
1916 Founder of the review *Dada* in Zurich.
1927 Dies in Locarno.
His most important book: *Die Flucht aus der Zeit.*

BONSET, I. K.

See Theo van Doesburg.

BRANCUSI, Constantin

Sculptor, born in Pestisani Gozj, Roumania.
1876 Lives in Paris.
1894–8 Studies at Cracow art academy.
1898–1902 Pupil at the Bucharest academy.
1904–7 Works with A. Mercié in Paris, under the guidance of Rodin.
1906 Exhibition in Paris.
1907 Complete simplification of forms and abstract expression.
1920 His exhibition at the Indépendants in Paris causes a scandal.
1926 A lawsuit is commenced against him by the American customs authorities, as they do not want to accept his sculptures as works of art.
1937–8 Travels to India; he is commissioned to make a sculpture for a temple in Haiderabad: *Bird in the Air.*
1957 Dies in Paris.
Brancusi was the pioneer of the abstract movement in sculpture.

CAMINI, Aldo

See Theo van Doesburg.

DOESBURG, Theo van (pen-name of C. E. M. Küpper)

Born in Utrecht, August 1883.
1899 Started painting.
1908 First exhibition at The Hague.
c. 1912 works as an art critic for several periodicals, among others *Eenheid.*
1914–16 Serves in the Army during World War I.
1916 Commences his collaboration with the architects Oud and Wils.
In this period group De Sphinx with Oud.
1917 Foundation of De Stijl. In the same year collaborates with Oud on a house at Noordwijkerhout.
1919 Project for a monument.
1920 Architectural projects at Drachten.

1921 Visit to Berlin and Weimar.
1922 Teaches at the Bauhaus, Weimar. Dada influence and lecturing tour.
1923 Exhibition of architectural projects with Van Eesteren and Rietveld at the Galerie de l'Effort Moderne, Paris, and later at the Ecole spéciale de l'Architecture.
1924 Exhibition in Weimar, first studies in town planning. First counter-compositions.
1925 Architectural exhibition at Nancy. Dynamic
1926 Publication of manifesto of elementarism. Commissioned to reconstruct l'Aubette at Strasbourg.
1927 Construction of l'Aubette.
1928 Publication of the results of the Aubette project.
1929 Further development of elementarism; project for a house at Meudon. Becomes editor of *l'Art Concret*.
1930 Lectures in Spain. First arithmetical compositions.
1931 Dies at Davos on 7 March. Articles in *De Stijl*.
Publications: *De Nieuwe beweging in de schilderkunst*, Delft 1917.
Drie voordrachten over de nieuwe beeldende kunst, Amsterdam 1919.
Grondbegrippen der nieuwe beeldende Kunst, Amsterdam 1919.
(German translation: *Grundbegriffe der Neuen gestaltenden Kunst*, Bauhausbücher no. 6, Munich 1924).
Klassiek, barok, modern, The Hague 1920.
Wat is Dada? The Hague 1924.
L'Architecture vivante, Paris 1925.

DOMELA NIEUWENHUIS, César

Born in Amsterdam, 1900.
1919–22 Starts painting from nature.
1922–23 In Ascona and Bern; first attempts in pure plastic art and in constructivism.
1923 Participates in the exhibition of the November Group exhibition at Berlin, with non-figurative work.
1924–25 In Paris, contact with Mondrian and Van Doesburg.
1924 Personal exhibition at The Hague.
1925 Joins De Stijl.

1927–33 In Berlin.
After 1928 he turns away from painting to the construction of reliefs.
He gradually draws away from neo-plasticism in search of subtler forms.
1933 Moves to Paris where he begins to make multi-coloured reliefs, using the contrasting effects of different materials.
Publications in *De Stijl*.

EESTEREN, Cornelis van

Born in Alblasserdam, 1897. Studies architecture at the Rotterdam academy and town planning in Paris at the Sorbonne and the Ecole des Beaux-Arts.
1921 Prix de Rome.
1922 First contact with Van Doesburg.
1923 Joins De Stijl, exhibits architectural projects with Van Doesburg in Paris; project for house on the river.
1925 First prize in the Unter den Linden competition, City of Berlin.
1927–30 Lecturer in town planning at the Weimar academy for architecture.
1929 Chief civil engineer-town planner to the City of Amsterdam.
1947 Professor at the Technical University at Delft.
1952 Head of the Department of Town Planning of the City of Amsterdam. Honorary President of the C.I.A.M.
Lives in Amsterdam.
Publications in *De Stijl*.

GRAEFF, Werner

Born in Wuppertal-Elberfeld, 1901.
1921 Joins the Bauhaus, where he is greatly impressed by van Doesburg's lectures. Concentrates on industrial design and is in close contact with De Stijl in the years 1922–3. Continues his technical studies at the Technical University of Berlin-Charlottenburg. Co-founder of the review 'G' with Mies van der Rohe and Richter.
1927 Press officer of the Werkbund exhibition at Stuttgart, also edits the books on the Weissenhofsiedlung. Makes abstract films with Richter.

1934 Leaves Germany.
1951 Returns to Germany. Professor at the Folkwang-Werkkunstschule, Essen. Makes abstract murals.

HOFF, Robert van 't

Born in Rotterdam, 1887, son of an eminent bacteriologist.
Studies architecture. Visits the US before World War I where he is much impressed by Frank Lloyd Wright and his work.
1916 Builds two important houses at Huis ter Heide.
1917 Joins De Stijl after his return to Holland.
1920 Leaves De Stijl. Now lives in England. Publications in De Stijl.

HUSZÁR, Vilmos

Born in Budapest, 1884. Studies in Studio Hollosy, Munich and at the School of Decorative Arts in Budapest. Has lived in the Netherlands since 1905. Co-founder of De Stijl. Designs stained glass and elaborates the application of De Stijl principles to interior decoration projects.
1923 Leaves De Stijl.
1960 Dies at Hierden, Netherlands.
Publications in De Stijl.

KIESLER, Friedrich

Born in Austria, 1896.
1923 Contact with De Stijl.
1924 Creates the new space theatre in Vienna.
1925 Demonstrates new spatial concept of housing and town planning in the Austrian Pavilion at the Great Exhibition in Paris; develops a new system of construction and tension in free exhibition units.
1926 Moves to the United States.
1933 Space house, New York City.
1937 Director of the Laboratory at the School of Architecture, Columbia University.
1947 Designs the 'Hall of Superstition' at the Galerie Maeght, Paris.
1965 Dies in New York.

KOK, Antony

Born in Rotterdam, 1882. Lives in Blerik and Tilburg.
1915 Meets van Doesburg and they become close friends.
He makes contributions to 'De Stijl's' literary propaganda, and is the model of Verwey's portrait studies '40 × 1'. He is employed by the Netherlands State Railways until 1943.
1952 Moves to Haarlem, where he remains.

LECK, Bart van der

Born in Utrecht, 1876, studies at the State School for Decorative Arts and at the academy in Amsterdam.
1905 Illustrations for the Song of Songs, in collaboration with P. J. C. Klaarhamer.
1910 First realistic studies.
1911 Interest in the accentuation of the plane.
1914 Stained glass window 'Mining Industry'.
1916 His stylization reaches a culminating point in 'The Tempest' and 'Harbourworks'.
1917 Abstract compositions, projects for an interior. Joins De Stijl.
1918 Designs interior of stand for Bruynzeel at the Utrecht Fair. First figurative compositions using elementary symbols.
1919 Makes studies in textile technique.
1928 Designs textiles.
1934 First attempts in interior decoration by distribution of colours (house at Hilversum).
1935 Makes his first studies in ceramics.
1940–41 Book illustrations.
1949 Design and execution of interior in colour, Amsterdam.
1952 Design and execution in colour of canteen interior at a factory in Amsterdam.
1958 Dies at Blaricum, near Amsterdam.
Publications in De Stijl.

LISSITSKY, El (Eliezer) Markovitch

Born in Smolensk, Russia, 1890.
1909–14 Studies engineering at Technical University, Darmstadt.

1914 Returns to Russia.
1919 Creates the Proun; joins the constructivist group in Moscow, founded in 1913 by Tatlin.
1921 Professor at the State Art School, Moscow. Starts the constructivist movement in Germany with L. Moholy Nagy. Contacts with Van Doesburg and Mies van der Rohe: they start the group 'G'.
1922–3 Editor of the periodical *Der Gegenstand* in Berlin.
1923–5 Lives in Switzerland; founder of the group and the review *ABC* .
1925–8 Works in Hanover as a guest of the Kestner Gesellschaft; designs the gallery for abstract art at the Landesmuseum.
1928 Returns to Moscow; teacher of visual education at State School.
1941 Dies in Moscow.

MONDRIAN, Piet

Born in Amersfoort, 7 March 1872. His first studies in drawing are made under the guidance of his father and an uncle.
1892–4 Studies at the Amsterdam Academy.
1895–1907 Naturalistic period; landscapes around Amsterdam; copying in museums, scientific drawings for the Leiden University.
1908–10 Moves to Domburg (Zeeland). Comes under the influence of Jan Toorop. Simplification of means of expression, primary colours (pictures of dunes and towers). Symbolist period (*viz.* his triptych *Evolution*).
1911 Moves to Paris. Influence of Picasso and Léger. Cubist period (paintings of cathedrals, harbours and scaffoldings in a simplified cubist manner; colours grey, brown and blue).
1914 In Holland at outbreak of World War I.
1915 Further steps towards abstraction; plus-minus paintings.
1917 Complete abstraction. Founding of De Stijl.
1919 Returns to Paris.
1920 Publication of *Le néo-plasticisme*.

1924 Publication of *Die neue Gestaltung* (German translation of *Le néo-plasticisme* and other articles).
1925 Leaves De Stijl.
1938 Moves to London.
1940 Bombed out in London, leaves for New York. Late period of *'New York City'* and *'Boogie-Woogies'*.
1944 Dies at Murray Hill Hospital, New York on 1 February.
Publications in *De Stijl*.
Néo-plasticisme, Paris 1920.
Neue Gestaltung, Munich 1924.
Plastic art and pure plastic art, New York 1945.

OUD, Jacobus Johannes Pieter.

Born in Purmerend, 1890. Studies at the School of Decorative Arts 'Quellinus' and at the Amsterdam Rijksnormaalschool voor Tekenonderwijs, afterwards Technical University at Delft. Works with architects Stuyt and C. Cuypers, later with Th. Fischer, at Munich. Returns to settle as architect in his home town.
1913 At Leiden.
1915 Project for a public baths designed under the influence of Berlage.
1916 Houses at Velp and at Broek in Waterland.
1917 Holiday hostel at Noordwijkerhout and the villa 'Allegonda' at Katwijk. Becomes co-founder of De Stijl. Designs the project for a seaside esplanade – the first architectural venture inspired by De Stijl.
1918 Becomes City Architect of Rotterdam. Project for workers' standardized dwellings; first block of the Spangen settlement at Rotterdam.
1919 Project for factory at Purmerend; second block of the Spangen settlement.
1920 Blocks of the Tusschendijken settlement at Rotterdam.
1921 Leaves De Stijl.
1922 Project for a country house near Berlin. Blocks of houses at Oud-Mathenesse, Rotterdam.
1923 Oud-Mathenesse, administration building.

1924 Blocks of houses at Hoek van Holland.
1925 Restaurant De Unie at Rotterdam, and blocks of the Kiefhoek settlement, Rotterdam.
1926 Project for the Rotterdam Stock Exchange.
1927 Weissenhoff settlement in Stuttgart, Germany. Extension of the Villa Allegonda at Katwijk.
1928 Chapel at Kiefhoek settlement, project for a house at Brno, Czechoslovakia.
1931 Project for country house at Pinehurst, North Carolina (USA); design for an interior for Jonkheer de Jonge van Ellemeet.
1934 Projects for a house for Mr D. and another dwelling house.
1934–36 Conversions of house for Dr H.
1935 Project for studios at Hillegersberg.
1936 Country house at Blaricum.
1937 Interiors for the *S.S. Nieuw Amsterdam.*
1938–42 Office building for Shell-Nederland at The Hague.
1942–3 Project for reconstruction of Hofplein at Rotterdam.
1947 Workers' standardized dwellings.
1947–8 Competitive design for the Head Office Royal Netherlands Steel Furnaces Co., Ijmuiden.
1948 National Army Monument at the Grebbeberg, Holland; office building for S.V.H., Rotterdam; project for religious centre, The Hague.
1949 National War Memorial, Amsterdam.
1950 Project for house at Bloemendaal; project for the reconstruction of the St Laurenskerk of Rotterdam; office building for S.V.H. Rotterdam.
1951 Project for meeting-house for provincial states of South Holland at The Hague.
1943–1955 Spaarbank, Rotterdam.
1950–5 Lyceum, The Hague.
1952 Project Bio-vacantieoord, Arnhem.
1954 Project office building 'The Utrecht', Rotterdam.
1963 Dies in The Hague.

Publications in *De Stijl.*
Hollandische Architektur, Munich 1926.
Nieuwe Bouwkunst in Holland en Europe, Amsterdam 1935.

RICHTER, Hans

Born in Berlin, 1888.
1912 First contact with modern art through the Blaue Reiter.
1913 During the Salon d'Automne, he meets Marinetti. Cézanne and cubism exert some influence on his art.
1916 First exhibition in Munich. Joins the Dadaist movement in Zurich.
1917 First abstract works.
1918 Through Tristan Tzara, Richter makes the acquaintance of Viking Eggeling, whose work shows a parallel development.
1921 First abstract film; *Rhythm 21*, with Eggeling.
1926 Stops painting, devotes his time entirely to motion pictures.
1929–30 Organizes Berlin Film League.
1933 Emigrates to France.
1941 Professor at City College, New York; director of the Film Institute.
1947 Makes *Dreams that money can buy* in collaboration with Duchamp, Léger, Max Ernst, Man Ray and Alexander Calder.
1950 Exhibits his scrolls, a new type of plastic composition, in various European galleries.

RIETVELD, Gerrit Thomas

Born in Utrecht, 1888; works as a cabinet-maker from 1899.
1906 onwards, works as a designer for jewellers. Studies theory, aided by P. J. C. Klaarhamer.
1918 Produces first wooden furniture after his own designs; joins De Stijl.
1920 Improves his wooden constructions.
1923 Co-operates with Van Doesburg and Van Eesteren.
1924 Builds house at Utrecht after his own plans. This is the first realization of De Stijl's architectural principles.
1928 Block of houses at Utrecht.

1934 Designs sets of furniture.
1953–54 Netherlands Pavilion, Venice Biennale.
1964 Dies in Utrecht.

SCHRÖDER-SCHRÄDER, T.

Born in Deventer, 1889; studies at the Technical University of Hanover.
1924 onwards, close collaboration with Rietveld.
1920 Designs an interior with Rietveld to demonstrate the new principles of space. Her own house at Utrecht designed jointly by Rietveld and herself, is the outstanding monument of the new concept.

SEVERINI, Gino

Born in Cortona (Italy) 1883; lives in Paris.
1901 Studies in Rome, meets Boccioni and Balla.
1906 Comes to Paris; friendship with Modigliani and Braque.
1910 Signs the manifesto of futurism, meets Picasso.
1915 Turns to neo-classicism.
1917 Contact with De Stijl.
1930 Reverts to a more decorative form of cubism.
1950 Prize at the Biennale, Venice.
1966 Dies in Paris.

VANTONGERLOO, George

Born in Antwerp, 1886. Studies at Brussels and at Antwerp Academy. After having been wounded early in World War I, he comes to Holland, where he is interned.
1917 First abstract sculptures; joins De Stijl.
1919 Lives in Brussels. Sculpture; the 'interrelation of masses'.
He moves to Mentone.
1921 Leaves De Stijl.
1924 Publishes his book *L'Art et son avenir*.
First production of sculpture based on mathematical formulae.
1927 Moves to Paris.

1929 Study for a bridge over the River Scheldt.
1930 Project for an airport.
1931 Vice-President of the group Abstraction-Création.
1965 Dies in Paris.
Publications in *De Stijl*.
L'Art et son avenir, Antwerp 1924.
Paintings, sculptures, reflections, New York, 1948.

VORDEMBERGE-GILDEWART, Friedrich

Born in Osnabrück, Germany, 1899.
1919 Begins to paint, his work being non-figurative from the very beginning. Settles in Hanover, where he is in close contact with Kurt Schwitters.
1924 He is invited by Van Doesburg to join De Stijl.
1925 Exhibits with the other members of De Stijl at the exhibition L'Art d'aujourd'hui in Paris.
1931 Becomes member of the group Abstraction-Création.
1936 Moves to Berlin.
1937–8 Works in Switzerland.
1938 Moves to Amsterdam.
1953 Professor at Hochschule Neue Gestaltung, Ulm.
Besides his activities as a painter, he is engaged in typographical designing and writes poetry.
1964 Dies in Ulm.
Publications in *De Stijl*.

WILS, Jan

Born in Alkmaar, 1891. Studies at Amsterdam, makes study visits to Germany. Begins his architectural career in the studios of Mullers and Berlage. He is finally established as an architect at The Hague.
1916 Co-operates with Van Doesburg.
1917 Joins De Stijl.
1919 Designs and carries out the conversion of the hotel De Dubbele Sleutel, at Woerden.
1920 Papaverhof, The Hague; Protestant

Church at Nieuw Lekkerkerk.
1921 Blocks of houses at Daal en Berg.
1922 Centrale Onderlinge.
1926 Apartment house, Josef Israelsplein,
The Hague.

1928 Olympic Stadium at Amsterdam.
1930 OLVEH building, The Hague.
1935 The City Cinema, Amsterdam.
Lives in The Hague.
Publications in *De Stijl*.

Index of Names

Page numbers in italics refer to figures in the text. Plate numbers are at the end of the entry; colour plates are indicated by roman numerals.

253